Biennial Ehsan Yarshater Lecture Series
SCHOOL OF ORIENTAL AND AFRICAN STUDIES
UNIVERSITY OF LONDON
(*January 11–16, 2007*)
No. 5

Supervised by
DORIS BEHRENS-ABOUSEIF

This publication is sponsored by
THE BAHARI FOUNDATION

THE ART AND ARCHITECTURE
OF TWELVER SHI'ISM: IRAQ, IRAN
AND THE INDIAN SUB-CONTINENT

by
JAMES W. ALLAN

Azimuth Editions

Published by Azimuth Editions

Azimuth Editions
7 Egerton Gardens, London SW3 2BP

Distributed worldwide by
Oxbow Books
10 Hythe Bridge Street
Oxford OX1 2EW
www.oxbowbooks.com

A CIP record for this book is available from the British Library

ISBN (10) 1-898592-29-2
ISBN (13) 978-1-898592-29-7

Design by Claudius Naumann
Printed in Italy

Jacket image: Tomb and Shrine of the Imam Reza, Mashhad © dbimages/Alamy

Contents

Foreword

I was deeply honoured when Professor Doris Behrens Abou-Seif invited me to give the Yarshater lectures at SOAS in January 2007. I have worked most of my life on Islamic minor arts, especially on Islamic metalwork, and I have little doubt that it was on that theme that Doris expected me to speak. The theme I chose, however, was rather different: the Shi'i art and architecture of Iraq, Iran and India. This idea derived from my work for the Ashmolean's Inter-faith Exhibition Service (AIFES). Here, Ruth Barnes had produced a highly successful exhibition on *Pilgrimage: The Sacred Journey*, which was shown in the Ashmolean Museum from January to April, 2006. During that exhibition I realised how difficult it would have been to include more Shi'i material. For there was no resource available to help identify possible objects, and more importantly to evaluate such objects within the context of Shi'i Islam. The Ashmolean Inter-faith Exhibition Service foundered for lack of funding, at a time when the Museum was involved in a £ 50 million redevelopment. However, I determined to focus future research on Shi'ism, so that future multi-faith exhibitions, wherever they were held, would have a resource to help their directors and designers to understand what makes Shi'i art Shi'i, and to enable them to illustrate Shi'i art in an appropriate, sympathetic and convincing way.

I am very conscious that in this book I have had to be selective. I soon discovered, as I researched and travelled, that I had chosen a vast topic which needed far more time than I had available. I therefore took some hard decisions. Most importantly, I decided to limit my study to the Twelver Shi'i communities of Iraq, Iran and India. I was fully aware that by doing so I would be omitting other such communities which are of international importance and great academic interest e.g. the Twelver communities in South Lebanon and Syria, the Zaydis of the Yemen, and the Isma'ilis in their historical incarnation as the Fatimid caliphate, and in their contemporary settings in Tajikistan and elsewhere. I am equally conscious that in this book I can only scratch the surface of the subject, and that each chapter or theme will itself be highly selective. I am also aware that this book is in many ways a gathering of the work and views of other scholars. However, these are all, I am afraid, problems associated with taking on such a huge topic. My aim is to provide a base on which others can build.

In this book, for ease of understanding, I shall for the most part use dates associated with the Christian era, in other words the dating system with which most readers are familiar. Only if an object or building actually bears a date will I give it in its Islamic original, or *hegiri*, form, and in that case I shall follow it with the equivalent date in the Christian era.

Transliterations, as always, are a major problem, given that we are dealing with words in Arabic, Persian, and contemporary Indian English, and that the latter usages are by no means uniform. For simplicity's sake, I have used no diacriticals, on the basis that those who know the languages do not need them, and those who do not are simply confused by them. Arabic or Persian words not commonly known in English are put in italics: they are defined on their first appearance in the text, and they are also to be found in the Glossary. Indian English words are not put in italics. For Arabic and Persian words and names, the letters 'ayn and the *hamza* are transliterated, but normal English language spellings of Indian names have been used, unless they are part of a quotation from an Arabic or Persian inscription or text. It is therefore possible to find 'Ali and Ali in the same sentence! Names of places are spelt as in contemporary English. The name of the 8th Imam I have transliterated as Reza, also following contemporary English usage, though in fig. 1 it appears as al-Rida.

Some of the images I needed proved difficult if not impossible to find, especially for the first chapter in the book, which largely focuses on the Iraqi shrines. It may be of interest to realise that, at the time of writing, Archnet, the great resource for architectural images on the web, contained no image of the shrine of 'Ali at Najaf, nor of that of Husain at Kerbala, though the riches of 'Google earth' were brought to my attention at the last minute. All the more do I want to take this opportunity to thank various organisations and individuals who helped me, as far as they could, with images of buildings, or with images of objects, as well as with information: in particular the Chidurji Foundation, the Khoi Foundation, Bob Alderman, Arezou Azad, Mark Brand, Peter Chelkowski, John and Vesta Curtis, Samar Damluji, Massumeh Farhad, May Farhat, Kjeld von Folsach, John Fritz, Javad Golmohammadi, Hamid Keshmirshekan, Elias Khamis, Geoffrey King, Yahya Michot, Sadiq Naqvi, Nahla Nassar, Alistair Northedge, Venetia Porter, Karen Ruffle, Vivienne Sharp, Tim Stanley, Fahmida Suleman, Parviz Tanavoli, Jon Thompson, Oliver Watson and Zeynep Yürekli-Görkay. I also want to thank Elias Khamis, Wilferd Madelung and Donald Richards for their help when my knowledge of Arabic proved inadequate. My thanks too to Mary Embleton, who helped at an early stage with my text, to Richard Jones for help with the maps, to Oleg Grabar and Luke Treadwell for reading my script and for their valuable comments, and of course to Doris Abouseif who set me on course for one of the happiest and most fulfilling periods of my working career. I am also deeply grateful to Dr Ehsan Yarshater, as sponsor of the Yarshater lectures, to the Oriental Faculty at Oxford University, who made me a grant towards my first trip to the Deccan, to the Bahari Foundation for their generous financial help, which allowed this book to be so fully illustrated, and to Claudius Naumann who so efficiently and brilliantly designed the book and prepared it for publication.

As a Christian I am deeply concerned to help build understanding between people of different faiths, and indeed people of none. Jesus' command that we should love our neighbours as ourselves is made all the more difficult if we do not understand our neighbours' cultural and religious background, or what they believe. It is my hope that this book will provide much greater understanding of Twelver Shi'ism, and its rich and fascinating cultural and artistic heritage.

Finally, my warmest thanks to Jennifer for her love and support during this project, and for the encouragement which the rest of my family provided to ensure that I completed this book.

James Allan

Introduction

The Shi'a is a movement which gives a privileged position to the Family of the Prophet Muhammad in the political and religious leadership of the Muslim community.[1] It derives its name from *Shi'at 'Ali*, "the party of 'Ali", a term used to distinguish 'Ali's followers from those of the caliph 'Uthman, after the latter's murder in 656. Sunni, on the other hand, derives from the phrase *ahl al-sunna wa'l-jama'a*, "those who follow the [prophetic] traditions and the [official/orthodox] concensus".

It is important here to define the beliefs of Shi'i Muslims, and to understand how they differ from those of Sunnis. Historically, there have been two major disagreements between Sunnis and Shi'is. The first was over the succession to the Prophet in the year 632 as leader of the Muslim community. Sunnis argued that there was no designated successor, and that the first four caliphs, Abu Bakr (632–634), 'Umar ibn al-Khattab (634–644), 'Uthman ibn 'Affan (644–656), and 'Ali ibn Abi Talib (656–661), were the agreed leaders, followed by other caliphal dynasties, for example the Umayyads (661–750) and the 'Abbasids (750–1258). The Shi'a believed that 'Ali, the 4th caliph, was the only rightful successor, and that authority should have passed to his descendants through Fatima, the Prophet's daughter. The Twelver, or Imami, Shi'is believe that those rights were transmitted in a hereditary line of 12 successive imams (Fig. 1). In Isma'ili Shi'ism, however, the line of recognised imams branched off after the 6th imam, Ja'far al-Sadiq, and continued from his son Isma'il, while in Zaydi Shi'ism, any of the descendants of Fatima and 'Ali who laid claim to the imamate and rebelled against the ruling authorities was deemed to be a rightful imam.

The second major difference between Sunnis and Shi'is centred on religious authority, the authority to define and interpret the revealed law of Islam. Sunnis believe that, after the death of the Prophet, authority was dispersed among his companions and followers, and was eventually held by religious scholars (Arabic *'alim*, pl. *'ulama*). Shi'is believe that this authority passed to 'Ali and the imams after him. In Twelver Shi'ism and Isma'ilism, the imams are believed to be infallible, and to have access to divine inspiration and knowledge transmitted to them exclusively by the Prophet.

Shi'ism did not appear fully-fledged: its development took a number of centuries. As Crone puts it, "Imami [i.e. Twelver] Shi'ism, as we now know it, crystallized in the course of the 8th–9th centuries, but only acquired its classical form in the 10th and early 11th". At the beginning it probably focussed on tribal differences, and the competing desires of the Hashemite and Umayyad clans of the Qurashi tribe to keep control of the succession to the Prophet. Such conflicts and divisions reached their climax in the battle of Kerbala (680), when the Prophet's grandson, Husain, and seventy members of his family and supporters, were massacred by forces of the second Umayyad caliph, Yazid. Those tribal elements too were strongly present in the 'Abbasid revolution of 750, which used Shi'i sympathies to overthrow the Umayyads, but, despite the attempts of the 'Abbasid caliph al-Ma'mun (813–833) to appoint the 8th Imam as his successor, destroyed Shi'i hopes of ever holding the caliphate. Early Shi'ism was also influenced by different messianic ideas circulating among early Muslims, giving different interpretations of the *mahdi* ("the rightly guided one") and his apocalyptic role, a role which crystallised in the Imami doctrine of the absence *(ghaiba)* of the 12th Imam, after the death of the 11th

[1] See Lewis 1960; Madelung 1971; Nasr 1978; Madelung 1997; Crone 2004, chapters 7, 8, 10; Bayhom-Daou 2005, especially pp. 1–15.

Imam in 874. However, such details, apart from Kerbala, are not important in this book, except in so far as they tend to disguise the fact that it was perfectly possible in early Islam to revere the Prophet's family and descendants—the 'Alids, or descendants of 'Ali—without being a Shi'i. This was a feature encouraged by the widely recognised scholarly role in the transmission of the Prophetic *hadith* of two of the imams, the 5th Imam, Muhammad al-Baqir (d. 733), and the 6th Imam, Ja'far al-Sadiq (d. 765), a role accepted by Sunni *ulema* (religious scholars).[2] (*Hadith* consists of the Traditions of the Prophet—his sayings or actions as recorded by those who knew him, and transmitted down the course of history by sound authorities.) Hence, out of affection for the family of the Prophet, pious Sunnis might visit the burial sites or shrines of the Imams, and indeed might act as patrons of such institutions, while not holding to Shi'i religious doctrine.[3]

McChesney, in his discussion of the shrine of 'Ali at Mazar-e Sharif, called this reverence for the immediate family of the Prophet *ahl al-bayt*ism[4]. He writes,

> This reverence for Muhammad, Fatima, 'Ali, Hasan and Husain is a nearly universal phenomenon in the popular religious beliefs and practices in Central Asia and Iran, not to say Arabic and Turkish speaking lands to the west in the Middle Ages. The phenomenon is often labelled "Shi'i", but the deep devotion it inspires in people who would identify themselves, from a legal standpoint, as Hanafi or Shafi'i points up how misleading the term "Shi'i" is here ... Devotion to the Family of the Prophet and the belief in the efficacy of saintly intercession can co-exist quite easily with adherence to a Sunni-Jama'i legal doctrine and with Shi'i historicism. The imams as descendants of the Family of the Prophet have spiritual importance for all people ... For people who in times of political confrontation could identify themselves as defenders of the caliphal rights of Abu Bakr, 'Umar and 'Uthman ... there was no contradiction in pilgrimages to the shrines of the eighth imam at Mashhad or of 'Ali at Balkh. Political issues required political responses, spiritual questions spiritual responses. The Family of the Prophet represented intercession, hope of salvation, a rallying point for public opinion, and consistently the most visible icon in the daily religion of the great bulk of the population.

This aspect of the Imami shrines has also been discussed by Farhat, who has drawn attention to a number of medieval Sunni pilgrims and patrons of the shrine of the 8th Imam at Mashhad. For example, one particular group of devotees were Khurasani *hadith* scholars, orthodox Muslims who respected the role of the Imam Reza in the transmission of *hadiths* of the Prophet. Another particular patron was Mahmud of Ghazna (998–1030), a staunch Sunni, who nevertheless seems to have seen 'Ali as a particular source of moral authority. He is said to have seen 'Ali in a dream, and interpreted 'Ali's question, "how long will this go on?", to refer to the shrine at Mashhad, which had been destroyed by his father in 997. As a result, Mahmud rebuilt the shrine. Sufis, too, with often broader religious beliefs, were regular visitors to the shrine, and such eminent Sunni Saljuqs as Malik Shah, and his vizir Nizam al-Mulk, also prayed at the shrine[5]. As we shall see further on, however, other Sunni patrons had additional religious or political agendas, into which they conveniently fitted their patronage of the Imami shrines.

[2] Their acceptance by Sunnis is well illustrated by the inclusion of a picture of the seal of Ja'far al-Sadiq in a late 18th century Ottoman prayer book in the Chester Beatty Library, Wright 2009, fig. 115

[3] This is discussed in an as yet unpublished article by Teresa Bernheimer entitled, 'Shared sanctity: early tombs and shrines of the 'Alid family in the eastern Islamic lands', which was originally given as a paper at the Montreal MESA conference in 2007.

[4] McChesney 1991 p. 33–34

[5] Farhat 2002, pp. 38–39, 43–45

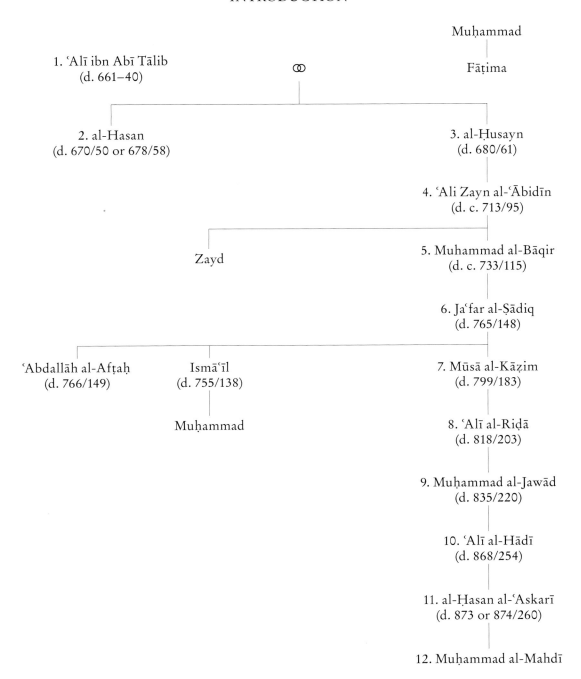

Fig. 1: The Twelve Imams. After Halm 1991.

Map of the Middle East.

CHAPTER 1

Shiʿism and Shrines

Early Islam did not encourage funeral rites or funerary monuments, and there were numerous *hadiths*, or traditions of the Prophet, which condemned erecting a building or a place of worship over a grave. The effects of this view can be seen in the strict orthodox rule of the 11th–12th century dynasties of the Maghrib, the Almohads and Almoravids, who left behind them virtually no mausolea in present day Morocco, while the Wahhabis of Saudi Arabia have systematically destroyed the early Islamic mausolea in their territory. However, whatever the theory, in most of the Islamic world, at most periods, mausolea were built, and the tombs of the dead were visited. Those of holy people were particularly valued, since *barakat* ("divine blessing") was assumed to transfer from the pious dead to pilgrim visitors to the site. No more so than in the case of the ʿAlids, the descendants of the Prophet Muhammad through his daughter, Fatima, and his son-in-law, ʿAli. By the 10th century pilgrimage to the great ʿAlid shrines, such as that of the prophet's grandson, Husain, at Kerbala, or that of ʿAli at Najaf, was actively encouraged by Shiʿi scholars. But, as we shall see, pilgrimage had already taken root much earlier than that.

Today the great Shiʿi shrines are almost all located in Iraq. The shrine of ʿAli is at Najaf[1], that of Husain is at Kerbala[2], those of the 7th Imam, Musa al-Kazim, and the 9th Imam, Muhammad al-Jawad, are at Kazimiya in Baghdad,[3] and those of the 10th and 11th Imams, ʿAli al-Hadi and al-Hasan al-ʿAskari, are at Samarra.[4] The only great Imami shrine further east is that of the 8th Imam, ʿAli Reza, which is in Mashhad, in north-east Iran.[5] Others of the Imams were buried in Medina, but their mausolea have not survived. Other descendants of ʿAli are buried in mausolea scattered around Iraq, Iran and other areas of the Near East, of which the most important is the mausoleum of Massumeh Fatima, the sister of the 8th Imam, ʿAli Reza, which is located in the city of Qum in northern Iran. It will be discussed later.

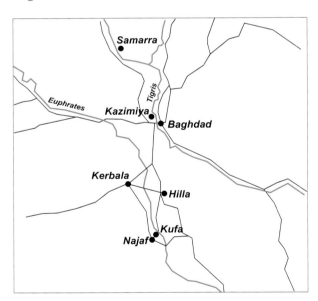

Map of central Iraq, showing the shrine towns.

[1] Mahir 1969.
[2] Nöldeke 1909.
[3] Al-Yasin 1962, 1963.
[4] al-Samarraʾi 1971.
[5] Farhat 2002; Saadat 1976.

Pictures of the buildings which make up the great Iraqi Shi'i shrines are remarkably rare. One of them, of the shrine of Fatima in Qum, was published on the dust cover of *Persia* by James Morris, Roger Wood and Denis Wright, in 1969[6] (Pl. 1.1). Such pictures of Shi'i shrines provide what one might take to be an image of a particular building type—one or more splendid domes, some minarets, a high porch, a surrounding courtyard and perhaps related buildings around. This chapter investigates that image, and tries to offer some understanding of how it came about, and what it tells us about the development of Shi'i architecture. Does it represent a building type, or is it a haphazard evolution of Islamic architectural history?

The great Shi'i shrines of Iraq have remained relatively unknown to western architectural historians, and it is extraordinary how difficult it is to find information about their architecture, let alone detailed pictures of them. This is for a number of reasons. The first is the impossibility of non-Muslims visiting such places. One of the very few visits was that of a Scotsman, one Dr. Griffiths, who visited the shrine of the Imam 'Ali in Najaf (Pl. 1.2) in 1805, but only just escaped with his life. Here is his account[7]:

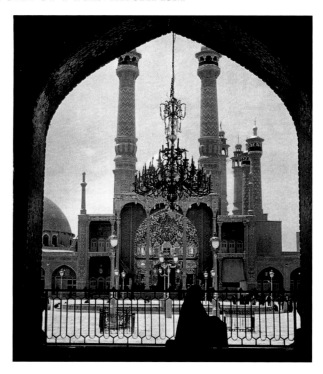

Pl. 1.1: Shrine of Fatima, Qum; dust-cover of *Persia*, by Morris, Wood and Wright, 1969.

It [the shrine] is seated upon an elevated ridge of sand hills: a tolerably good street runs nearby from south to north about three hundred yards. The houses on each side are flat-roofed; many of them being so constructed that their roofs are but little above the level of the street. To enter the habitable parts of them it is necessary to descend from the streets down several steps; so that one is apt to imagine the street had been formed between two rows of houses already built.

After proceeding along this street, another turns abruptly to the right; and on the left of the angle is the grand entrance to the celebrated mosque [i.e. the shrine]. In a variety of shops, near the gates of the mosque, were exposed to sale water-melons and other fruits, as well as many dried grains: but in almost all of them the proprietors were reposing themselves; and on account of the extreme heat not a single person appeared walking in the street. Being thirsty, I wished to purchase part of a melon, and addressed myself to the shopkeeper for the purpose; but taking me for a Greek, he loaded me with abuse, and refused to contaminate himself even by selling me one of the articles of his shop-board. I retired without making him any reply; and, upon my return past his hut, observed he had again laid himself down to sleep.

On approaching the gate of the mosque, I observed that all good Mussulmans, at each side of the entrance, were in the same drousy disposition. Stimulated by an irresistible, but unpardonable curiosity, I hastily walked into the first court. An elegant fountain, ornamented with colored tiles, and a profusion of Arabic sentences, was constructed in the center; and a corridor round the area afforded a shady walk to that part of the building, where two handsome doors led to the interior of the mosque. I went to that on the left-hand side; and finding no one at prayers, entered it far enough to see the whole of the apartment. The dome is very handsome, but by no means so large as that of St. Paul's, as Colonel Capper

6 Another is in Ghirshman et al. 1971, p. 105.
7 Griffiths 1805, pp. 370–72.

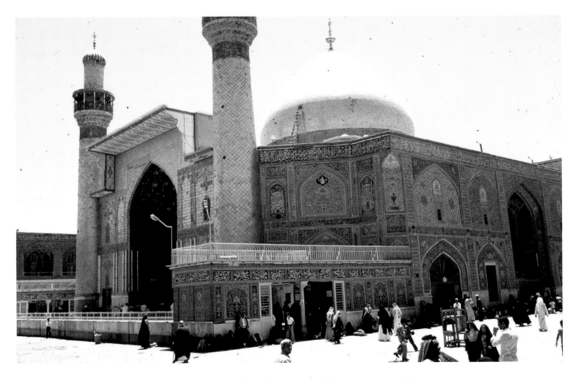

Pl. 1.2: Shrine of 'Ali, Najaf. Photo: G. M. King.

judged it to be from a distance. The mosque is richly ornamented with balls of ivory, glass, ostriches eggs, and a prodigious number of lamps, not only in the center, but on every side. Very small-sized rich carpets covered the flooring, and two extraordinarily large silver candlesticks were placed near the Mahareb [sic. i.e. mihrab].

Apprehension of discovery now began to operate upon me, and I traced back my steps with caution, greatly dissatisfied at having found nothing extraordinary; but, before I would repass the gate, an old man started up, and called to me in Persian. Not receiving any answer, he awakened two others; when they all jumped up from the elevated part where they had been sleeping, and exclaimed most vehemently. One of them, armed with a scimitar (fortunately for me not unsheathed), and another with a short stick, made many blows at me; which parrying in the best manner I was able, although not so successfully as I could have wished, I dashed through these bearded heroes, and was assailed in my flight by many large stones, of which, for many days, I bore the marks.

A consciousness of the penalties I might incur by my imprudent behaviour, and the fear of being seized, stimulated my efforts to escape; and in spite of the burning sun, or almost equally burning sand, I stopped not until I left the village very far behind me. Arriving at the tent, Mr. H. who tempered his reproaches with a thousand kind expressions, pointed out in the strongest terms the danger as well as the folly of my proceeding; and although I could not but acknowledge the propriety of his observations, yet I felt a secret satisfaction at having accomplished what probably no European had ever before attempted.

Virtually no other western, non-Muslim 19th or 20th century traveller ever ventured inside any of the Shi'i Iraqi shrines. Moreover, very few travellers even bothered to go near them, let alone draw what they saw. The German traveller, Niebuhr, ever enterprising, was one of the few, and in 1765 he made small drawings of the shrine at Kazimain, the shrine of 'Ali at Najaf, and the shrine of Husain at Kerbala (Pls. 1.3, 1.4).[8]

[8] Niebuhr 1776, vol. 2, pl. XLII.

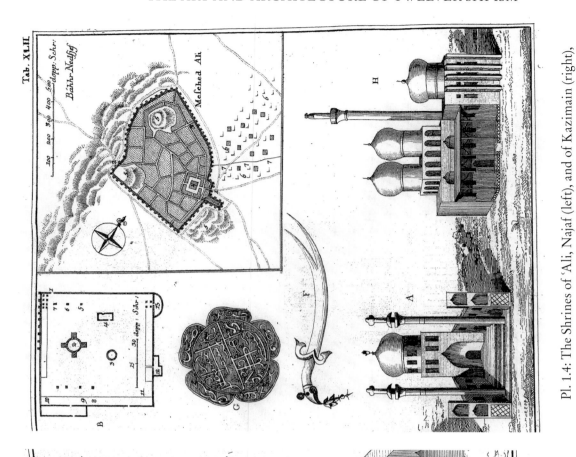

Pl. 1.4: The Shrines of 'Ali, Najaf (left), and of Kazimain (right),
as drawn by Niebuhr, 1765.

Pl. 1.3: Shrine of Husain, Kerbala,
as drawn by Niebuhr, 1765.

Pl. 1.6: Shrine of 'Ali, Najaf, as painted
by Matrakçı Nasuh, 1533–36, Istanbul University
Library, T.5964, after Yurdaydın 1976 pl. 64b.

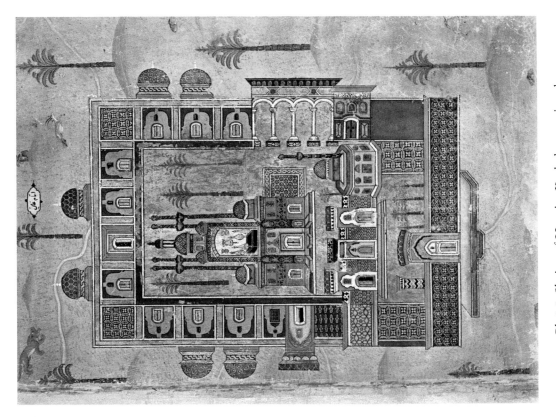

Pl. 1.5: Shrine of Husain, Kerbala, as painted
by Matrakçı Nasuh, 1533–36, Istanbul University
Library, T.5964, after Yurdaydın 1976 pl.62b.

One important Muslim visitor should be mentioned at this point, Matrakçi Nasuh. Matrakçi Nasuh was a historian, soldier, calligrapher and painter, who travelled with the army of Suleyman the Magnificent on his campaign against the Safavids in 1533–36. He wrote of the places the army visited, and illustrated them with his own paintings. Although he illustrates the city of Baghdad, he does not unfortunately include a detailed painting of the shrine at Kazimiya. However, he does include two paintings of the shrine of 'Ali at Najaf and two of the shrine of Husain at Kerbala,[9] the only known visual records of the two shrines prior to those of Niebuhr (Pl. 1.5, 1.6).

In more recent times, it has been possible for Muslim scholars from the western world to enter the shrine, and in November 1934 Mehmet Aga-Oglu led an expedition to the shrines at Najaf and Kerbala from the University of Michigan. Out of this came a catalogue of the rugs and textiles in the shrine at Najaf[10] (see below, Chapter 3), and a brief article on the Il-Khanid tile mihrab in its mosque,[11] but nothing about the architecture of the shrine.

The second reason why the Shi'i shrines of Iraq have remained relatively unknown to western architectural historians is the almost total lack of articles or books about them in European languages. There are a couple of notable exceptions, in particular the study of the shrine at Kerbala written by Nöldeke[12]. Fortunately, this gap has been filled over the last fifty years by the publication of studies in Arabic, but these have hitherto failed to reach the wider audience they deserve[13]. Although the quality of illustration has proved a major problem, they are an extremely valuable resource.

The third reason is the destruction of so much Iraqi Islamic architecture over the centuries, especially at the hands of the Mongols, a situation which sadly continues today. This has left most of Islamic Iraq as an architectural vacuum. A major exception is the archaeological site of Samarra, while the early history of the city of Baghdad has been reconstructed from textual evidence. Otherwise, very few pre-Mongol buildings have survived, and all too little is known about the architectural heritage of the 'Abbasid caliphate—a caliphate which lasted for more than five centuries, from 749–1258, and at its height must have been incomparable, both in the splendour of its buildings and the richness of its material culture.

War was not the only destructive power at work in early Islamic Iraq: flood, fire, religious zeal and individual whim have all taken their toll. Because of its geographical location, close to the river Tigris, Kazimiya was particularly susceptible to the river's annual flood. For certain periods we have a relatively full record of its history, and for example we know that the shrine was badly damaged or destroyed by flood at least 5 times in the space of 75 years between 1073 and 1249—in 1073–74, 1159, 1163–64, 1217, and 1248–49.[14] For other periods when less is known about the shrine, we can only surmise on the possible effects of flooding, but there is little doubt that the buildings at Kazimiya had a very chequered history.

Fires in these buildings were a major problem too, for the shrines were full of lamps, candlesticks and textiles, as well as the wooden cenotaph of the imam concerned, together with wooden doors, and the wooden domes (Pl. 1.7). There is no surviving image of the interior of one of the Iraqi shrines before the 20th century, but an illustration in the Great Mongol *Shah-nameh* ("The Book of Kings"), an early 14th century royal manuscript, vividly makes the point. The bier of Iskandar is placed in a building hung throughout with lamps; the bier itself has a tall candle in a massive candlestick at

⁹ Yurdaydın 1976, pls. 47b, 48a (Baghdad), pls. 58b, 64b (Najaf), pls. 57a, 62b (Kerbala).
¹⁰ Aga-Oglu 1941.
¹¹ Aga-Oglu 1935.
¹² Nöldeke 1909. See also Strika 1974, and Leisten 1998.
¹³ For al-Kazimiya see Al-Yasin 1962, 1963 and 1967. For Najaf see Mahir 1969. For Samarra see al-Samarra'i 1971 vol. 2
¹⁴ Al-Yasin 1962 pp. 124–25.

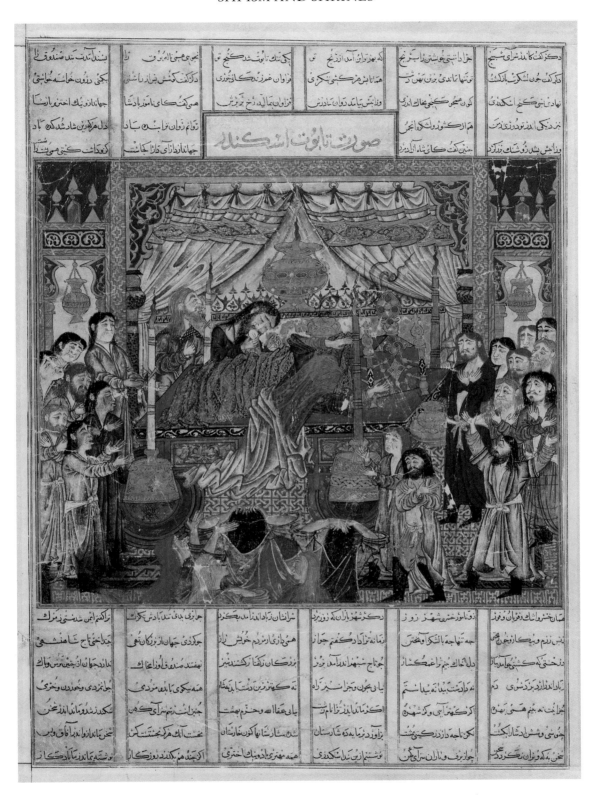

Pl. 1.7: The bier of Iskandar, Great Mongol Shah-nameh, Iran, early 14th century.
Freer Gallery of Art, Smithsonian Institution, Washington, DC: Purchase, F1938.3.

each corner; a pair of large curtains drape the scene; and the bier has a textile covering. Textile hangings are regularly mentioned in the sources. For example, the Hamdanid Nasir al-Dawla (929–969) adorned the tomb of the 11th Imam, Hasan al-'Askari, in Samarra, with curtains, while later in the century the Buyid 'Adud al-Dawla (978–983) curtained the tomb with brocade.[15] So too, another Hamdanid, Abu'l-Haija 'Abdallah Hamdani (d. 929), decorated the shrine at Kerbala with wonderful curtains and covered the floor with most precious mats.[16] In 1302, Ghazan, the Il-Khanid ruler, visited 'Ali's tomb at Najaf and hung with his own hands the curtains he had ordered for the shrine;[17] the following year he visited the shrine of Husain at Kerbala and gave carpets to the mausoleum.[18] Matrakçi's paintings from the early 16th century show that lamps were an essential part of the shrines in Najaf and Kerbala,[19] and Niebuhr also emphasises their presence at Najaf: "on the ground many silver lamps, including some of gold and garnished with precious stones".[20] In 1805 the Scots traveller, Dr. Griffiths, as noted above, commented on the shrine at Najaf: "Very small-sized rich carpets covered the flooring, and two extraordinarily large silver candlesticks were placed near the Mahareb [i.e. mihrab]."[21] It is no surprise that fires were all too regular events at the shrines. In 1016 a great conflagration broke out in the shrine of Husain at Kerbala, caused by the upsetting of two wax candles during the night: it reduced the *qubba* (the dome) and the *riwaqs* (the porticos) to ruins. In 1242–43 a fire at the shrine in Samarra destroyed the tombs of 'Ali al-Hadi and Hasan al-'Askari, and again in 1694 a fire destroyed the cenotaphs, doors and other woodwork. This latter fire was caused by a wax candle falling onto some of the floor coverings in the night.[22] During the last century, the use of many small areas of the shrine at Kazimiya for refreshments must have been another fire-hazard.

Some destruction was for deliberate religious or political motives. We do not know what commemorative structure was over the grave of Husain in the early 9th century, but in 850–51 the Caliph al-Mutawakkil, jealous for the power of the orthodox 'Abbasid caliphate, ordered that it should be destroyed, along with all the surrounding buildings and homes, and that the site should be watered and used as a field.[23] Under the Shi'i Buyid rulers, Karkh, the Shi'i quarter of Baghdad, was destroyed a number of times e.g. in 971–72 by a fanatical Sunni chamberlain called Safi, and in 973–74 by the Sunni populace, and it is possible that the Kazimain shrine suffered the same fate. Miskawaihi notes that "the dispute between the two factions, which had formerly been on religious questions particularly, now became political as well as religious, as the Shi'ah adopted the watchword of Bakhtiyar and the Dailemites, while the Sunnah adopted that of Sabuktakin and the Turks".[24]

Sectarian interests certainly led to the destruction of the shrine of Kazimain in the mid 11th century. The details of this event are so instructive that the passage from Ibn al-Athir's *al-Kamil* will be quoted in full.

> This year [441/1049–50] the inhabitants of Karkh were ordered not to mourn nor do what they customarily do on the Day of Ashura. However, they would not accept that and went ahead. There was a mighty riot between them and the Sunnis, in which many people were killed or wounded. The trouble did not end until the Turks crossed over and pitched their tents amongst them. Then they stopped. The Karkh inhabitants embarked on the building of a wall around their quarter, and when the Sunnis of the

15 al-Samarra'i 1971, vol. 2, pp. 117–18
16 Nöldeke 1909, p. 38
17 Hammer-Purgstall 1842, vol. 2, p. 119
18 Nöldeke 1909, p. 40
19 Yurdaydin 1976, pls. 62b and 64b.
20 Niebuhr 1776, vol. 2, p. 211: what was inside the shrine was related to him by his (presumably Muslim) companions.
21 Griffiths 1805, p. 371; for a 16th century brass lampstand dedicated to the shrine of 'Ali see Canby 2009, fig. 48.
22 al-Samarra'i 1971, vol. 2, p. 130.
23 Tabari quoted by Nöldeke 1909, p. 36
24 *Miskawaihi* 1921, vol. 2, pp. 331, 355.

Qalla'in[25] and like quarters saw what they were doing, they started to build a wall around the Qalla'in Market. Both communities expended enormous sums of money on the constructions. There was much disturbance and markets closed. The trouble increased and eventually many people moved from the west bank to the east and took up residence there. The Caliph ordered Abu Muhammad ibn al-Nasawi to cross over, settle the situation and stop the violence. When the folk on the west bank heard that, both the Sunnis and Shiites banded together to resist him. In the Qalla'in and other places they proclaimed "Come to the best of work" in the call to prayer, whereas in Karkh they declared "Prayer is better than sleep"[26] and publicly blessed the Companions. His planned crossing was cancelled.[27]

In Safar of this year [443/1051–2] there was renewed trouble in Baghdad between the Sunnis and the Shiites, which was many times worse than it had been before. The accord that we have mentioned under the recent year was not proof against collapse because of the deep hatred in people's hearts.

The reason for this rioting was that the men of Karkh had started to repair the Fishmongers' Gate and those in the Qalla'in to repair what remained of the Gate of Mas'ud. When the inhabitants of Karkh had finished, they built some towers on which they inscribed in gold "Muhammad and 'Ali are the best of men". The Sunnis objected to this and claimed that the inscription [should be] "Muhammad and 'Ali are the best of men. Whoever 'accepts' is a grateful believer, and whoever 'denies' is an unbelieving ingrate."[28] The men of Karkh objected to the addition and said, "We have not gone beyond our normal practice when we put an inscription on our mosques." The Caliph al-Qa'im bi-Amr Allah sent Abu Tammam, the Syndic of the 'Abbasids, and the Syndic of the 'Alids, namely Adnan ibn al-Radi, to investigate the matter and report. What they wrote upheld the view of the Karkhites. The Caliph and the deputies of [al-Malik] al-Rahim ordered an end to the conflict, but no attention was paid to this. Ibn al-Mudhahhib the Cadi, al-Zuhayri and other Hanbalis, followers of Abd al-Samad, took it upon themselves to urge the mob to intensify the troubles, and al-Malik al-Rahim's deputies refrained from any policing measures because they were annoyed at Ra'is al-Ru'asa on account of his predilection for the Hanbalis. These Hanbalis prevented the transporting of water from the Tigris to Karkh. In addition the dyke of the Isa Canal had burst and caused them [in Karkh] a lot of trouble. Several of the Shiites undertook to go to the Tigris and to bring away water, which they put in containers. They poured rose water into it, and called out, "Water for free!" The actions of these men were used as further incitement of the Sunnis.

Ra's al-Ru'asa was severe on the Shiites, who removed "are the best of men" and wrote instead "on them both be peace!" The Sunnis said, "We will only be satisfied if the bricks on which 'Muhammad and Ali' is written are pulled out and if 'Come to the best of works' is not used in the call to prayer." The Shiites baulked at that, so the fighting went on until the 3 Rabi' I [15 July 1051]. A Hashemite on the Sunni side was killed. His family carried him on a bier around the Harbiyya and the Basra Gate and all the other Sunni quarters, and roused the people to take revenge. Later they buried him near Ahmad ibn Hanbal after a great crowd had gathered, many times larger than ever before.

Returning from the burial they made for the Shrine of the Straw Gate. Its gate was closed, but they dug holes in the wall and threatened the doorkeeper, who, in fright, opened the gate and in they came. They plundered the lamps, the gold and the silver prayer niches, the hangings etc., and stole what was in the tombs and chambers. Night fell and they went away. When morning came they gathered in numbers and marched on the Shrine. They set fire to all the tombs and vaults. Fire destroyed the tomb of Musa and that of his grandson, Muhammad ibn Ali, and the neighbourhood, and the two teak domes

[25] To the east of the Shiite quarter of Karkh on the western side of Baghdad there was a quarter and canal both named after the Qalla'in i.e. the sellers of roast meat (see Le Strange, *Baghdad*, 83) (Richards 2002, p. 76 n. 23).

[26] See below p. 15.

[27] Richards 2002, pp. 75–76.

[28] Prof. W. Madelung has suggested to me that 'accepts' *(radiya)* is probably here being used in an absolute sense as the opposite of *rafida* (to reject), and that what is at issue is the historic order of the first four caliphs. It is nevertheless odd that the Sunnis accepted, if only for a while, the first part of the statement as it stands. In 482/1089 the Shiites of Karkh district were obliged to accept a much less ambiguous Sunni inscription on their mosques ... In the first half of the fourteenth century Ibn Battuta found Bedouin at al-Qutayf, who, as declared Rafidis, pronounced after the last *takbir* of their prayer 'Muhammad and 'Ali are the best of men. Whoever disobeys them is an unbeliever' (*Rihla*, p. 291) (Richards 2002, p. 79 n. 8).

that covered the two shrines. The facing and adjacent tombs of the Buyid rulers, Mu'izz al-Dawla and Jalal al-Dawla, and of the viziers and leading men were burnt, as were the tombs of Ja'far, son of Ja'far al-Mansur, and the Emir Muhammad, son of al-Rashid, and of his mother, Zubayda. Nothing like this dreadful affair had ever been seen before.

On the morning of the 5th of the month [17 July 1051] they came back and dug for the grave of Musa ibn Ja'far and of Muhammad ibn Ali to transfer them to the cemetery of Ahmad ibn Hanbal. The rubble hindered their knowing where the grave was, but their digging came near its edge. Abu Tammam, the Syndic of the 'Abbasids, and other Sunni Hashemites heard what they were doing and came and stopped them. The inhabitants of Karkh attacked the Hall of the Hanafi lawyers. They ransacked it and killed the Hanafi's professor, Abu Sa'd al-Sarkhasi. They burnt down the Hall and the lawyers' lodgings. The disturbance spread over the East Side, where the residents of al-Taq Gate and Bajj Market and the Cobblers' and others came to blows.

When the news of the burning of the Shrine came to Nur al-Dawla Subays ibn Mazyad, it horrified him and had a deep affect on him, because he, his family and all his lands, al-Nil and that district, were all Shiite. In his lands the khutbah for the Imam al-Qa'im bi-Amr Allah was discontinued. He was written to and censured for that, but he explained that the people he ruled were Shiite and were of one mind with him, and that he was unable to upset them, just as the caliph was unable to prevent the foolish persons who had done what they did at the Shrine. However, he restored the khutbah to what it had been.[29]

This type of sectarian violence was relatively common, certainly in the Saljuq period. Ibn al-Athir writes:

The Year 444 [1052–53] … At Baghdad dissension occurred between the Sunnis and the Shiites, which it was difficult to control … The Shia restored the phrase "Come to the best of works" to the call to prayer, and they inscribed on their mosques "Muhammad and Ali are the best of mankind." Fighting took place between both communities and there was much wicked damage.[30]

Ibn al-Athir makes futher reference to the problems caused by the call to prayer under the year 448 (1056–57), and by the inscriptions placed over the gates of the Shii mosques under the year 482 (1089–90).[31]

However, some twenty years later the two communities came to some sort of settlement. According to Ibn al-Athir,

This year in Sha'ban [502/March 1109] the common people of Baghdad, Sunni and Shiite, reached a settlement. They had been the cause of trouble over a long period. Caliphs, sultans and prefects had struggled to improve the situation but it had proved impossible for them until God Almighty gave his leave and it came about without any intermediary.

The reason was that after Sultan Muhammad had killed the King of the Arabs Sadaqa, as we have recounted, the Shia in Baghdad, the inhabitants of Karkh and elsewhere, were fearful because Sadaqa and his family were Shiites and the Sunnis exposed them to rude taunts on account of the dismay and anxiety that came upon them because of his death. So the Shiites were fearful and put up with what they were hearing. Their fears continued until Sha'ban. At the commencement of this month the Sunnis made their preparations for the pilgrimage to the tomb of Mus'ab ibn al-Zubayr,[32] which they had not performed for many years, having been prevented from doing so to put a stop to the disturbances which resulted from it.

29 Richards 2002, pp. 79–81.
30 Richards 2002, p. 89.
31 Richards 2002, pp. 113, 243.
32 The brother of the 'anti-caliph' 'Abd Allah ibn al-Zubayr, for whom he served as governor of Iraq. He died in battle with the Umayyad 'Abd al-Malik in 72/619 (Richards 2002, p. 144 n. 10).

When they made their preparations for their progress, they agreed to take their route through Karkh. They announced this and the general opinion of the inhabitants of Karkh was that they should not object or resist them. The Sunnis began to send off the inhabitants of each quarter one after the other, accompanied by much decorative display and weaponry. The population of the Gate of Degrees came with an elephant made of wood with armed men upon it. All of them made for Karkh to cross through it, and the inhabitants met them with incense, perfume, chilled water and display of weapons. With every sign of joy they conducted them through and out of their quarter.

On the eve of the middle of the month the Shia went out to the shrine of Musa ibn Ja'far [the Seventh Imam] and to others and not a single Sunni impeded them. People were astonished at this. When [the Sunnis] returned from their visit to the tomb of Mus'ab, the inhabitants of Karkh met them with joy and delight. It chanced that the elephant of the Gate of Degrees group fell apart at the Harb Gate bridge. Some persons appositely recited, "Did you not see how your Lord dealt with the followers of the elephant ...", down to the end of the chapter[33].[34]

The strife recorded by Ibn al-Athir in his *al-Kamil* is important for showing how Sunnis and Shi'is distinguished their beliefs in the public arena, and allows us to enumerate the chief causes of sectarian violence. First it was a matter of the *adhan*, the call to prayer. Sunnis used the phrase, "Come to the best of work", whereas Shi'is used, "Prayer is better than sleep".[35] Secondly, there were days which were special to Shi'is, pre-eminently the Day of 'Ashura (10 Muharram), when Shi'is mourn the martyrdom of Husain at Kerbala. Mourning customs and other rituals were already in place in the 11th century.[36] Thirdly, Shi'i buildings were identified by the inscriptions placed on them, in which the veneration of 'Ali and the implied downgrading of the four orthodox caliphs were key elements. It is important to note that monumental inscriptions were evidently read, understood, and considered to be important by both Shi'is and their opponents. Fourthly, Shi'is patronised and protected the shrines of the Imams. The paramount importance of the shrines is clear from the ultimate punishment meted out in 1051–52 on the inhabitants of Karkh by the neighbouring Sunnis: the destruction of the shrine of Kazimain, and an attempt to remove the bodies of the two imams to the Sunni cemetery of Ahmad ibn Hanbal.[37]

We know from historical sources that sectarian conflict was not confined to Baghdad. At Mashhad in 1116 there was a great riot between rival supporters of the 'Alids and the *fuqaha* (the legal scholars), in the course of which the inhabitants of Tus surrounded the shrine and ransacked it. Five years later 'Adud al-Din Faramarz, a vassal of Sanjar, built a fortified wall to protect the residents of the shrine from any future attack of this sort.[38] Nor was the destruction of shrines solely the result of sectarian differences. For example, the shrine at Kazimain was destroyed by fire in 1258, this time as a result of the capture and looting of Baghdad by Hulegu's Mongol troops.[39]

A gloomy picture, perhaps, but the historical sources not only record destructions, but also numerous reconstructions—monuments to the tenacity and dedication of their patrons. The rest of this chapter assesses how far these rebuilds were a rather random replacement or accretion process, or how far there was a shrine type which architects and patrons had in mind and were seeking to continue.

[33] See Koran, cv, 1–5. The reference is to the Abyssinian army under Abraha which unsuccessfully attacked Mecca c. 570 AD. Either this passage was quoted jocularly, or as one suspects, sectarian animosities had not entirely ceased (Richards 2002, p. 144 n. 12).

[34] Richards 2002, pp. 143–44.

[35] Richards 2002 p. 76. In this example, dating from 1049–50, the calls to prayer were reversed. This was due to the decision of the two communities on a joint plan of resistance to Caliphal interference in their affairs, by demonstrating that they were not in conflict with each other.

[36] Richards 2002, p. 75.

[37] Richards 2002, p. 80.

[38] Farhat 2002, p. 46.

[39] Le Strange 1900, p. 343.

In order to do this, we shall first look at the different architectural elements which appear in the various shrines, and try to trace where and when they first appeared, in order to see if there is any pattern to their development. There are a number of distinct architectural elements in the buildings as they survive today: domed chambers, ivans (vaulted halls open at one end), surrounding walls, minarets, porticos, halls, and porches. And there are institutional elements too, mosques, khanqas (dervish institutions), madrasas (religious schools) and so on. We shall discuss them in turn.

The early development of the shrine complexes is lost in the mists of time. Indeed so lost was the site of the burial of 'Ali ibn Abi

Pl. 1.8: So-called tomb of Imam Ibrahim near Baghdad, 1976. Chadirji collection no. 3 76 053 29.

Talib, that there was deep disagreement about its true location. The earliest building erected as a memorial to him at Najaf was undoubtedly that built by Harun al-Rashid (786–809), but the site remained contested for centuries: for example, the 13th century geographer, Yaqut, claimed that 'Ali was buried in 'Ain al-Baqr, near Akka, in Palestine, while the 13th century traveller, Ibn Jubayr, says that he was buried in the Omayyad Mosque in Damascus.[40] However, an Andalusian traveller, Abu Hamid al-Gharnati, who visited Balkh between 1153–55, records the finding of 'Ali's tomb there in 1135–36, and the building of a large shrine. A piece of brick found beneath 'Ali's body had written on it, "This is the one who loves the Prophet, 'Ali, may God honour him", and the piece of brick was hung in a silk purse in the shrine's mihrab. In the Timurid period, the site was rediscovered, and is today's Mazar-e Sharif, the "Noble Shrine", in northern Afghanistan. For in 1480–81, a chronicle came to the attention of the Timurid ruler of Khurasan, Sultan Husain Baiqara, claiming that the tomb of 'Ali had been discovered at Mazar-e Sharif in the 12th century. As a result, the site of the alleged tomb was excavated, a white stone tablet was found saying that it was the tomb of "the Victorious Lion of God, the Brother of the Messenger of God, 'Ali, the Friend of God". An order was given to erect a new mausoleum—a dome, surrounded by ivans and rooms, with a bazaar, shops and a bath-house nearby. Thus was a shrine created, and a new town came into existence, and that shrine still attracts many thousands of worshippers today.[41]

(Pl. 1.8) A photograph in the Chadirji collection has an anonymous but fascinating caption which runs as follows: "The tomb of Imam Ibrahim, between Kerbala and Hilla, started with a tin, then flags, and at the end they built a dome for it."[42] Of course this is not necessarily the way every shrine began, but the principle of starting little and growing larger was certainly true of the majority, and a dome was usually the key feature. Certainly, the domed chamber is now at the heart of every contemporary shrine of a Shi'i Imam. In Arabic the dome is denoted by the word *qubba*. The earliest record of such a structure seems to be for the shrine of 'Ali at Najaf, which had a *qubba* built by the Talibite Sayyid ruler of Tabaristan, Muhammad ibn Zaid al-Da'i (AD 861–900).[43] Later, according to Ibn Hawqal, writing in AD 977, the Hamdanid ruler, Abu'l-Haija 'Abdallah ibn Hamdan (905–929), constructed a

40 Mahir 1969, p. 123.
41 McChesney 1991, pp. 27–32; Golombek 1977, pp. 335–43.
42 Chadirji Research Centre, Kingston on Thames, photograph no. 3 76 053 29.
43 Browne 1905, p. 158 does not give these details, which are, however, recorded by Mahir 1969, p. 130.

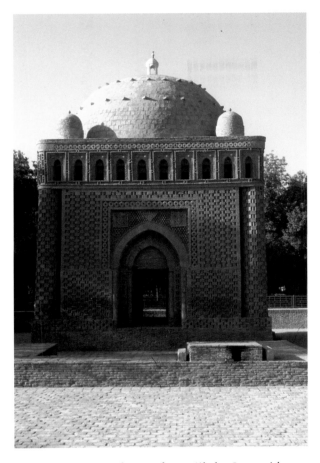

Pl. 1.9: Mausoleum of Isma'il the Samanid,
Bukhara, pre-943. Photo: J. W. Allan.

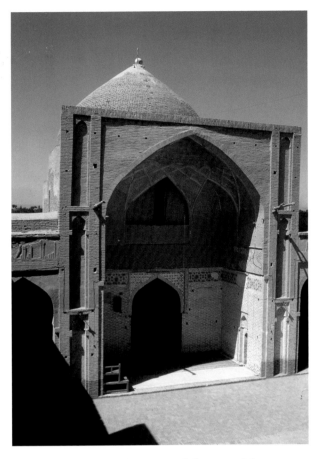

Pl. 1.10: Qibla ivan and dome, Friday
Mosque, Zavareh, 1135. Photo: J. W. Allan.

magnificent *qubba* (dome) over 'Ali's tomb.[44] This is described as having four doors—one presumably in each side. Perhaps the building resembled the mausoleum of Isma'il the Samanid in Bukhara, which today has a doorway, though no door, in the centre of each side (Pl. 1.9). By the mid 10th century, the shrine of al-'Askari at Samarra was also covered by a dome, built by the Buyid, Mu'izz al-Dawla, in 948–49.[45] *Qubbas* may therefore have been standard in the late 9th–10th centuries. Prior to that we know too little to be sure, except that there may be one 9th century domed mausoleum still at least partially standing, the Qubbat al-Sulaibiyah at Samarra. The function of this building, however, has been debated. It was originally identified as the mausoleum of three orthodox 'Abbasid caliphs: al-Mustansir (d. 862), al-Mu'tazz (d. 868) and al-Muhtadi (d. 869).[46] However, recent scholarship has suggested that it may have been built as a model of the Ka'ba, to be used for circumambulation, and that its role as a mausoleum came afterwards.[47] Its possible use as a mausoleum is supported by the existence of another octagonal mausoleum with an ambulatory, built in Natanz in western Iran in 998–99.[48]

[44] Ibn Hauqal 1964, p. 232; text p. 240.
[45] al-Samarra'i 1971, vol. 2, p. 117.
[46] Creswell 1989, pp. 373–74, following Herzfeld.
[47] Northedge 2006.
[48] Blair 1986, p. 47.

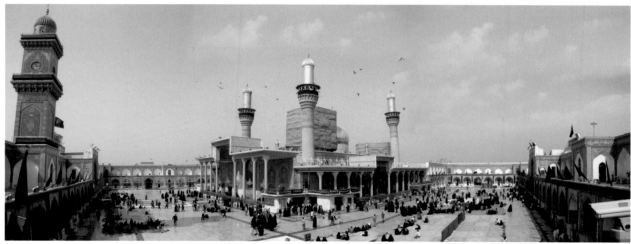

© Google Earth

Pl. 1.11: Kazimain. (One of the two golden domes is covered in scaffolding.)

Moving on to the next item, the *iwan* (Arabic) or *ivan* (Persian), an ivan is a large vaulted hall, open at one end, of variable depth. The earliest record of an ivan in one of the Shi'i shrines comes from Kazimain, which, in 1237–38, was recorded as having a large ivan connected to the hall opposite the entrance door.[49] Ivans were only widely introduced into Iranian mosques from the late 11th century onwards. It therefore seems unlikely that one would have been added to a domed shrine earlier than the 12th century. What exactly such ivans looked like is uncertain, though they would presumably have resembled those added to the Friday Mosque in Isfahan in late Saljuq times, or the mid-12th century ivans at Zavareh in western Iran (Pl. 1.10). Other ivans recorded at the great Iraqi shrines are all much later additions, like the Iwan al-'ulema at Najaf, which is Safavid.[50] However, these could have been replacements for others which had been introduced in the late pre-Mongol or post-Mongol period, but were not recorded in the literature or in inscriptions.

The earliest record of a minaret associated with an Imam's shrine comes from Mashhad, where Mahmud of Ghazna (997–1031) is recorded as rebuilding the sanctuary after it had been destroyed by his father, Sabuktagin, and Mahmud's governor of Khurasan, Suri, is recorded as having built a minaret there.[51] Interestingly, both Mahmud of Ghazna and his governor were Sunni Muslims, a point to which we shall return in due course. The Ghaznavid and Ghurid taste for commemorative minarets and towers is well known, and notable surviving examples are the minaret of the Ghaznavid rulers, Mas'ud III (1099–1114) and Bahram Shah (1118–1152) in Ghazna,[52] the famous minaret at Jam in Afghanistan, built by the Ghurid Ghiyath al-Din Muhammad (1163–1203),[53] and the Qutb Minar in Delhi, built by his brother, Qutb al-Din Aybak, in 1199.[54] A free-standing minaret roughly contemporary with that built by Suri at Mashhad is to be seen at the mausoleum of Arslan Jadhib (997–1028), Vali of Tus under Mahmud of Ghazna, at Sangbast, in Khurasan.[55]

Just how confusing the relationship of minarets to shrines can be, is demonstrated by those at Kazimain (Pls. 1.11, 1.18). In 1058 al-Basasiri, a pro-Fatimid Turkish general, included a minaret as well

[49] Al-Yasin 1962, p. 127.
[50] Mahir 1969, p. 155.
[51] Farhat 2002, p. 39.
[52] Pope 1938, vol. 5, pls. 355–56; Sourdel-Thomine 1953.
[53] Maricq and Wiet 1959.
[54] Page 2001.
[55] Pope 1938, vol. 2, p. 986 and vol. 5, pl. 260C.

as a mosque in his rebuilding, suggesting that the role of the minaret was defined by the presence of the mosque. However, in 1097 Majd al-Mulk, finance minister (*mustawfi*) of the Saljuq sultans Malik-Shah and Berk-yaruq, reconstructed Kazimain with two minarets.[56] Nearly a century later, in 1180, Kazimain was rebuilt with several minarets. But in the Jalayirid rebuild of 1367–68 it returned to two minarets. However, in 1508 the Safavid Shah Isma'il I increased the number to four. And of course there were not only four large minarets but also four small ones rising from the corners of the roof.[57]

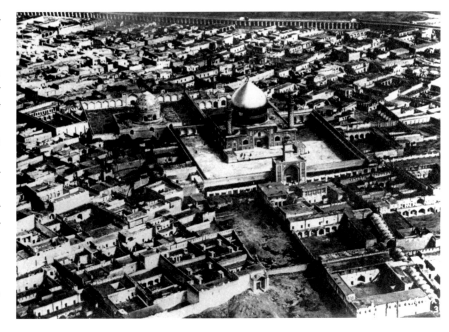

Pl. 1.12: Samarra from the air. Chadirji collection MEC-Smith-PA21324.

Another important architectural element was the *bahw*, or hall, which can be seen in the air photograph of the shrines at Samarra (Pl. 1.12), where there are halls surrounding the domed tomb chambers. Ibn Hawqal's description of the *qubba* at Najaf, quoted above, suggests a square domed edifice with a door in the centre of each side, and the probability of no covered halls around it: covered halls around would have made the four doors insignificant as architectural features, and unworthy of comment. The monumentality of the walls of the dome chamber of the shrines of 'Ali and 'Abbas, as shown on their ground plans (Figs. 2 and 3), suggests that they once stood free, the more so since the walls of the rooms around them are not built in such a way as to take the dome's thrust[58]. As we have already seen, the 9th century Qubbat as-Sulaibiyah in Samarra had an ambulatory, but the building may not have been constructed as a mausoleum. Hence, the only pre-Mongol evidence for a *bahw* at a great Shi'i shrine is from Kazimain, where al-Basasiri is recorded as having included a large *bahw* in the 1052–53 rebuild[59]. In the post-Mongol period, in 1349–50, Hasan Jalayiri is recorded as strengthening the *bahw* in front of the shrine at Samarra, which clearly indicates that it predated his reign[60]. Such halls may therefore have been more common.

Another 11th century example could be the Bala-Sar mosque in the shrine at Mashhad[61] (Fig. 7: K–L on the plan; the tomb chamber is G). It is a long hall adjacent to the tomb itself on the west side i.e. on the side of the Imam's head, which may have been the work of Mahmud of Ghazna. At Mashhad the construction of the mausoleum left so little room around the head end of the Imam's tomb that prayer "at the head of the Imam" (*al-salwa 'inda ra's al-imam*) could not easily take place. Hence this hall may have been built to accommodate the needs of pilgrims.

[56] Majd al-Mulk was also responsible for building a *qubba* over the tombs of the Imams Hasan ibn 'Ali, Zayn al-'Abidin, Muhammad al-Baqir and Ja'far al-Sadiq in the Baqi' cemetery in Medina—Calmard 1971, p. 62.

[57] Al-Yasin 1962, pp. 124–25; Al-Yasin 1963, pp. 157–58.

[58] Nöldeke 1909, p. 22

[59] Al-Yasin 1962, p. 123.

[60] al-Samarra'i 1971, vol.2, p. 121.

[61] Farhat 2002, p. 41.

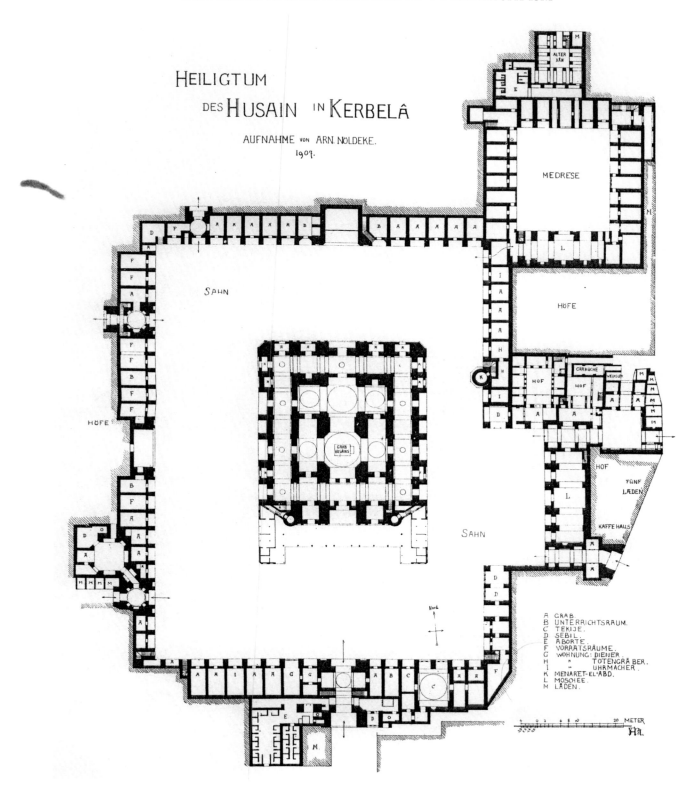

Fig. 2: Plan of the Shrine of Husain, Kerbala. After Nöldeke 1909.

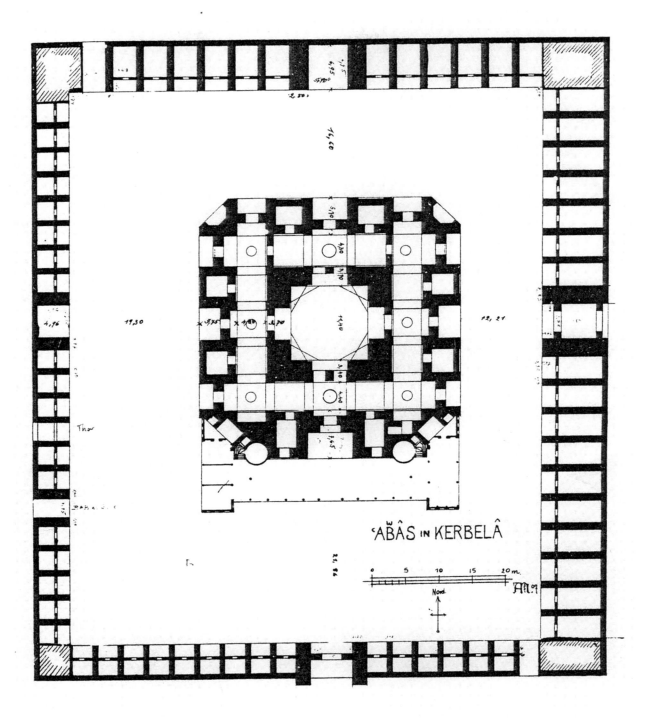

Fig. 3: Plan of the Shrine of 'Abbas, Kerbala. After Nöldeke 1909.

Fig. 4: Plan of the Shrine of 'Ali, Najaf. After Nöldeke 1909.

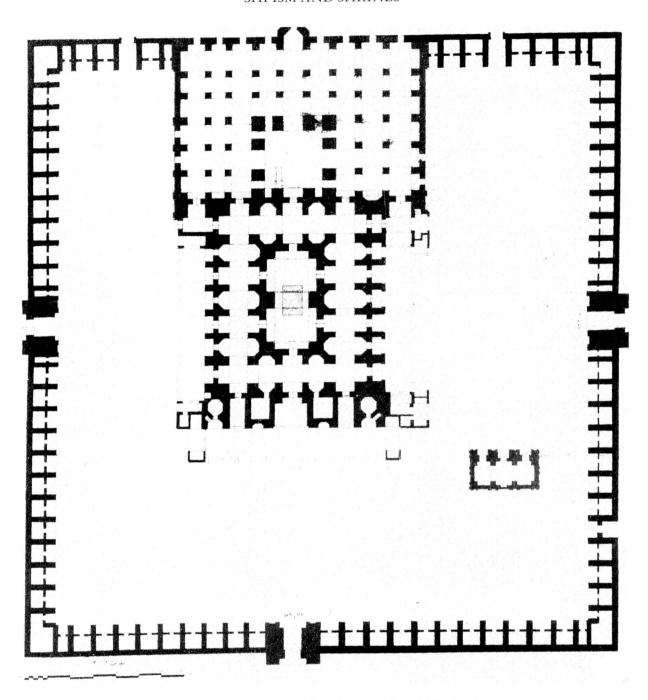

Fig. 5: Plan of the Shrine of Kazimain. After Al Yasin 1963.

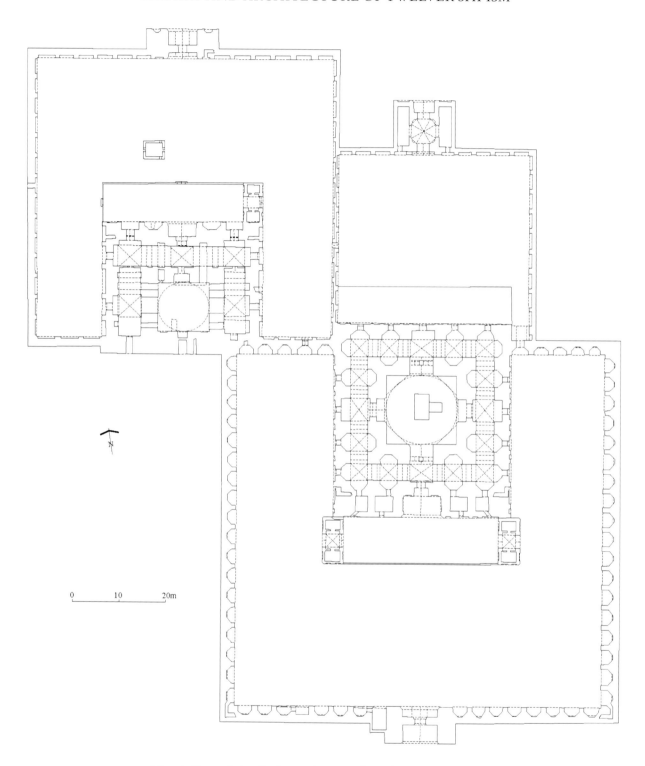

Fig. 6: Plan of the Shrine at Samarra by Alistair Northedge.

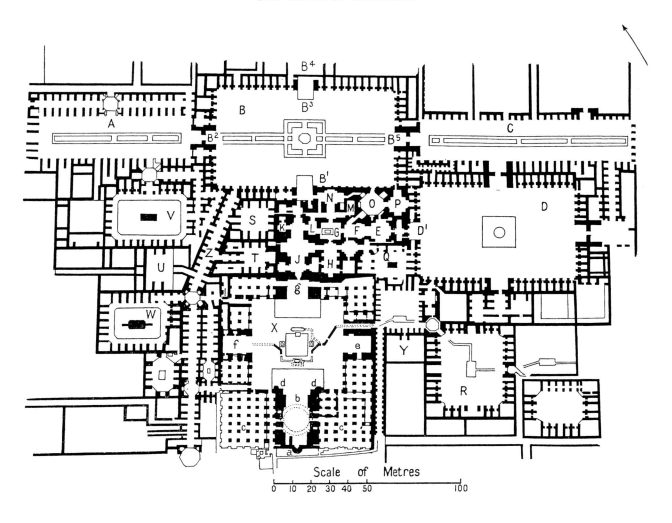

Fig. 7: Plan of the Shrine of the Imam Reza, Mashhad. After Pope 1938.

A Bālā Khiyābān (Upper Esplanade).

B Ṣaḥn-i-Kuhna (the Old Court).

B¹ The gold īvān (Īvān-i-Ṭalā) of 'Alī Shīr Naw''ī (now called the Īvān-i-Ṭalā-i-Nādirī).

B² Entrance from Upper Esplanade of Shāh 'Abbās I.

B³ Īvān of Shāh 'Abbās II.

B⁴ Minaret of Shāh Ṭahmāsp.

B⁵ Entrance from Lower Esplanade.

C Pā'īn Khiyābān (Lower Esplanade).

D Ṣaḥn-i-Naw (the New Court).

D¹ The gold īvān of Fatḥ 'Alī Shāh.

E Dār as-Sa'āda (Chamber of Felicity).

F Dome chamber of Ḥātim Khān.

G Ẓarīḥ-i-Ḥaẓrat (the Tomb Chamber).

H Dār al-Ḥuffāẓ (Chamber of the Guardians).

J Dār as-Siyāda (Chamber of the Nobility).

K Bālā-Sar (Above the Head (a)).

L Bālā-Sar (Above the Head (b)).

M Mosque of the Ladies

N Tawḥīd Khāna (Chamber of Monotheism).

O Dome chamber of Allāhverdī Khān.

P Dār aẓ-Ẓiyāfa (Chamber of Hospitality).

Q Madrasa of 'Alī Naqī Mīrzā.

R Madrasa-i-Pā'īn-i-Pā (Madrasa Below the Feet).

S Madrasa-i-Bālā-Sar (Madrasa Above the Head).

T Madrasa-i-Parīzād.

U Madrasa Do-Dar (Madrasa of Two Doors).

V Caravanserai Vazīr-i-Niẓām.

W Caravanserai Nāsirī.

X Masjid-i-Gawhar Shād.
 a Miḥrāb.
 b Sanctuary īvān (īvān-i-maqṣūra).
 c Oratory (Shabistān).
 d Minaret.
 e Īvān of Ḥājjī Ḥasan.
 f The water īvān (īvān-i-āb).
 g Īvān of the Nobility (Īvān-as-Siyaāda)

25

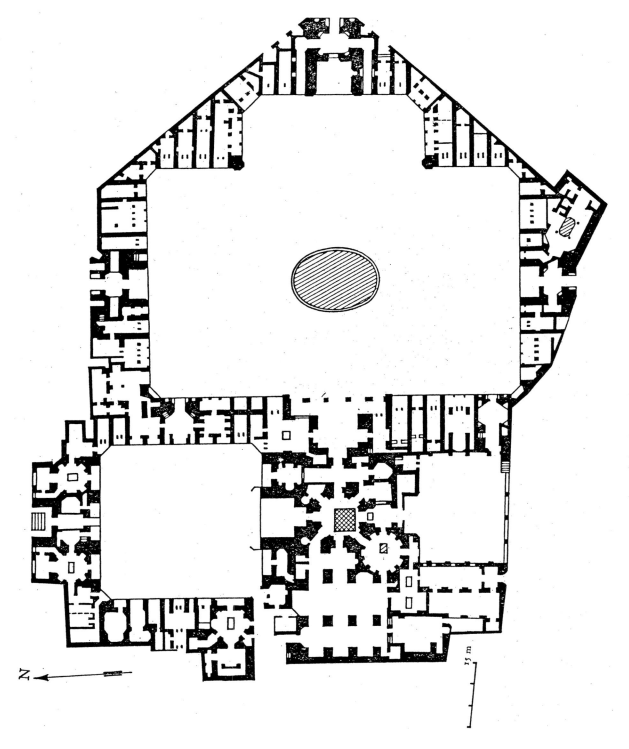

Fig. 8: Plan of the Shrine of Fatima, Qum. After Godard 1965.

The lack of information about the use of halls in these buildings is tantalising. For all the shrines today have halls around the mausolea themselves, and large numbers of pilgrims would have required much larger areas of space than could be enclosed by a *qubba*. Examples of halls in early Islamic buildings in Iran or Iraq are difficult to find before the 14th century, when the cross-vaulted hall is introduced, as for example in the winter prayer hall of Oljeitu in the Isfahan Masjid-e Jame'. However, there are large areas of vaulting covering the area in the Isfahan Jame' between the small dome chamber and the courtyard, which, with appropriate walling, might give some idea of earlier styles. The importance of such halls is clear from the shrine of Ni'matallah in Mahan, not far from Kirman, in which magnificent halls were built by Shah 'Abbas the Great in the 17th century (Pl. 1.13). Seen from the side they show a series of long vaults with upward projecting domical vaults to allow light to enter. Seen from inside, they are some of the greatest examples of vaulted halls in the central Islamic lands, and demonstrate the beauty of the Safavid halls that must once have surrounded some of the great Iraqi shrines. The quality and variety of designs used for the domical vaults at Mahan also show the brilliance of the Safavid architect.[62]

Today the great shrines of Shi'ism all stand within walled enclosures. Such enclosures probably go back to the 9th century AD. The earliest recorded wall around the shrine at Najaf was built by a Tabaristani ruler, either Zaid al-Da'i or his brother Hasan, before 900.[63] The Hamdanid, Nasir al-Dawla, built a wall around the Samarra shrine as early as 944–45, and the rebuilding of Kazimain by the Buyid ruler, Mu'izz al-Dawla (945–967), also included a massive surrounding wall.[64] We also know that walls were built around the shrine at Kerbala by Hasan ibn al-Fadl (d. 1023–24).[65] The purpose of such walls is rarely specified, but they would have had a number of important functions. First, they would have defined the sacred territory. Secondly, they would have provided protection against intruders: at Mashhad in 1121, as already mentioned, a fortified wall was built to protect the shrine from riots.[66] Thirdly, they would have provided some defence at least against flooding, a particularly important point, as we have seen, for Kazimain.

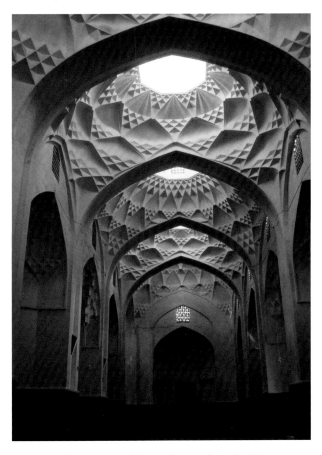

Pl. 1.13: Vaulting of one of the halls in the Shrine of Ni'matullah, Mahan, Iran, early 17th century. Photo: J. W. Allan.

[62] A smaller variant is suggested by the entrance corridor of the Mosque of Shaikh Lutfullah in Isfahan, Canby 2009, fig. 13.

[63] Mahir 1969, p. 130

[64] al-Samarra'i 1971, vol.2, p. 117; Al-Yasin 1962, p. 122

[65] Honigmann 1978, p. 637.

[66] Farhat 2002, p. 46.

Another architectural feature of the shrines of the Imams was the *riwaq* or portico, i.e. an open colonnade. We do no know exactly where such porticos stood, for that information is never given. There are two possible positions. One is around the mausoleum itself, the other around the inside of the enclosure walls. The latter option is probably to be preferred, since the mausoleum is more likely to have been surrounded by the halls just mentioned. A *riwaq*, or portico, as a covered walk way around the inside of the enclosure walls, is a logical, functional development, providing shade and/or shelter. We know that there were *riwaqs* as early as the 10th century, for 'Adud al-Dawla is recorded as having built them at the shrine at Samarra in 978–79.[67] Those at Kerbala were probably part of the Hamdanid or Buyid building works, for they are recorded as having been destroyed by fire in 1016.[68] Perhaps they resembled the surviving 10th century work in the Friday Mosque at Na'in in central Iran (Pl. 1.14). *Riwaqs* at Kazimain are first mentioned in 1180.[69] Today, the shrines are surrounded not by *riwaqs*, but by an architectural feature called in Persian a *kunj*. This consists of a niche facing onto a courtyard with a doorway in the rear, which leads into a room; there is often a second storey above. This architectural form probably originated in Timurid times but was extremely common from the Safavid period onwards.

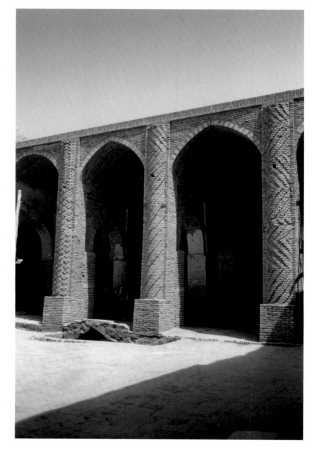

Pl. 1.14: Courtyard arcade, Friday Mosque, Na'in, Iran, 10th century. Photo: J. W. Allan.

Interestingly, in the 1180 reconstruction of Kazimain are also mentioned rooms around the periphery of the shrine. If these were developed out of the *riwaqs* in certain parts of the enclosure, then they could be early examples of the *kunj* style just mentioned, which has rooms behind the niches at ground and first floor level (Pl. 1.15).

One element which we have not mentioned hitherto is the orientation of the shrines [Figs. 2–7]. Unexpectedly, this is not a constant. The shrines of Husain and 'Abbas at Kerbala both face slightly west of south i.e. have a qibla orientation towards Mecca, as does the shrine complex of the Imam Reza in Mashhad. However, the shrine of 'Ali at Najaf faces east. Why this should be so is unclear, except that the site of 'Ali's grave was already known in pre-Islamic times as the site of the graves of Adam and Noah. Hence, the orientation may have been fixed by the early history of the site. At Qum, on the other hand, the *sahn-e 'atiq* ("the Old Courtyard") is on the north side of the shrine, suggesting an original northward orientation for the dome chamber, which is unexplained.

The evidence so far suggests that, prior to the Mongol invasions, shrines developed in a fairly haphazard way. However, a form did indeed evolve, consisting of a *qubba*, with perhaps porticos, halls, minarets, and ivans—some or all of them, and in varying numbers, around, the whole set with-

[67] al-Samarra'i 1971, vol.2, p. 118.
[68] Nöldeke 1909, p. 39.
[69] Al-Yasin 1962, p. 125

in a walled enclosure. When precisely this came about is impossible to know, but it is evident that the different elements arose from different needs, some largely practical, others a mixture of practical and aesthetic. However, this was by no means the end of the story, for three particular architectural or decorative features had not yet been developed.

Now, of course decoration had its own history over the centuries—brick, stucco, tiles, mirror-work and so on, and that is not our concern here. One decorative element, however, is particularly striking:

Pl. 1.15: Courtyard façade, Kazimain.
Chadirji collection no. (1) S6 006 16.

the gold which now dominates the exterior of so many of the shrines. Indeed, gilded domes, ivans and minarets are perhaps the most outstanding features of the great Shi'i shrines today. The earliest example of architectural gilding appears to have been at Mashhad, under Shah Tahmasp in the 1530's. We shall discuss the political importance of this act in Chapter 2. The immediate catalyst for the gilding of the dome appears to have been a dream in which Tahmasp saw the Imam 'Ali, who asked him to build a dome like the one in Najaf, but its significance was greatly increased by Tahmasp's act of repentance the same year. Be that as it may, the story of the dream is fascinating, because so far no other evidence has come to light to suggest that the dome at Najaf was already covered with gold by 1533. The only Islamic dome to have been gilded which would have been standing at that period, was that of the Dome of the Rock in Jerusalem, but even that, by the 16th century, had been changed, and was probably leaded.[70] The origin of the idea for gilding the dome at Mashhad is therefore uncertain.

The dome as it stands today (Pl. 1.16) is the result of a number of re-builds and re-gilds, and probably does not represent accurately the form of Tahmasp's dome. However, we may have a record of that gold dome in the manuscript of Jami's *Haft Awrang* in the Freer Gallery of Art, Washington, which was prepared for Tahmasp's nephew Ibrahim Mirza between 1556 and 1565.[71] The illustration of Zuleikha entering the capital of Egypt shows half a golden dome and a minaret, which may have been inspired by those of the shrine, together with musicians, standing perhaps for the royal *naqar-khaneh* ("trumpet house") associated with the shrine.

That golden dome over the tomb of the Imam Reza, and the golden minaret which he built on the north side of the *sahn-e kuhna*, the "Old Court", had a chequered history, due to looting and earthquakes, but they must have been fashion setters. Before his accession, Nadir Shah, in 1730, built a golden minaret in the upper part of the *sahn-e kuhna*, to counterbalance that of Tahmasp, and after his accession covered the southern gateway with sheets of gold, hence its historic name, "Nadir's

[70] Creswell 1969, pp. 92–96.
[71] Simpson 1998, p. 32 fol. 100b.

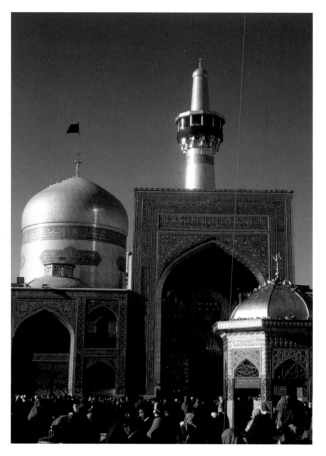

Pl. 1.16: Golden dome, Shrine of the Imam
Reza, Mashhad. Photo: Y. Michot 1981.

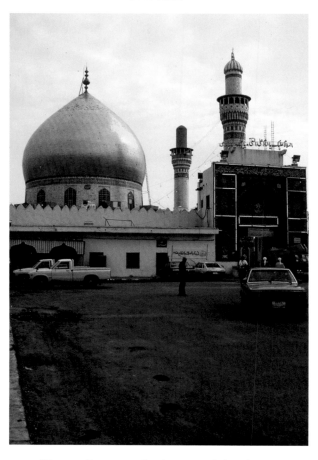

Pl. 1.17: Dome and minarets of the Shrine
of al-'Askari, Samarra. Photo: S. Damluji.

Golden Gate". At Najaf, in 1743–44, he replaced the tilework of the dome, ivan and minarets with gilded copper plaques, 20 × 20 cm square.[72]

Kerbala attracted the attention of the founder of the Qajar dynasty, Agha Muhammad Khan, who had the dome and minaret covered in gold. On his death in 1796–97, his work was continued by Fath 'Ali Shah, who used gold left over from Kerbala to gild the two domes and four small minarets at Kazimain a project completed in 1814, and he also re-gilded Kerbala's dome after the Wahhabi looting of 1801.[73] Fath 'Ali Shah was also responsible for the golden ivan on the east side of the Imam Reza's tomb at Mashhad, looking onto the *sahn-e naw*, or "New Court". In 1868–9 the Qajar ruler, Nasir al-Din Shah, was responsible for the gilding of the dome of al-'Askari at Samarra, which used some 72,000 tiles; the minarets were also gilded (Pl. 1.17). The gold left over from that work was used by his representative, Shaikh 'Abd al-Husain al-Tehrani, to gild the large ivan at Kazimain, a project which was finished in 1869. The four minarets at Kazimain were gilded c. 1880.[74] Hence the gilding of parts of the shrines was an on-going process over a period of some 300 years.

[72] Streck 2004, p. 605; Mahir 1969 p. 170.
[73] Nöldeke 1909, p. 46; Al-Yasin 1963 pp. 166–67.
[74] al-Samarra'i 1971, vol. 2, p. 124; Al-Yasin 1963, pp. 167–68.

Secondly, the platforms and porches. The platforms (*dikka*) are used as approaches to the mausolea, and provide the base on which the second item, the porch (*tarima*) sits, and this combination of features is, like the gilding, one of the most striking elements in today's shrines. It might be thought that the porch derives from the *talar*, the roofed, wooden, pillared space, open to the environs, so characteristic of the wooden architecture of Mazandaran.[75] This was adopted by the Safavids for their palatial architecture, and appears for example in the 'Ali Qapu in Isfahan.[76] However, the relationship of the *tarima* to the *talar* is far from straightforward. For the *talar* is characterised by a horizontal roof-line, whereas the

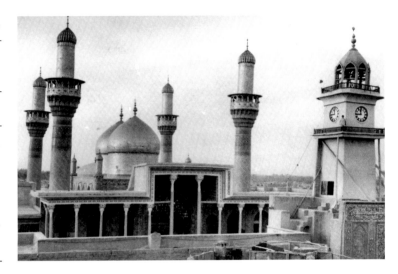

Pl. 1.18: Kazimain. Photo: Chadirji collection no. C ZGH 1 068 .

tarima is characterised by a roof-line with a raised centre. I have been unable to find examples of the latter form in Iran, but they are found in Central Asia. An early example seems to be in the early 16th century Balyand Mosque in Bukhara, but other examples are 19th or 20th century, e.g. that of the Hazrati Imam mosque in Shahr-e Sabz which dates from the second half of the 19th century, or the Bolo-Khauz in Bukhara which dates from 1915–17, or the Summer Mosque of the Khoja Ahrar ensemble in Samarqand which dates from 1909–21.[77] Pugachenkova comments that these wooden porticos were characteristic of popular architecture in Central Asia, a point confirmed by pictures of houses in Ichan Qal'a in Khwarazm.[78] Serious research is needed to establish whether there is indeed a relationship between Iraq and Central Asia in this context: for the moment the origin and significance of the *tarima* must remain uncertain. Be that as it may, both the platform and the porch aappear very late in the Iraqi shrines. At Kazimain (Pl. 1.18), the two platforms were not built until 1864–65. In that year the first porch was constructed, the second followed in 1867–69, and the third in 1903–14.[79] At Kerbala, the porches also appear to date from the second half of the 19th century. At Samarra, the porches were not constructed until 1948–49 and 1960–61.[80]

An interesting side-light is thrown on these features by the 19th century kerbalas in Lucknow. These will be discussed in more detail in Chapter 2, but it is good to introduce them here, for they are copies of the great Shi'i shrines, usually on a smaller scale, and are the buildings to and from which Muharram processions proceed. In one particular example, the Talkatora (Pl. 1.19), built in the early 19th century, we have a copy of the shrine of the Imam Husain at Kerbala. However, where it most obviously differs is in having no porch, since it was built before the porch was added to the Iraqi shrine.

75 Mazandaran is the area to the south of the Caspian known until the 13th century as Tabaristan.
76 Babaie 2004, pp. 99–100, 107.
77 Papadopoulo 1980, pl. 874; Pugachenkova 1981, pls. 19, 78, 137.
78 Prochazka 1990, pp. 57 (Arabic) and 100 (English). See also Prochazka 1993 p. 69 for a typical Bukharan quarter mosque with such a portico.
79 Al-Yasin 1963, pp. 167, 169.
80 al-Samarra'i 1971, vol. 2, p. 128.

Another item which should be mentioned briefly is the clock-tower. Kazimain, for example, has two. In 1870–71, the Persian vizir Dust Muhammad Khan visited the shrine and gave a clock, for which a tower above the east entrance was then built, completed in 1883–84. In 1885–86, however, a larger clock was donated by one Haj Muhammad Mahdi Abushahri: this was then set up over the south gate.[81] The shrine at Mashhad, on the other hand, has no clock-tower. The clock presented by Muzaffar al-Din Shah in 1900 was at first exhibited on the portal of the Old Courtyard, and then in 1957 was placed on the portal of the New Courtyard, where it now stands.[82] Clock towers were built all over the Middle East in the 19th and early 20th

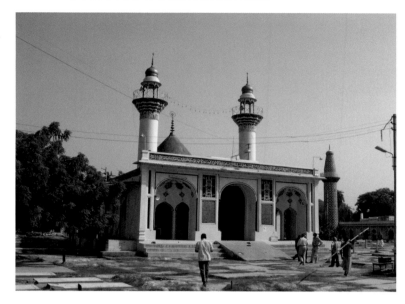

Pl. 1.19: Talkatora Kerbala, Lucknow, c. 1798–1814. Photo: J. W. Allan

centuries, especially in the Ottoman empire, where they were championed by Sultan Abdulhamid II (1876–1909). At least 50 were built during this period in Anatolia. An early example is the Nusretiye clocktower in Istanbul, which dates from the reign of Abdulmecid in the 1850's, but perhaps the most famous is the Dolmabahçe clock tower built between 1890–95.[83] Clock towers are also to be found in India, and a good example, dating from 1910, stands in Lucknow. Hence, their appearance at the Iraqi shrines was part of a widespread fashion.

We have established that the various architectural elements in the great Shi'i shrines were introduced over a period of over 1000 years, but we have also seen that by the Mongol conquests these shrines had an identifiable form, even if it lacked some of the characteristics we now associate with the Imami shrines. It is appropriate to ask at this point whether, at any stage in its history, that form set a fashion for other buildings, or was copied in any other way. Two particular buildings deserve comment at this point, the shrine of 'Abbas ibn 'Ali, near that of his brother Husain, at Kerbala, and that of Massumeh Fatima (d. 816–17), the sister of the 8th Imam, in Qum. Images of the shrine of 'Abbas, showing its golden dome and two golden minarets, together with its porch and surrounding wall, suggest that it is a copy of that of Husain nearby, but when it came to be in its present form is uncertain, since scarcely anything has been published about it.[84] The shrine of Fatima at Qum (Pl. 1.1, and Fig. 8), with its golden dome, its golden ivan, its minarets, its porch and courtyards, also echoes the shrines of Iraq, but in this case we know a considerable amount about its history. Like them, it developed its final form over many centuries. In 1519 Shah Isma'il I redecorated the mausoleum, and built the great ivan and the minarets; Shah 'Abbas I embellished the sanctuary and transformed two of the courtyards (sahns) into madrasas; Fath 'Ali Shah in 1795–96 made the two small Safavid sahns

[81] Al-Yasin 1963 p. 168.
[82] Haram (social and cultural), p. 29.
[83] Kreiser 1997, p. 110; Özdemir 1993, pp. 200, 205
[84] For the groundplan see Nöldeke 1909 p. 17 Taf. 3. Calmard 1985, p. 78 says nothing of the history of the shrine except that it was renovated in 1965–66.

into one large one (the *sahn-e 'atiq*, or "Old Court"), and in 1803–4 gilded the dome; and in 1883 Amin al-Sultan, vizir of Nasir al-Din Shah, added the vast *sahn-e jadid*, or "New Court". Qum also became the site of Safavid royal burials, and includes the tombs of Shah Safi, Shah 'Abbas II, Shah Sulaiman, and Shah Sultan Husain. So too those of Fath 'Ali Shah and Muhammad Shah Qajar.[85]

Amongst the other Shi'i shrines in Iran, the largest is probably the Mausoleum of Shah Cheragh in Shiraz, which is the burial place of Mir Sayyid Ahmad, son of the 7th Imam. This was founded in the 12th century but owes its present appearance to the Safavids and Qajars. With its tiled dome, porch, two short minarets, and large court, its relationship to the Iraqi shrines is apparent, but not nearly as close as that at Qum.[86] Another large shrine is that of Hazrat-e 'Abd al-'Azim at Rayy. 'Abd al-'Azim was one of the sons of the Imam Hasan who was martyred in the 9th century, and the shrine also includes the mausoleums of Imamzadeh Hamza, brother of the 8th Imam, and Imamzadeh Tahir. The complex includes domed tomb chambers, one with a golden dome, an ivan, various courtyards and two minarets.[87] Another shrine bearing some relationship to the shrines of the Imams is the Imamzadeh Sultan 'Ali ibn Muhammad Baqir at Ardahal, which has a central porch and twin minarets,[88] and other shrines offer occasional references, for example the Imamzadeh Sayyid Isma'il in Tehran.[89] Other small *imamzadehs*, or tombs of descendants of the Prophet, are more than simple domed chambers or tomb-towers, in that they have courtyards, for example the Darb-e Imam, the Harun-e Vilayat, and the Imamzadeh Isma'il in Isfahan.[90] However, all these courtyards seem to be very late 19th–20th century additions, and do not suggest any relationship to the great shrines of Iraq, or to the shrine of the 8th Imam in Mashhad. Numerous other descendants of the Prophet who died in Iran were buried in relatively modest structures which cannot outwardly be distinguished from the small domed shrines or tomb-towers of wealthy secular patrons.[91]

This was also true in Iraq, where a certain number of mausolea attributed to descendants of the Prophet survive. Examples are those of Imam Yahya ibn al-Qasim ibn al-Hasan ibn 'Ali ibn Abi Talib, and Imam 'Awn al-Din, both in Mosul, and that of Sittna Zainab at Sinjar.[92] Each consists of a square building covered by a polyhedral dome, and any additional buildings, as at Sittna Zainab, are modern. In India, on the other hand, we do find direct copies of the Iraqi shrines—in the form of kerbalas. These will be discussed in due course (see below pp. 77–78).

Now let us look at the other institutions which congregated around these shrines. First is the *masjid*, the mosque where formal prayers would have taken place. The earliest evidence for the presence of a mosque alongside a shrine comes from Mashhad, where the Samanid governor, Fa'iq al-Khasa, incidentally a Sunni, built a mosque sometime before 984.[93] The next evidence comes from Kazimain, where in 1058 al-Basasiri included a mosque in his rebuilding of the shrine. That seems to be the only pre-Il-Khanid evidence. At Najaf, the 14th century traveller, Ibn Battuta, says that one of the doors of the *qubba* led into a mosque covered with a ceiling, and the Masjid-e Ra's today contains an Il-Khanid mihrab, so it too could be an Il-Khanid building.

[85] For the history of the shrine see Tabataba'i 1976, vol. 1, pp. 46–119, Mechkati n.d., pp. 224–26, and Calmard 1986. For a convenient plan see also Godard 1965, fig. 226, and for an image of Fath 'Ali Shah's tomb Godard 1965, fig. 168.

[86] Mechkati n.d., pp. 126–27.

[87] Mechkati n.d., pp. 206–8, www.abdulazim.com.

[88] Mechkati n.d., p. 242.

[89] Parviz 2000, p. 233 pl. 526.

[90] Godard 1937, pp. 47–57 for the Darb-e Imam, pp. 63–69 for Harun-e Vilayat, and pp. 131–42 for the Imamzadeh Isma'il.

[91] Hillenbrand 1974 surveys the evidence.

[92] Sarre and Herzeld 1911–20, vol. 2, pp. 249–70, Abb. 250 and 261, and pp. 308–11, Abb. 285.

[93] Farhat 2002, pp. 31–33.

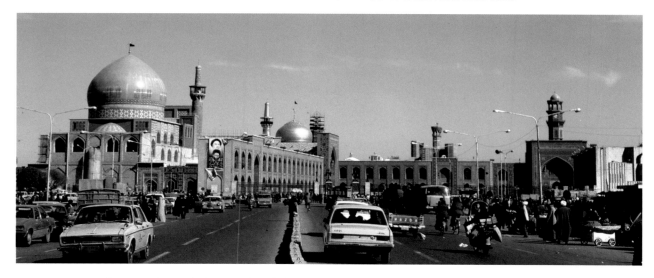

Pl. 1.20: View of the outside of the Shrine of the Imam Reza, Mashhad, showing
the Masjid-e Gawhar Shad on the left. Photo: Y. Michot, 1981.

The earliest shrine mosque of whose history we can be sure, and certainly one of the great mosques of
all time, is the Masjid-e Gawhar Shad in Mashhad, built by the wife of the Timurid ruler, Shah Rukh,
between 1416 and 1418 (Pl. 1.20). Whereas the other mosques mentioned were designed primarily
as places where pilgrims could pray, the mosque of Gawhar Shad had strong political and religious
overtones. These will be discussed in the next chapter.

Alongside mosques, madrasas (religious colleges) also found their place in shrine complexes. There
is no record of a madrasa at any of the shrines in the pre-Mongol period, but in 1326–27 Ibn Battuta
visited Kerbala and describes a large madrasa there. Under the Timurids madrasas multiplied. At Mash-
had (Fig. 8), the madrasa Do-Dar was founded in 843/1439.[94] Another Timurid madrasa was that com-
missioned by Shah Rukh, in which Babur ibn Baysunghur was buried, though we do not know where
it was in relation to the shrine.[95] It may be the Madrasa Bala Sur which is the first courtyard to the right
of the tomb behind the facade of the *sahn-e kuhneh*, though we cannot be certain.[96] Another madrasa of
the period was Parizad,[97] and two others are recorded.[98] This extraordinary accumulation of madrasas
at a shrine seems to be explained by the fact that in Khurasan almost all the rulers and notables of the
court were buried, not in free-standing mausolea, but in mausolea built as part of madrasas. Since to be
buried within the purview of the shrine of the Imam Reza was to ensure the blessing *(barakat)* of the
Imam and his intercession for the next life, madrasas at the shrine inevitably multiplied.

For other institutions associated with the great shrines, a few examples may suffice. A public
rest house was built at Kazimain in 1097, a building where the poor were fed in 1207–8, and later
an orphanage.[99] In the early 14th century the Il-Khanid Ghazan built a sufi *khaneqah* and a *dar al-
siyyada* (for descendants of the Prophet) at Najaf,[100] and a *zawiya* at Kerbala, in which according to

[94] O'Kane 1987, pp. 179–87, cat.no. 15.
[95] O'Kane 1987, p. 22.
[96] O'Kane 1987, pp. 158–61, cat. 12.
[97] O'Kane 1987, pp. 133–35 no. 4.
[98] Golombek and Wilber 1988 ,vol. 1, p. 450 nos. 97 and 100.
[99] Al-Yasin 1962, pp. 124–25.
[100] Mahir 1969, p. 134.

Pl. 1.24: Shrine of Ayatollah Khomaini from the air. Photo: Y. Michot, 1993.

ing over 30,000 graves, is named after Fatima al-Zahra, the Imam Husain's mother, and is the burial place of many revolutionaries and soldiers from the Iran-Iraq war. In the mausoleum complex, the cenotaph of the late Ayatollah is centrally placed under a gilded dome, which is supported by 8 massive marble columns, and other more slender columns support the space-frame ceiling, which is also articulated with clerestories. Floor and wall surfaces are polished marble. The cenotaph itself is housed in a glass chamber with a metal grilled enclosure. The exterior of the shrine complex is a highly recognizable landmark, with a gold dome on a high drum and four free-standing minarets.

The complex relies on obvious outward symbols to link it to other Shi'i shrines—the minarets recalling those of the shrine of Husain at Kerbala, the golden dome with its high drum that of the shrine of Fatima at Qum. But these are combined with 20th century technology—the minarets and dome are concrete and steel structures carrying prefabricated metal sheets, and the rest of the roof and columns are also of prefabricated metal. In the centre is indeed a cenotaph within a metal grill, but the latter is not a sophisticated craft work of steel, silver or gilt, but a lattice of soldered metal pieces, and it stands not within one of a number of rooms or spaces, as would be the case in traditional shrines, but in the centre of a vast and originally completely open space: the latter is now separated into male and female areas by a wall.

Construction of the complex commenced in 1989, and when completed the tomb will be the centrepiece of a 5,000 acre development (Pl. 1.24). Included in the proposal is a university for Islamic studies, a seminary, and a shopping mall, together with hotels and all the other 21st century requirements of the pilgrimage centre of a nation, including relocation of Tehran's international airport. The porches seem to be the only missing item. Shi'ism has its latest addition to a varied and fascinating tradition of shrine architecture. If ever there was a symbol of Shi'ism as a political power, it is this.

CHAPTER 2

Shi'ism, Royal Patronage and Political Power

The architectural development of the great Shi'i shrines, their numerous rebuilds and repairs, and their final forms, highlighted with large amounts of gold, have shown how important these buildings have always been for the spiritual life of the Muslim world. In Chapter 3 we shall consider their role as treasuries, but this chapter will focus on the royal patronage which was responsible for their development, and it will try to understand why Sunnis were among those royal patrons. The chapter will then move into Iran and the Indian sub-continent to focus on the Shi'i dynasties of those areas, and the way their faith was expressed through their architecture and art.

Before detailing the involvement of Sunni patrons in the Iraqi shrines, let us briefly consider the numerous royal, Shi'i, patrons who were so often responsible for their architectural development. In the early Islamic period, the Talibite Sayyids of Tabaristan, the Hamdanids and the Buyids were all notable for their work at the shrines, and we have already noted some of their particular constructions, or rebuilds, and their patronage of furnishings as well as brick. One might cite as examples the Hamdanid qubba at Najaf, and their wall around Samarra, and the Buyid qubba and riwaqs at Samarra. We might also note here the Buyid rebuild of Kazimain under Mu'izz al-Dawla (945–967)[1] and five surviving wooden plaques destined for an un-named Shi'i shrine bearing the name of 'Adud al-Dawla (978–983).[2]

The motives behind such building projects were probably largely religious. The historian Ibn Isfandiyar says of Muhammad ibn Zaid that he "began to preach the Shi'ite doctrine, and to inculcate the deepest veneration for the House of 'Ali, and to repair their shrines, and to build fresh ones where he supposed their graves to be".[3] Of the Hamdanids' motives we know all too little, apart from the fact that, as a family, they seem to have had pronounced Shi'i sympathies.[4] Again, Buyid motives were probably primarily religious: Ibn Isfandiyar also records that 'Adud al-Dawla "surrounded these holy places with houses and bazars, and instituted the observances of Muharram and the Yawm al-Ghadir and other Shi'i practices".[5] Buyid piety was such that a number of them had themselves buried in a shrine precinct, for example, Mu'izz al-Dawla at Kazimain, and 'Adud al-Dawla and other Buyid rulers in the mausoleum of 'Ali at Najaf.[6] One other Shi'i patron of Kazimain should perhaps be mentioned in passing: al-Basasiri. Al-Basasiri was the Turkish general who occupied Baghdad in 1058 and proclaimed the *khutba* (the Friday sermon) in the name of the Fatimid caliph. The same year he included a mosque in his rebuilding of the shrine at Kazimain.[7] His triumph was short lived,

1 Al-Yasin 1962, p. 122.
2 Blair 1998, p. 136.
3 Browne 1905, p. 158.
4 Canard 1971, p. 127.
5 Browne 1905, p. 158.
6 Busse 1969, p. 201–2.
7 Al-Yasin 1962, pp. 123–24.

however, for the situation was reversed on the arrival of the Saljuq Tughril, since it was the 'Abbasid caliph who then confirmed Tughril as Sultan.

The next Shi'i dynasty to control the Iraqi shrines, albeit briefly, was that of the Safavids. The Safavids are well known as patrons of Mashhad, but Shah Isma'il I—and this fact seems rarely to be mentioned in western literature—was also an important patron of the Iraqi shrines. In 1508 he made a pilgrimage to the holy sites of Iraq. We do not know what he gave to the shrine at Kerbala, or if he was involved in any building work there, but to the shrine of 'Ali at Najaf he gave "excellent presents, and marvellous rarities, and on the residents of the town he bestowed honours and wondrous gifts."[8] The same year he ordered new wooden cenotaphs for the shrines at Samarra, and completed the tile mosaic there, which had been begun under the Jalayirids.[9] Most importantly, he completely rebuilt Kazimain. This included the expansion of the *rawda* (the sacred precinct), marble paving for the porticos, two new cenotaphs, the embellishing of the *mashhad* (the shrine itself) and its exterior with Qur'anic tiles and historical texts, 4 minarets to replace the 2 already there, a new large mosque on the south side of the area, the removal of the stables in the courtyard (presumably to provide unclut-tered circulation space), and a suitable donation of furniture and lamps to furnish the shrine. The remains today include: a Qur'anic frieze around the inside of the *rawda*, finished in the year 1524, during Tahmasp's reign; a frieze on the outside of the eastern portico, finished in the year 1520; two wooden cenotaphs dated 1520; and 3 wooden doors, now in the Museum.[10]

It is clear from the work which Isma'il initiated in Iraq that he saw the great shrines of the Imams there a propaganda key to his politico-religious ambitions. The loss of them to the Ottomans must therefore have been a major blow, and explains the radical re-direction of later Safavid architectural energy to the shrine of the 8th Imam, 'Ali Reza, in Mashhad.

The Qajars were also major patrons of the Iraqi shrines. As we have seen, they continued Nadir Shah's gilding of domes and minarets, and built the platforms and porches at Kazimain and Kerbala. It may seem obvious that the Qajars, as Shi'i rulers of Iran, would be keen to leave their mark on the Shi'i shrines. But there were in fact additional motives for their involvement. For the Qajars were faced with a problem of legitimacy which the Safavids had been spared. The Safavids, through alleged Imamite descent, could claim to be *mujtahid*s—learned men who could exercise rational judgement in matters of religious law. The Qajars, having no such legitimacy, were in theory subject to *taqlid*—submission to the directives of the learned, the *'ulema*, in matters of religious law. However, as po-litical rulers they were unwilling to submit to the *'ulema*, and one of the dominant themes of Qajar history thus became persistent tension between the monarchy and the *'ulema*.[11] Hence there is more than mere piety in the Qajar determination to embellish the Iraqi shrines.

Let us now turn to Sunni patrons. Sunni patrons are in fact surprisingly numerous, and begin early in 'Abbasid times. For example, the first dome over the tomb of 'Ali is known to have been built by the 'Abbasid caliph, Harun al-Rashid (786–809), patronage which seems to run completely contrary to Harun's well-known anti 'Alid policy, and his imprisonment of the 7th Imam, Musa al-Kazim.[12] Explanation of his patronage therefore remains uncertain. The shrine at Kerbala, which indeed had been destroyed during Harun's reign, was reconstructed under al-Ma'mun (813–833).[13] This was evi-dently part of al-Ma'mun's attempt to recover broad Shi'i support for the caliphate by appointing the

[8] Mahir 1969, p. 137.
[9] al-Samarra'i 1971, vol. 2, p. 121.
[10] Al-Yasin 1963, pp. 158–63. It is not clear whether these are the same doors as illustrated in *A Guide to the Arab Museum at Khan Marjan* 1938, pp. 32–2 and pl. 27, which are said to have come from the mosque in Samarra.
[11] Algar 1991, pp. 714–16.
[12] Grabar 1966, p. 20; see also Omar 1971, pp. 232–34.
[13] Raghib 1970, p. 31.

8th Imam, 'Ali al-Reza, as his successor, a plan destroyed by the 8th Imam's untimely death.[14] In the 9th century Kerbala was destroyed at least four times during al-Mutawakkil's reign (847–861),[15] part of an anti-'Alid policy which, according to Ibn Isfandiyar, was propagated by his minister, 'Abdallah ibn Yahya ibn Khaqan "who was continually inciting him to kill the descendants of the Prophet, and even prevailed on him to destroy the tombs of the martyrs of Kerbala, dam up the water, grow crops on the site of their graves, and set Jewish watchmen and keepers there to arrest and slay any Muslim who visited these holy places".[16] Interestingly, the shrine at Kerbala was reconstructed at least once with the Caliph's permission, and later rebuilt by his son al-Muntasir (861–862). This was in line with the more tolerant approach the latter showed towards the 'Alids, giving them back their estates, and permitting pilgrimage to their graves and shrines.[17]

After the see-sawing of early 'Abbasid caliphs in their attitude towards the shrines, there is more clarity about religious and political motives for the later 'Abbasid caliphs, who, just before the Mongol invasions, emerge as patrons on a grand scale. Nasir li-Din Allah (1180–1225), and al-Mustansir (1226–42) were patrons of the shrine at Samarra;[18] Nasir li-Din Allah, az-Zahir (1225–26), al-Mustansir and al-Musta'sim (1242–58) of the shrine at Kazimiya;[19] and al-Mustansir of the shrine at Najaf.[20] And of these, two were complete rebuilds, those of al-Musta'sim at Kazimiya and of al-Mustansir at Najaf. The reason for all this involvement in the shrines seems to lie in the policies of Nasir li-Din Allah.[21] Nasir adopted religious policies that were strongly at variance with those of his predecessors, or such contemporaries as Nur al-Din or Salah al-Din. He was not concerned, as they were, to unite Sunnism against Shi'ism: his aim was to bring these two major parts of Islam together, and to unite them under 'Abbasid caliphal authority. Indeed, in the words of Hartmann, "al-Nasir's policy aimed at orienting and obligating all Muslims towards the caliphate as the sole spiritual and secular centre of this [post-Buyid and post-Saljuq] world." For this purpose he reorganised the *futuwwa* as a men's confederation under his personal authority, and propagated an encyclical written by him relating to hadith (the traditions of the Prophet). He also enlisted the support of the Shafi'i Sufi shaikh al-Suhrawardi, who advocated both union between Sunni and moderate Shi'is, and between *futuwwa* and Sufism. At this period the Shi'a accounted for about half of Baghdad's population, and al-Nasir clearly took into account and developed their interests. Specifically, he built close contact with Shi'i *naqibs* (syndics), and appointed Shi'is as vizirs and other high officials. A significant inscription at Ghaybat al-Mahdi in Samarra, which he had extensively renovated and enlarged, gives some colour to his ambitions, by designating him builder and protector of the Shi'i sanctuary. It is no surprise, therefore, to find him busily engaged in renovating not only Samarra but also Kazimain, so close to the caliphal palace. Of al-Zahir's ambitions we can say little: he only ruled for 9 months. But we know that the work at Kazimain continued. Moving on to al-Mustansir, his Mustansiriyya Madrasa in Baghdad was the first universal Sunni madrasa, serving the needs of all four *madhhabs* (schools of religious law): its foundation, combined with his conciliatory behaviour towards the Shi'i, including rebuilding the shrine at Najaf, suggest that Islamic unity continued to be the late 'Abbasid goal.[22]

[14] Madelung 1997, p. 424; Farhat 2002, pp. 10–16.

[15] Raghib 1970, pp. 33–34.

[16] Browne 1905, p. 158.

[17] Bosworth 1993.

[18] Northedge 1995, p. 1040.

[19] Al-Yasin 1962, pp. 125–27; for a mulberry wood cenotaph given by al-Mustansir to Kazimain see Combe, Sauvaget and Wiet 1939, no. 3976; *Arts of Islam* 1976, no. 453.

[20] Mahir 1969, p. 132.

[21] Hartmann 1993.

[22] Hillenbrand 1993, pp. 727–29.

The Sunni Jalayirids also patronised the shrines.[23] The shrine at Najaf was destroyed by fire in 1354, and was rebuilt in 1358–59.[24] At Kazimain, Sultan Uwais provided what must have been a rebuild in 1367–68: two domes, two minarets, marble cenotaphs, glazed Qur'anic tiles in the sacred area, and a portico and *rabat* (dervish lodging) in the courtyard.[25] No authoritative study of the dynasty is available to provide the full background to such patronage, but the details of the rebuild at Kazimain suggest a response to the extensive flooding known to have occurred a number of times in the mid 14th century. In other words, Jalayirid works at Najaf and Kazimain may both have been straightforward solutions to local needs.

The discussion so far has been focused on the Shi'i monuments of Iraq, but a similar situation pertained to the Shrine of the Imam Reza in Mashhad. Here Timurid patronage makes a strong political statement.[26] Originally the Mosque built between 1416 and 1418 under the patronage of Shah Rukh's wife, Gawhar Shad, had no external monumental gateway and the external walls were of plain brick, showing that the mosque was conceived as an extension of the shrine's space. But the sheer monumentality of the building, and the way it overshadows the tomb, highlights the orthodoxy for which the mosque stands, as do its inscriptions, from which any references to the Imam Reza are conspicuously absent. As the largest communal religious space in the city it would have been the main public forum where the Sunni *khutba* would have been read in name of the Timurid ruler.

Returning to Iraq, the Sunni Ottomans were evidently concerned for the well-being of the shrines, although their motives are difficult to unravel. Suleyman the Magnificent (Pl. 2.1), on capturing Baghdad, made pilgrimages to the tombs of 'Ali and Husain, built a dome over the tomb of the great lawyer Abu Hanifa, and restored the tomb of the founder of the Qadriyya order, Shaikh 'Abd al-Qadir al-Gilani.[27] These activities suggest a desire to bring all the different Baghdadi communities on side, rather than any specific religious beliefs of the Ottoman Sultan. Incidentally, the capture of Iraq by the Ottomans left many details begun by Shah Isma'il I at Najaf unfinished, so in 1554 Suleyman the Magnificent ordered their completion. In practice, the work was greatly prolonged, and for

Pl. 2.1: Sultan Suleyman the Magnificent on horseback, etching by N. Nelli, c. 1530. Hungarian National Museum, Budapest, no. TKCs115.

[23] Though possible Shi'i tendencies or sympathies of members of the Jalayirid and Turkoman dynasties are mentioned by Calmard 1993, p. 113.

[24] Mahir 1969, p. 133.

[25] Al-Yasin 1963, p. 157.

[26] Golombek and Wilber 1988, vol. 1, no. 90; Farhat 2002, pp. 101–2.

[27] Veinstein 1997, p. 834.

example the north minaret was not completed to its full height until 1570–71, when it was finished by order of Selim II. Even then it remained unroofed.[28] At Kerbala the Minaret al-'Abd was built in 1574–75 under the Ottomans, and in 1583 the sanctuary was restored,[29] but the circumstances of the patronage are unclear. Ongoing repairs of shrines in the late 18th and 19th centuries, under the Mamluk Pashalic, or after 1831 under the Sultanate, are recorded, but the nature of their patronage is often in doubt.[30]

Moving on to Nadir Shah (Pl. 2.2), patronage of the Iraqi shrines continued. In 1740–41 Nadir Shah sent gifts to the shrine at Kazimain, and his favourite, Radiyya Sultan Begum, during her pilgrimage to Kerbala, presented the shrine with 20,000 *nadiri*s for improvements to be made to it.[31] However, Nadir Shah's relationship with the Shi'i shrines of Iraq was made complicated by his own proposals for the religious reform of Iranian Shi'ism.[32] On taking the throne in 1736 he ordered the abandonment by the Shi'is of two of the practices traditionally most offensive to

Pl. 2.2: Nadir Shah, portrait, oil on canvas, unknown artist. British Library F44.

Sunni sentiment—the ceremonial vilification of Abu Bakr and 'Umar, as well as other Companions of the Prophet, and the rejection of the legitimacy of the first three Caliphs. Shi'ism was to be reabsorbed into the main body of Islam as the fifth *madhhab*, named the *Ja'fari madhhab*, after the 6th Imam Ja'far al-Sadiq. In 1743 during his Iraqi campaign, Nadir Shah convened a meeting of Sunni and Shi'i *ulema* at Najaf to try and reconcile the two groups. Although this proved inconclusive, it is presumably no coincidence that at Najaf, that same year, he ordered the removal of the ceramic tiles which covered the dome and the minarets, and the ivan, and their replacement with sheets and tiles of gold[33]—an attempt, one assumes, to draw together Shi'i and Sunni sentiments through their mutual respect for the Prophet's son-in-law, 'Ali.

Our survey suggests that both Shi'i and Sunni rulers who cared for the shrines of the Imams in Iraq did so with a mixture of motives. In the Shi'i case, piety and politics both had a role. Among Sunni rulers motives were even more varied. Early 'Abbasid caliphs had differing views of the importance of the shrines, and destruction and reconstruction could alternate even within an individual reign. The last 'Abbasid caliphs and Nadir Shah, on the other hand, had a common interest in trying

28 Al-Yasin 1963, p. 164.
29 Honigmann 1978, p. 637.
30 al-Samarra'i 1971, vol. 2, p. 123; Mahir 1969, pp. 154, 159, 170.
31 Honigmann 1978, p. 638.
32 Algar 1991, pp. 706–10.
33 Mahir 1969, p. 162.

to unite Islam, and therefore drawing in the Shi'i community. On other occasions the main motive seems to have been political, for example to keep the local population happy, hence the Jalayirid rebuilds. This seems the likely motive for Suleyman the Magnificent's bipartisan approach at the time of his conquest of Baghdad. But there also seems to have been a genuine tension within the faith of some of the individuals concerned: officially Sunni but with a deep reverence for 'Ali and the Family of the Prophet. This shows itself not only in rebuilding or repairing the shrines but in using the shrines as burial sites e.g. the early 'Abbasid caliph, al-Amin, and his mother, Zubaida, who were both buried in Kazimain.[34] It also shows itself through pilgrimage: in 1086 both the Sunni Saljuq sultan, Malik Shah, and his vizir, Nizam al-Mulk, made pilgrimages to both Najaf and Kerbala,[35] while in 1302, as noted above in Chapter 1, the Il-Khanid ruler, Ghazan, visited Najaf, and with his own hands hung the curtains he had ordered for the shrine.[36] And of course the pilgrimages of Suleyman the Magnificent, as already mentioned.

So far we have been looking at shrines in terms of the patronage which brought about their architectural development over the centuries. Now let us turn our discussion around, move our focus away from the history of individual shrines, and look at the way in which Twelver Shi'is, on achieving political power, expressed their faith in their architecture and their art. To do this we shall move out of Iraq, and concentrate attention on Iran and India. We shall first consider the Safavids and the Qajars in Iran. Then we shall move to the 16th–17th century Shi'i dynasties of the Deccan—the Nizahmshahis of Ahmednagar, the Adilshahis of Bijapur and the Qutbshahis of Golconda and Hyderabad. Finally we shall focus on the 18th–19th century Nawabs of Awadh, or Lucknow. As we progress we shall see two different artistic aspects emerging: the use of inscriptions to establish and project Shi'i belief, and the promotion of specific types of architectural edifice or complex to serve Shi'i needs. However, we shall also see different Twelver Shi'i dynasties expressing their Shi'ism very differently depending on the circumstances of their rise to political power, and their ability to retain it.

It should be noted at this point that our intention in this next section is not to look at every known Shi'i inscription from the Islamic world. That is beyond the scope of this book, and would require a vast amount of research and publication space. What follows samples the inscriptions of the various dynasties cited, in order to draw out some of the most obvious ways in which they expressed their faith.

We begin with Shi'i coinages of Iran prior to the rise of the Safavids in the early 16th century. Early 'Alid rebels or local Shi'i dynasties of Tabaristan, in northern Iran, between the 8th and 10th centuries adopted a number of distinctive titles or Qur'anic quotations on their coinage. The title *al-mahdi al-haqq amir al-mu'minin*, "the true Mahdi, Commander of the Faithful", is found on an early example,[37] while two particular Qur'anic quotations are used: "Say, I do not ask for any reward for it other than love of (my) relatives" (Sura 42:23),[38] which was first adopted by rebels against the Umayyads, and "People of the House, God only desires to put away from you abomination and to cleanse you" (Sura 33:33) is also used,[39] both of which can be given Shi'i interpretations through the words 'relatives' and 'house'. Others include references to fighting, but could apply to any rebel group, e.g. "Sanction is given unto those who fight because they have been wronged; and Allah is indeed able to give them victory" (Sura 22:39).[40] At a much later date, the Il-Khanid sultan, Oljeitu (1304–16), displayed his Shi'i beliefs on his coinage, issuing dinars with, on their obverse, an expanded profession of the Shi'i

34 Le Strange 1900, pp. 161, 163–64.
35 Hasan 1964, text p. 437, ll. 9–10, trans p. 455.
36 Hammer-Purgstall 1842–43, vol. 2, p. 119.
37 Miles 1965.
38 Miles 1965, pp. 333–35.
39 Stern 1967 pp. 212, 217, 219.
40 Miles 1965, pp. 334–35; Stern 1967, pp. 211–12, 217, 219.

faith, including the phrase *'ali wali allah*, "'Ali is the friend of God", together with the blessings of the 12 Imams around the margin.[41]

Turning to architecture, Shi'i inscriptions, or inscriptions using Qur'anic quotations for Shi'i purposes, are rare in pre-Safavid Iran, but they do exist. For example, Sura 33:33 occurs in the inscription around the top of the walls of the dome in front of the mihrab in the mosque in Na'in, built c. 960, in the Buyid period. More interesting for our purposes is the way Oljeitu's mihrab in the winter prayer hall of the Friday Mosque in Isfahan (1310) uses inscriptions to assert the Shi'i faith. The arch of the tympanum quotes Sura 4:59, "Oh ye who believe! Obey Allah, and obey the messenger and those of you who are in authority". The Sura offers no identification for those referred to in the latter phrase. However, it is explained in the inscription through a *hadith* from an early traditionist, Jabar ibn Zayd al-Ja'fi, in which the prophet is asked who "those of you who are in authority" are, and on the lower arch of the mihrab is written the Prophet's reply—that they are 'Ali and the twelve Imams.[42] One other, incomplete, example of a Shi'i hadith is to be found on the Mausoleum of Sultan Oljeitu at Sultaniyya, in an inscription which starts, "'Ali ibn Abi Talib, may God ennoble his countenance, said: 'Four …'" Such Shi'i hadiths are very rare on Shi'i buildings prior to the 16th century, though, as we shall see, the use of hadith is of paramount importance in the Safavid period as a propagandist device. Also on the Isfahan mihrab is to be found the Shi'i *shahada*, which occurs too on other Shi'i buildings of the period, e.g. the Mausoleum of Oljeitu at Sultaniyya,[43] and the mihrab of the Friday Mosque at Varamin (1322–26).[44] It occurs in the following century in the Masjid-e Jame' in Yazd, restored by the Turcoman Shi'i ruler, Jahanshah in 1457 (though this inscription may be Il-Khanid), in the mosque at Varzaneh, south-east of Isfahan (1444–45), and in the mosque at Bundrabad, near Yazd, which dates from the reign of Sultan Husain Baiqara (1470–1506).[45]

The Il-Khanid period also witnessed more extensive use of square kufic, which seems to have been used to proclaim both the Sunni and the Shi'i message.[46] The first surviving occurrence of square kufic in a monumental inscription is to be found at Ghazna, on the minaret of the Sunni Ghaznavid ruler Mas'ud III (1099–1115): it is used there for his name and titles. Square kufic inscriptions also appear on Saljuq monuments, though these have rarely been studied in detail.[47] Under the Il-Khanids square kufic was used for Sunni and Shi'i inscriptions, for example the Sunni names of the Rashidun, and the Shi'i *shahada* and the names of the twelve Imams. And at Pir-e Bakran, near Isfahan, it is clearly linked to changing Il-Khanid ideologies: the building's first decorative phase (c. 1303) uses it for the names of the Rashidun and the *shahada*, corresponding to the contents of the *khutbas* of the period and of the inscriptions on the coinage, while the second decorative phase (c. 1312) incorporates the names of the Fourteen Immaculates, coinciding with the introduction of their names onto the coinage, and for the *Asma al-Husna*, the 99 names of God. The Il-Khanid coinage, on the other hand, only uses square kufic from the reign of Abu Sa'id (1316–35).[48] Hence, although square kufic was used for Shi'i inscriptions it becomes clear that the significance of the script relates to the more general religious context, not to Shi'ism in particular.

[41] Blair 1983, pl. IX figs. 1 and 3; Allan 2003, p. 41 fig. 25. Luke Treadwell has pointed out to me that Oljeitu was also the first Muslim ruler to put the four orthodox caliphs on his coins, prior to his conversion to Shi'ism.

[42] Honarfar 1965, pp. 119–20.

[43] Blair 1987, p. 45.

[44] Kratchkovskaia 1931, inscription X.

[45] Far 1999, pp. 31, 238, and 239.

[46] Majeed 2006 discusses square kufic in great detail, and with extremely helpful diagrams, and is especially important in our own context for her discussion of square kufic in Il-Khanid Iran, particularly at Pir-e Bakran.

[47] Majeed 2006, pp. 22–27 for the Ghaznavid minaret; p. 225 n. 1 for Saljuq inscriptions.

[48] Majeed 2006, p. 111 for a table of Il-Khanid monuments with square kufic inscriptions; pp. 241–44 for funerary associations; pp. 261–63 for links with official Il-Khanid ideology.

However, the use of the *Asma al-Husna* in a Shi'i context at Pir-e Bakran deserves comment, for it is widely used elsewhere in Islamic art and architecture in overwhelmingly Sunni contexts, e.g. on the cenotaph in the mausoleum of the Mughal sultan, Jahangir, built in Lahore by Shah Jahan (1628–58). The relatively early importance of the 99 names to Shi'is is clear from the fact that the 11th century scholar al-Kulaini made a compilation of Shi'i *hadith* containing a chapter entitled, "Which of the greatest names of God have been given to the Imams". And in the early 14th century Oljeitu's Shi'i adviser, 'Allama Hilli, also wrote on the importance of the divine attributes of God in his book on the principles of Shi'i theology.[49] We have therefore an interesting example of what was originally and remained a Sunni text, which then acquired specific meaning and signficance for Shi'is. This is a point to which we shall return.

Shi'i inscriptions are also found on architectural furnishings of the Il-Khanid period. A fine pair of doors dating from the reign of Muzaffirid Qutb al-Din Shah Mahmud (1358–75) grace the Imamzadeh Isma'il in Isfahan (Pl. 2.3). Above them, in the tympanum, is the historical inscription and the words *la allah illa allah*, "There is no god but God". Square panels on the doors themselves bear the words *al-mulk lillah*, "sovereignty belongs to God", and *al-'uzma lillah*, "greatness belongs to God", but the main panels have a *Char Muhammad* or a

Pl. 2.3: Wooden door carved with four rotating names of 'Ali, and the names of the Imams, Imamzadeh Isma'il, Isfahan, 1358–75. Photo: J. W. Allan.

Char 'Ali in the centre, i.e. the name of *Muhammad* or the name of *'Ali* repeated four times, forming a revolving figure. The floral ground around bears the names of the 12 Imams in cursive script.[50] A wooden Koran stand in an almost identical style by Hasan ibn Sulaiman Isfahani, dated to 1360, is in the Metropolitan Museum of Art, New York, and is confusingly attributed to West Turkestan.[51] It is inscribed with the names of the 14 Immaculate Ones, and was apparently made for a Shi'i madrasa, and one can only conclude that the craftsman was an Isfahani and was manufacturing fine wooden fittings and furniture for Shi'i buildings in Isfahan itself.

Intriguingly, the earliest example of a *Char 'Ali* is to be found on a pair of Buyid window shutters, apparently from a funerary structure commissioned by 'Adud al-Dawla in 363/973.[52] Its long popularity as a Shi'i motif is demonstrated by its use in the mid 14th century doors of the Imamzadeh

49 Majeed 2006, p. 168
50 Honarfar 1965, p. 530.
51 Welch 1987, no. 50.
52 Majeed 2006 pp. 97, 241–42, and chapter 2 fig. 5; Ghouchani 1985, p. 4 pl. E.

Isma'il, which we have just mentioned, and its occurrence in the early 16th century in the inlay of the cenotaph of Shah Isma'il Safavi in Ardabil, to which we shall return later.

It is under the Safavids that a much fuller range of Shi'i inscriptions make their appearance, and the Safavid dynasty's devotion to its Shi'i creed is immediately visible in its coins, starting with those issued by Isma'il I and continuing throughout the dynasty.[53] The reverse always carries the Shi'i *shahada* ("There is no god but God, Muhammad is the Prophet of God, and 'Ali is the friend of God"), often together with the names of the 12 Imams. The three coins of Isma'il I (1501–24) illustrated here (Pl. 2.4) bear no mint names, but all have the Shi'i *shahada*, the names of the 12 imams around, and in the case of nos. 1776 and 1778 the *nad-e 'Ali* (prayer to 'Ali) as well. On these it reads:

> Call unto 'Ali, Him that causes wonders to appear
> You shall find him your help in distress
> Every care every sorrow shall vanish
> through your divine trusteeship O 'Ali! O 'Ali! O 'Ali!

On a later Safavid example from the reign of Shah Tahmasp II (Pl. 2.5), the Shi'i *shahada* can be more clearly seen, along with the names of the 12 Imams. Shi'i titles found on Safavid coins include *ghulam-e imam-e mahdi*, "slave of the Mahdi" (i.e. the 12th Imam), *ghulam-e 'Ali ibn Abi Talib*, "slave of 'Ali ibn Abi Talib", *bandeh-ye shah-e vilayat*, "servant of the king of divine trusteeship" (i.e. 'Ali), and *kalb-e astan-e 'Ali*, "dog of the threshold of 'Ali", one of which recurs as we shall see in Deccani coinage. We also find distiches about 'Ali and the family of the Prophet, and about the 7th Imam, 'Ali Reza, whose shrine at Mashhad was of such paramount importance to the Safavids. From the coinage, there is thus no doubting the religious persuasions of the Safavids.

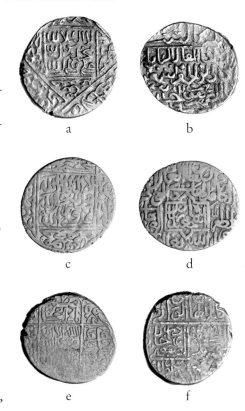

Pl. 2.4: Coins of Shah Isma'il I 907–930/1501–24: a/b gold, undated, no. 1776; c/d silver, undated, no. 1777; e/f silver, dated 929/1523, no. 1778. Photo: Ashmolean Museum, University of Oxford.

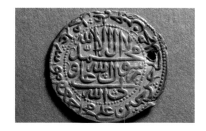

reverse

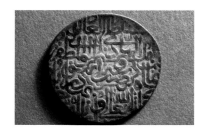

obverse

Pl. 2.5: Silver coin of Shah Tahmasp II, 1135/1722–3.
Ashmolean Museum no. 565. Photo: Ashmolean Museum, University of Oxford.

[53] See Poole 1887, Rabino di Borgomale 1945, Album 2001.

Not surprisingly, the seals of the Safavids echo the same theme. Thus, a seal of Shah Tamasp (Pl. 2.6), now in the Khalili collection, bears the names of Allah, Muhammad and 'Ali, the name of the Shah, *Bandeh-ye Shah-e Velayat Tahmasb* "Servant of the King of Holiness (i.e. servant of 'Ali) Tahmasp", and verses expressing Shi'i devotion:

> When they rolled up the book of our transgressions,
> They took it away to the balance of deeds and weighed it.
> Our sins were greater than any man's, but
> They forgave us for the love of 'Ali.[54]

These verses are also inscribed on the tilework of the west ivan of the Friday Mosque in Isfahan,[55] and on a steel balance in the Tanavoli collection.[56] According to Chardin, the three large seals of Shah Sulaiman also bore the words *Bandeh-ye Shah-e Velayat*, together with the Shah's name, *Sulaiman*, and the date 1080 (1669–70), while the small ones had *din*, "religion", instead of *velayat*.[57]

Turning to the religious architecture of the Safavids, the few extant Iranian monuments dating from Shah Isma'il's reign bear testimony to his Shi'i persuasions. First comes the Harun-e Velayat (Pl. 2.7), a domed shrine built in Isfahan in 1513, under the patronage of the Grand Vizir Durmish Khan.[58] A number of features are worthy of note. First, as already mentioned, this building is a shrine, not a mosque. Secondly, as Babaie points out, the foundation inscription quotes the hadith, *Manzilat-e Harun*, which reads: *anta minni bi-manzilati Harun min Musa 'alayhim salam*, "In relation to me [Muhammad], you ['Ali] occupy the same position as Harun occupied in relation to Musa, upon them be peace".[59] Babaie concludes that this quotation must relate the shrine to the Qur'anic Harun, the Aaron of the Old Testament. In the Old Testament Aaron was the brother of, and spokesman for, Moses. This hadith points to a comparable relationship between the Prophet Muhammad and his cousin and son-in-law, 'Ali. "If Harun of the inscribed hadith were to be understood as a reference to Imam 'Ali," continues Babaie, "it would not be unreasonable

Pl. 2.6: Seal of Shah Tahmasp, rock crystal, 3.1 × 2.4 cm; Khalili Collection, London, TLS 2714. Photo: Khalili Collection.

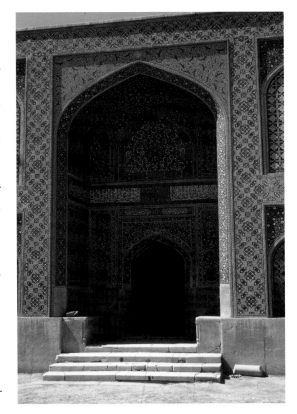

Pl. 2.7: Portal of the shrine of Harun-e Velayat, Isfahan, 1513. Photo: J. W. Allan.

[54] Falk 1985, p. 102 no. 67; Thompson and Canby 2003, pl. 3.19.
[55] Seherr-Toss 1968, pl. 85.
[56] Allan and Gilmour 2000, p. 530 J.1.
[57] Allan 1978, p. 1104.
[58] Hillenbrand 1986, pp. 761–64; Babaie 2004, pp. 33–35.
[59] Honarfar 1965, p. 361, though Honarfar 1965 suggests p. 360 says that Harun was a descendant of 'Ali.

to deduce that the shrine is dedicated to 'Alid devotion, rather than any particular saintly personage".

Babaie also points out the relationship between the different inscriptions on the façade. Above the door, but below the foundation inscription, is a Persian couplet which names the patron and deputy-architect. This gives a triangle with Shah Ismail's name at the apex, and those of Durmish Khan and his architect Husain flanking the base. Above the foundation inscription, another inscription giving the names of the Fourteen Immaculates surrounds the arched tympanum with its peacocks, the peacocks probably symbolising Paradise. Isma'il thus takes the place of an intermediary between the earthly and heavenly realms.

The foundation inscription in the portal of the Harun-e Velayat includes not only Isma'il's titles, but mentions his descent from 'Ali, and entitles his rule a caliphate, presumably to emphasise Isma'il's hostility towards the Ottomans and his aim to replace the Ottoman sultan as head of the Islamic *umma*, or religious community. It also mentions the ever-open door of the Shah's bounty, a punning reference to the door of the shrine and to the saying of the Prophet that 'Ali is the door to knowledge. Indeed, an inscription over

Pl. 2.8: Inscription over east door of the shrine of Harun-e Velayat, Isfahan, 1513. Photo: J. W. Allan.

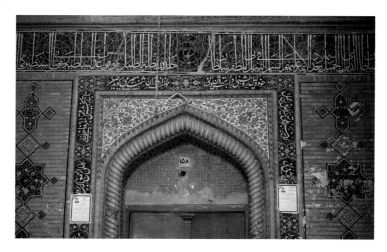

Pl. 2.9: Inscription on the portal of the Masjid-e 'Ali, Isfahan, 1522–23. Photo: J. W. Allan.

the east door of the shrine (Pl. 2.8) includes that very hadith: *ana madinat ul-'ilm wa 'Ali babuhu*, "I am the city of knowledge and 'Ali is its gate". There can therefore be no doubting the strong Shi'i emphasis in this building.

In Isfahan's Masjid-e 'Ali, completed a decade later than the Harun-e Velayat, in 1522–23, the tiled inscription band around the portal (Pl. 2.9) has two lines of text in two different colours on a blue ground. The upper line is a selection of Qur'anic verses referring to Isma'il (the Biblical Ishmael), and the lower line is the foundation inscription, providing the names of both the ruler, Shah Isma'il I, the patron, Mirza Shah Husain, and the calligrapher, Shams al-Din al-Tabrizi[60]. Isma'il is described as the one on whom descends the grace of having his name repeated in the Qur'an as many times as there are Imams. As Hillenbrand puts it:

[60] Honarfar 1965, p. 372.

Since the name of Ismail occurs in the Qur'an twelve times, and since it was the Twelver Shi'i faith that Ismail had instituted as the national creed, this phrasing may be seen not only as intensely topical but also an attempt to elevate Ismail to the rank of Imam at least by implication … In this context the choice of the words for the chronogram at the end of the inscription is surely also significant: "He has come the opener of the gates" …[61]

In other words, it may be deliberately suggesting that Isma'il, who has now come, is indeed 'Ali, the opener of the gates, reincarnated.

As we have already seen, in 1508 Shah Isma'il I had made a pilgrimage to the holy sites of Iraq and initiated work at the shrines of the Imams. It is clear from this that he saw them as key to his architectural propogandist purposes. The loss of them to the Ottomans was therefore a major blow to his ambitions, and explains the radical re-direction of Safavid architectural energy, first under Isma'il's successor, Shah Tahmasp, but more particularly under Shah 'Abbas the Great in the late 16th and early 17th century.

In Tahmasp's reign we find remarkably little evidence of architectural patronage. One of the rare instances of an inscription recording his rule is in the tilework of the qibla (south) ivan in the Isfahan Masjid-e Jame' (Pl. 2.10), which was restored in 1531–32.[62] That on the interior of the ivan refers to Tahmasp as the

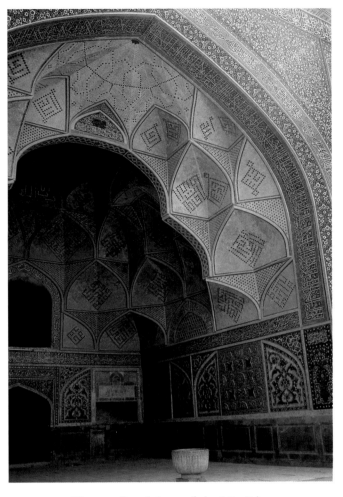

Pl. 2.10: South ivan of the Masjid-e Jame', Isfahan. Photo: J. W. Allan.

commander of the army of al-Mahdi (*sahib al-zaman*), and the inscription around the external façade of the ivan contains in an inner band prayers to the Fourteen Immaculates, and in an outer band the first twenty-one verses of Sura 48, *Surat al-Fath*, "Sura of Victory". This is a Qur'anic chapter which can be linked to Tahmasp's recent victory over the Uzbeks, but it can also be seen to assume messianic overtones prefiguring the arrival of the Mahdi. It seems likely that the work at the Friday Mosque in Isfahan was meant to emphasise the doctrines of Twelver Shi'ism to a Sunni population traditionally hostile to such views.

It is worth mentioning here the apparently surprising lack of new Friday Mosques under the Safavids, prior to that of Shah 'Abbas I in Isfahan. This seems to have been the result of royal uncertainty about their legality. Between 1511 and the 1560's, there was a continuing debate over the issue among Shi'ite scholars, a debate which focussed on the absence of the Mahdi. Some scholars asserted

[61] Hillenbrand 1986, p. 765.
[62] Farhat 2002, pp. 138–40; Babaie 2004, pp. 38–39; Canby 1999, p. 46 points out that verses 7–16 are missing because they were replaced by Shah 'Abbas II with his renovation inscription in 1662.

that in the absence of the Mahdi, Friday prayer was not obligatory, and would be permissible only if conducted by an eligible *mujtahid*, the most learned of Shi'i religious scholars, while others insisted that Friday prayer was obligatory in all circumstances. It was only in the early 17th century that the Safavids finally decided that Friday prayers were obligatory in all circumstances, and began to build Friday Mosques. Hence, religious belief in this case led to omission of buildings rather than to the use of new buildings for propagandist purposes.

On a more positive note, Tahmasp's reign was also important for his gilding of the dome of the shrine in Mashhad,[63] which we have already discussed in Chapter 1. He ordered this to be undertaken after his public act of repentance, and his successful 3rd campaign against the Uzbeks in 1533: the golden dome undoubtedly came to signify the covenant between the Safavid dynasty and the Shi'i Imams.

However, it was Shah 'Abbas I who gave the shrine at Mashhad the overwhelmingly Safavid and Shi'i emphasis which it has continued to hold until today. After the damage done to it by Uzbek looting in 1589, he had the dome of the shrine at Mashhad regilded, a work which was finished in 1607. But much more important, following his pilgrimage to Mashhad in 1612–13, he commissioned new works and the restoration of the buildings within the shrine, and also commissioned two mausoleums outside Mashhad. The list of commissioned works within the shrine given by Iskandar Munshi includes: the enlargement of the court of the shrine (B on the plan), and the building of four gateways around it; the digging of a canal to take water to the middle of the courtyard; and the laying out of the avenue between the east and west gates of the city. In addition, there was no doubt a programme of restoration of other buildings in the shrine, now lost under later Qajar restorations. Amongst 'Abbas's aims was evidently the promotion of Mashhad as a place of pilgrimage and visitation through the provision of beautiful gardens and promenades (*khiyabans*), and an abundant supply of water. Outside the city he commissioned the erection of a mausoleum over tomb of Khwaje Rabi, a companion of the Imam 'Ali, 2 km outside Mashhad, and the building of a shrine to house the footprints of Imam Reza on the road near Nishapur, at Qadamgah.[64] Shah Abbas's building campaign, in May Farhat's words, "marked the point of consolidation of Safavid dynastic power and the triumph of Twelver Shi'ism as its state ideology".[65]

The use of space, the scale of building, and the provision of facilities are not the only instructive elements in Shah 'Abbas's projects at Mashhad. Perhaps surprisingly, inscriptions tell us even more. In particular it is worth looking at the mausoleum of Allahverdi Khan.[66] Allahverdi Khan was Shah 'Abbas's governor of Fars, and then *sardar-e lashkar*, head of the army. He was one of 'Abbas's most important and loyal amirs, and is best known for his famous bridge in Isfahan. The inscriptions which decorate his mausoleum must reflect the beliefs of his sponsor and protector, Shah 'Abbas, and their contents prove extremely interesting.

First of all, the inscriptions contain highly relevant hadiths, which emphasise the Shi'i claims that 'Ali and his descendants were the rightful successors of the Prophet. One inscription, for example, reads[67]:

> Al-Bukhari and Muslim have narrated in their *Sahih* [Book of Traditions] that the Apostle of God stepped out one early morning covered with a figured black cloak. When Husain arrived, he covered him with the cloak, and when Hasan arrived, he covered him and when Fatima arrived, he covered her, and when 'Ali arrived he covered him and then said: "O People of the House, God only desires to put away from you abomination and to cleanse you."

63 Farhat 2002, pp. 123, 143–48.
64 Farhat 2002, pp. 177.
65 Farhat 2002, p. 178.
66 Farhat 2002, pp. 191–97.
67 Farhat 2002, pp. 193.

This latter quotation comes from Sura 33:33, and is frequently used as an authenticating Qur'anic text by the Shi'a. From this hadith comes the phrase used to describe these members of the Prophet's family, "the People of the Cloak".

In another area of the mausoleum comes Sura 33:33 again, followed by two sayings of the Prophet, the first being the hadith of the *safina*, the tradition about Noah's ark[68]: "My family among you is like Noah's ark. He who sails on it will be safe, but he who holds back from it will perish." This is a theme which was taken up by Firdausi at the beginning of the *Shah-nameh*, and is picked out in Safavid manuscripts of the work, in particular in Shah Tahmasp's copy.[69] Following it, in the mausoleum of Allahverdi Khan, is a hadith about the Mahdi, the 12th Imam, who has gone into occultation[70]:

Pl. 2.11: Silver pilgrim tokens of different dates from the Shrine of the Imam Reza, Mashhad. Photo: S.Album collection.

> al-imam Abu'l-Qasim Muhammad b. al-Hasan, *sahib al-zaman*, was born on the night of mid-Sha'ban, in the year 255. The date of his death is known by God, after he fills the earth with justice and fairness, as it was filled with injustice and tyranny.

Again, the very strong emphasis on Shi'i belief is apparent.

There are also some fascinating quotations relating to Mashhad as a holy city and site.

> The Apostle of God said: A part of me will be buried in the land of Khurasan. Paradise will be incumbent upon every believer who visits it, and his body will be saved from fire. The Apostle of God has spoken the truth.[71]

Here we have a straightforward attempt to establish Mashhad as a centre for pilgrimage, not only rivalling Kerbala and Najaf, but even Mecca. Pilgrim tokens from different periods are testimony to the role of Mashhad as a centre of pilgrimage, particularly from the Safavid period onwards (Pl. 2.11).

Another inscription from the tomb of Allahverdi Khan reads:

> On the authority of Imam Abi'l-Hasan al-Rida, There is a place in Khurasan which in time will be frequented by angels. One shift descends from the sky and another goes up until the horn is sounded. He was asked: "O son of the Apostle of God, which place is this?" He said, "It is the land of Tus, and it is a garden among the gardens of Paradise. Who visits me in that place is as if he visited the Apostle of God, and God will grant him merit equivalent to one thousand pilgrimages accepted into the grace of God, and one thousand accepted minor pilgrimages. I and my fathers will be his intercessor on the day of Resurrection."[72]

[68] Farhat 2002, pp. 196.
[69] Welch 1972, p. 85.
[70] Farhat 2002, pp. 196.
[71] Farhat 2002, pp. 193.
[72] Farhat 2002, pp. 195.

Not only do these inscriptions affirm standard Twelver Shi'i belief, but, with the Iraqi shrines and holy places of Islam under Ottoman control, they are clearly designed to exalt the status of Mashhad and the pilgrimage to the shrine there over and above the tombs of other Shi'i Imams, and even Mecca itself.

Friday Mosques, as noted above, were not built by the Safavids until the reign of Shah 'Abbas I, who was responsible for the great Masjid-e Shah (now called the Masjid-e Imam) in Isfahan. This proves to be a treasure-trove of Shi'i inscriptions, and once again the emphasis is on hadiths.[73] At a relatively straight-forward level, the drum of the dome, divided by windows into 8 sections, is decorated with the names of the 14 Immaculate Ones in kufic script.[74] Much more elaborate, however, is the inscription on the Portal (Pl. 2.12), which includes both the Qur'an and hadith, and reads[75]:

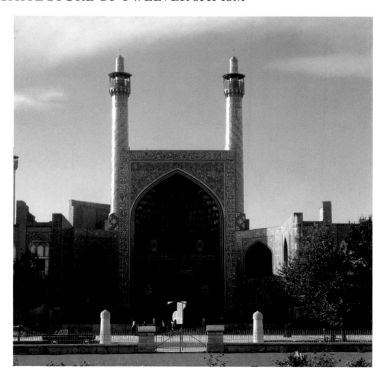

Pl. 2.12: Portal of the Masjid-e Imam (Masjid-e Shah), Isfahan, 1612–1616. Photo: J. W. Allan.

"A place of worship which was founded upon fear of God from the first day is more worthy that thou shouldest stand [to pray] therein, wherein are men who love to purify themselves. Allah loves the purifiers" [Sura 9:108]. From Ibn 'Abbas, he said: "The Prophet of God said, ' 'Ali is my legatee and my deputy, and Fatima his wife, chief of the women of the two worlds, is my daughter, and al-Hasan and al-Husain chiefs of the youth of the people of Paradise, and whoever is a friend of them is a friend of mine, and whoever is hostile to them is hostile to me, whoever comes to them, comes to me, whoever tyrannises them tyrannises me, whoever does good to them does good to me, whoever keeps in contact with them keeps in contact with God, whoever rejects them rejects God, whoever takes care of them assists God, and will forsake those who forsake them. Oh God, whoever of your prophets, and your messengers, has valuables and a people of the house, 'Ali, Fatima, al-Hasan and al-Husain are the people of my house, and my valuables. So take away from them polution and purify them completely.' The Commander of the Faithful, 'Ali ibn Abi Talib, says: 'Whoever goes repeatedly to the mosque will gain one of eight things: a brother from whom one gains benefit from God, a piece of knowledge which is found to be appealling, a solid [Qu'ranic] verse [or divine sign], an expected mercy, a word which turns him back from a bad thing, or he will hear a word which shows him the way to true guidance, or he will abandon a sin out of fear or shame.' The Prophet said, 'I am the city of knowledge and 'Ali is its gate.' "

The portal thus speaks out into the great maydan of the city, and proclaims, for all to see, the Shi'i faith of the Safavids, their devotion to 'Ali, and to the house of the Prophet.

[73] Necipoglu 2007 first drew western scholarly attention to these, though the inscriptions had been published in Honarfar 1965.
[74] Newid 2006, pls. A17–18.
[75] Honarfar 1966, p. 431.

of blocks of stone, examples of which stand in the Masjid-e Shah and Masjid-e Jame' in Isfahan.[84] These follow a tradition established in earlier centuries, exemplified by the great stone basin found in Qandahar dating from 1490,[85] but now two particular types of Shi'i inscription recur. One is in Arabic, in *thulth* script, and gives the names of the 14 Immaculates. The second is in Persian, in *nasta'liq*, and very often mentions Husain. For example, the Persian inscription on the basin in front of the north ivan of the Masjid-e Jame' in Isfahan includes the following words: "For the thirsty this basin was completed. It was donated for the king of the oppressed, Husain ibn 'Ali. Whoever drinks water may curse Ibn Ziyad." Such inscriptions recall the fact that Husain and his followers were prevented from reaching the river to get water to drink before the battle of Kerbala.

Pl. 2.13: Detail of the silver plated doors, Madrase-ye Chahar Bagh, Isfahan, 1708–9. Photo: J. W. Allan.

Mosque doors are also inscribed with Shi'i messages. The silver plated doors of the Madrase-ye Chahar Bagh in Isfahan are particularly appropriate (Pl. 2.13). The main cartouches bear the *hadith* already quoted, "I am the city of learning and 'Ali is its gates", and the framing inscription includes the following:

> Khedive of the Realm of Religion, a dog at the portal of [Imam] 'Ali's shrine,
> A rose-bud in the garden of the City of Learning,
> Abu'l-Muzaffar Shah Husain the Sultan,
> Who has caused the granite of Ignorance to be split by the glass rod of Learning
> A king whose crystalline nature is as pure in colour as the Pearl of Najaf [i.e. 'Ali]
> And whose lineage goes back to the soil under the gate of the City of Learning.
> Thanks to the helmsmanship of that Shadow of God
> The Ship of Learning is safe from dangerous storms.
> The Holy Prophet was City of Learning itself, and 'Ali was its gate
> The Shah is a special slave to the gate of the City of Learning …

Two themes stand out: the idea of 'Ali as the gate of the city of knowledge, which is of course entirely appropriate to the function of a madrasa, and the hadith of the *safina*, reflecting the idea of the safe sailing of the ship of the Prophet's family. And the inscription ends with an *abjad* dating reading "God has opened to Isfahan the gates of the City of Learning", equivalent to the year 1120/1708–9.[86]

We can thus see a number of key features in Safavid patronage of architecture. First, inscriptions, particularly hadiths, are used to emphasise the Shi'i beliefs of the regime. The Safavids had inherited the use of inscriptions to denote Shi'i buildings, but only rarely had hadiths associated with the Prophet been employed to that end. Now, they take over as the main vehicle for promoting the Shi'i beliefs of the patrons of the relevant buildings. Secondly, Isma'il planned to promote the Shi'i shrines of the Imams in Iraq, and began that process. However, the loss of Iraq led to a redirecting of

[84] See Newid 1998. They are also to be found in other buildings e.g. the Imamzadeh Isma'il in Isfahan, Honarfar 1965, p. 539.

[85] Auboyer 1968, no.117.

[86] Allan 1995, p. 132.

religious energies towards the shrine of the Imam Reza at Mashhad, the only shrine of an Imam under Safavid control, in order to focus the country's religious fervour on a national as well as spiritual centre.

Moving on to the Qajar dynasty, we have already dealt with their patron-age of the Iraqi shrines, and the religious pressure under which they ruled. An-other way in which the Qajars sought to by-pass the 'ulema and build religious bridges with their subjects was through encouraging the performance of *ta'ziyehs*, the dramas which take place every year in the month of Muharram, in which the death of Husain at Kerbala is acted out.[87] Lady Sheil, in 1849, recorded an immense *tekiyeh* built for this purpose by the then Prime Minister,[88] but the most famous ex-ample was the Tekiyeh Dawlat (Pl. 2.14).[89] In 1873 Nasir al-Din Shah visited London, where he greatly admired the Royal Albert Hall. On his return he determined to build an equivalent auditorium in Tehran, to be used for *ta'ziyeh*. This was duly con-structed next to the Gulistan Palace. Un-like the Albert Hall, however, it was never roofed, and was only provided with awn-ings, but it held several thousand people. E. G. Browne described how it worked[90]:

Pl. 2.14: Painting of the Tekiyeh Dawlat by Kamal al-Mulk (1852–1940). Gulistan Palace, Tehran.

> There are boxes all around, which are assigned to the more patrician spectators, one, specially large and highly decorated, being reserved for the Shah. The humbler spectators sit around the central space or arena in serried ranks, the women and children in front. A circular stone platform in the centre consti-tutes the stage. There is no curtain and no exit for actors, who, when not wanted, simply stand back.

When the first *tekiyeh* was built to house the Kerbala dramas is uncertain. As early as 1786 an in-scription in a building in Astarabad records a *tekiyeh* hall being used for mourning ceremonies, but the fact that the word *tekiyeh* also refers to a building holding dervish living quarters confuses the issue.[91] However, Francklin's account of the staging of *ta'ziyeh majalis* in Shiraz in 1787 suggests that *ta'ziyeh* as we now know it was being developed in the late 18th century, so buildings or halls dedi-cated to them at this period need not surprise us.[92] Two other travellers, Fraser in 1833 and Holmes in

87 For the most recent series of articles on *ta'ziyeh* see *The Drama Review*, vol. 49, 4, Winter 2005.
88 Aghaie 2004, pp. 22–23.
89 Peterson 1981, pp. 94–97, Figs. 21–23.
90 Browne 1893, pp. 551–52.
91 Peterson 1979, pp. 65–67.
92 Francklin 1790, pp. 240–51.

1844, record being lodged in *tekiyehs* used for the Muharram ceremonies.[93] Indeed, Holmes reports:

> In every mahal of the town, one or more larger buildings, called *takiyehs*, had been prepared at the expense of the inhabitants, or by some rich individual, as an act of devotion for the various performances of the season.

Whether these buildings were sufi *tekiyehs* which also acted as the settings for the Muharram dramas is uncertain, though it seems likely that specifically focussed buildings did indeed develop during the first three decades of the 19th century.

Certainly, by the 1860's they were widespread. For example, in the Caspian provinces, Rasht is recorded as having 36 compared to 22 mosques and 34 madrasas.[94] Tehran had 54 permanent *tekiyehs* in 1852, and 43 in 1899, compared to 121 madrasas or mosques in 1852, and 85 in 1899, showing the importance of the Muharram rituals at this period.[95] The *tekiyeh* now acquired a variety of forms, many resembling private houses, but with regional differences too, and they could also combine a number of different buildings. No complete survey has ever been undertaken, but the variety can be seen in the standing monuments. The most impressive *tekiyeh* still standing is that in the *maidan* (square) of Mir Chaqmaq in Yazd (Pl. 2.15). Built in the late

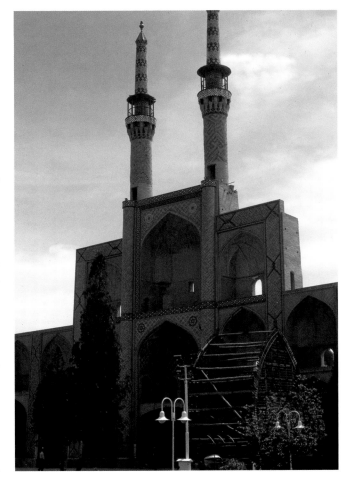

Pl. 2.15: *Tekiyeh* in the *maidan* (square) of Mir Chaqmaq in Yazd, late 19th century. Photo: J. W. Allan.

19th century, it forms a huge portal some 38 m high, and served as seating for distinguished witnesses of the ceremonies held in the *maidan*. Another, somewhat similar, one stands in the maidan in Taft.[96] An interesting and important example is the Tekiyeh Mu'avin al-Mulk in Kirmanshah.[97] This *tekiyeh* consists of three adjoining buildings: a covered *husainiyeh*, dedicated to Husain; a domed *zainabiyeh*, dedicated to Zainab, which also contains the *maqbara* (tomb) of the patron after whom the building is named, Hasan Khan Mu'ini Mu'avin al-Mulk (d. 1949); and an *'abbasiyeh*, in the courtyard of which dramas relating to the death of Abu'l-Fazl 'Abbas, Husain's youngest brother, are held. These three buildings are in fact part of an even larger complex, which includes a *saqqa-khaneh* (public fountain), several shops, and two hammams. It was originally built c. 1885, was damaged at the time of the

[93] Fraser 1838, vol. 2, p. 462; Holmes 1845, p. 326.
[94] Peterson 1979, p. 72.
[95] Aghaie 2004, p. 31.
[96] Godard 1937, fig. 50.
[97] For a discussion of the building and its tilework see Peterson 1981, pp. 107–19, from which much of the following description is taken, and for further images see Newid 2006, pls. B.4, C.6, F.7, G.9, H.7–8, I.3–4, J.8–10, J.17–18, K.1, M.2; Beny and Nasr 1975 pl. 154.

Constitutional Revolution, and then rebuilt on a larger scale c. 1913–20. Smaller versions of *tekiyehs* are to be found around the Yazd area. In Na'in several *tekiyehs* follow the plan traditionally used for the *zur-khaneh* (the traditional Iranian gymnasium)—a building enclosing an octagonal arena with seating alcoves on the platform around. The only requirement of such a building is a space as a stage, and lodgings for visiting participants if the actors are not local.[98]

Although rarely of royal origin, one other characteristically Iranian institution should be mentioned here, the *saqqa-khaneh* or public drinking fountain (Pl. 2.16). This has a role not just in supplying water for passers-by, but also in reminding Shi'is of the struggle of Abu'l-Fazl 'Abbas to get water from the Euphrates at the battle of Kerbala, in the course of which he lost both his hands. Those who drink send prayers and greetings to 'Abbas and Husain, and curse Yazid. Such fountains vary greatly in size—some may be a simple alcove in a wall, but those that are large enough are often decorated with religious paintings, usually of 'Abbas, and guarded with protective latticework. Passers-by often touch it, and hang a padlock or a piece of cloth there, in the same way as at the zarihs (cages or grilles) at shrines.[99]

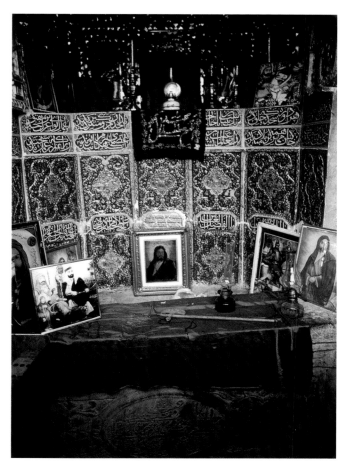

Pl. 2.16: *Saqqa-khaneh* (public drinking fountain), Iran. After Tanavoli 2001, p. 313.

A final comment about the patronage of Shi'i institutions in Iran. The Qajars undoubtedly maintained and enhanced the shrines within their territory, but since the Islamic Revolution the patronage of shrines has greatly expanded. Virtually every imamzadeh has been done up, often completely retiled, with volumes of mirrorwork added to enhance its appearance, all part of a programme to focus the population on the Shi'i message of the Revolution, and to encourage voluntary alms-giving into the national coffers. The author's visits in the 1990's to the Imamzadeh Sultan 'Ali ibn Muhammad Baqir at Ardahal and the Imamzadeh Habib ibn Musa in Kashan, where Shah 'Abbas I is alleged to be buried, immediately come to mind, the former enhanced by retiling and large additions of mirrorwork, the latter by complete destruction and rebuilding.

Let us now turn our attention to Shi'ism and political power further east, in India. In particular let us look at the Shi'i dynasties of the Deccan: the Nizamshahis, the Adilshahis and the Qutbshahis. In Iran from the Safavid period onwards, Shi'i belief was not a problem, because it was the official faith of the nation, and of a very powerful government. But this was not so in the Deccan. Under the earlier Sunni Bahmanid dynasty, in particular during the vizirate of Mahmud Gawam, there had been

[98] Peterson 1979, p. 73; Calmard 2004, p. 517.
[99] Tanavoli 2001, pp. 313–14.

pressure on Shi'a Muslims to practice *taqiya*, or "dissimulation"—the doctrine whereby a Shi'i Muslim may hide his faith and beliefs, if he feels that the declaration of it may endanger his or his family's life, property or honour. In court circles there was a continuing struggle between Iranian immigrant Afaqis, who were often Shi'i, and local Dakhnis, who were usually Sunni. It was often therefore more convenient for those of Shi'i faith to practice *taqiya*, and keep their faith to themselves.

Why the three Deccani dynasties of the Nizamshahis, the Adilshahis and the Qutbshahis should have chosen the Shi'i rather than the Sunni route is by no means clear.[100] Obviously personal belief comes into it, but there may have been political influences as well—from Safavid Iran perhaps, which had so successfully established a Shi'i state, or from a desire to marshal support among the numerous heterodox elements in Deccani society. Perhaps the rulers wanted to champion a belief in 'Ali, the imamate and reverence for the *ahl al-bayt* (the family of the Prophet), to help provide stability and legitimacy. Be that as it may, the heterogeneity of the area proved at times too difficult to maintain, and the Nizamshahis and Adilshahis at different periods of their history vacillated between Sunnism and Shi'ism.

The numismatic evidence emphasises the ambivalence of the times. Not all the Adilshahi rulers managed to maintain their Shi'i faith in the political circumstances of the day, or were indeed Shi'i. For example, the founder of the dynasty, Yusuf, vacillated according to the political pressures at court, while Ibrahim I (1534–1558) removed the names of the Imams from the *khutba*.[101] However, subsequent Adilshahis had no hesitation in including their Shi'i faith on their coins: "Lion of God, the victor, 'Ali ibn Abi Talib" proclaim the coins of Ali Adil Shah (1558–80), while Ibrahim II (1580–1627) calls himself *ghulam-e murtaza 'Ali*, "The servant of 'Ali the chosen one", and Ali II (1656–72) *ghulam-e haidar-e safdar*, "The servant of 'Ali the brave" (Pl. 2.17).[102]

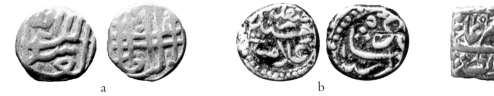

Pl. 2.17: Coins of the Adil Shahs: a) Ali I, the inscriptions read on obverse *Asad Allah al-ghalib* and on reverse *'Ali ibn Abi Talib*; b) Ali II, on obverse *Ghulam-e haidar-e Safdar*, on reverse *'Ali Adil Shah sanah*; c) Ibrahim Adil Shah, on obverse *Ghulam-e murtaza 'Ali*, on reverse *Ibrahim abla bali*. Goron collection.

Under the Nizamshahs, however, the copper coins are silent on the Shi'i front, and the only references to Shi'ism come on the gold pagodas of Murtaza Nizam Shah (1565–88) and Burhan II (1591–1595), where we find the Shi'i *shahada* (i.e. the words of the Sunni *shahada*, but including the phrase *'Ali wali Allah*).[103] In a sense this is explicable, for the Nizamshahs vacillated between the faiths. Their founder, Ahmad Nizam Shah Bahri, was a Sunni. His successor, Burhan (1510–53), was influenced by a Persian exile, Shah Tahir Husain, to promulgate Shi'ism in 1523. In 1553 there was a civil war between his sons, Miran Shah Husain a Shi'i, and Abd al-Qadir a Sunni, supported by Afaqis (Persian immigrants) and Dakhanis respectively. These divisions were suppressed by the next ruler, Murtaza (1565–88), and once again the dynasty became Shi'i.

[100] For a summary see Cole 2002, pp. 22–30.
[101] Nayeem 2005, pp. 82–84.
[102] Goron and Goenka 2001, pp. 312–18.
[103] Goron and Goenka 2001, pp. 323–27.

Pl. 2.18: Damri Mosque, Ahmednagar,
India, 1568. Photo: J. W. Allan.

Pl. 2.19: Inscriptions on the mihrab
of the Damri Mosque, Ahmednagar,
India, 1568. Photo: J. W. Allan.

More surprising is the fact that, with the possible exception of a single gold fanam, the Qutbshahis never refer to the Shi'i faith on any of their coins.[104] Yet the Qutbshahis were the most uniformly Shi'i of all the three Deccani dynasties.

When we turn to the architecture associated with the Shi'i dynasties of the Deccan, we find that some Deccani religious architecture makes no obvious claim to be Shi'i. Take, for example, the largest mosque in Hyderabad, the Mecca Masjid, begun in 1614 by Muhammad Qutb Shah.[105] Despite being a grandiose building, some 74 m long and 59 m deep, it is virtually devoid of decoration, and certainly contains no inscription to highlight the Shi'i faith of its founder, or of the Qutbshahi dynasty.

Where Deccani religious buildings do indicate the sect of the founder, however, they do so through inscriptions. Thus numerous mosques and mausolea in Golconda and Hyderabad have inscriptions which include the Shi'i *shahada* ("There is no god but God, Muhammad is the Prophet of God, 'Ali is the *wali* (friend) of God"), and/or the *nad-e 'Ali* (prayer to 'Ali).[106] Other examples have a variety of other Shi'i inscriptions. For example, in the Jami Masjid in Hyderabad (1597) we find, "Oh God, until the advent of Sahabul Amir [the Mahdi], may this place of prostration survive like the Kaaba".[107] In the mosque of Miyan Mishk we find the names of the twelve Imams in a circle, and, referring to

[104] Goron and Goenka 2001, pp. 332ff.
[105] Bilgrami 1927, no. 12, pp. 36–42.
[106] Bilgrami 1927, throughout.
[107] Bilgrami 1927, p. 30.

the patron of the building, the words, "The Deccan is by divine grace the abode of love, Qutb Abul-Hasan is by soul the lover of 'Ali".[108]

Sometimes, the Shi'i identity of the building is provided by the words "O Ali" alongside "O God" and "O Muhammad". These supplications are sometimes, but not always, above or near the mihrab. Examples may be found in the Nizamshahi Damri Mosque at Ahmednagar (1568) (Pl. 2.18), and in the Qutbshahi Hosaini Mosque (1636) and mosque of Rahim Khan (1643) in Hyderabad.[109] In the Damri mosque the invocations are carved beside the mihrab (Pl. 2.19), and set

Pl. 2.20: Calligraphic roundel above the mihrab of the Nau Gumbaz Mosque, Bijapur, India, 1620's. Photo: J. W. Allan.

the Shi'i tone of the building. However, the inscription above the mihrab has been removed. This is a relatively common occurrence in the Deccan, which seems to be due to later Sunni occupants of the building. Another example of this phenomenon is the Kali Masjid in Aurangabad, a Nizamshahi building dating from 1600: the mosque has been given a Sunni identity by the removal of the original inscription above the mihrab and its replacement by the orthodox *shahada*; the names of the orthodox caliphs have been painted on the walls.

As we have seen, Shi'is can also use a very limited selection of Qur'anic verses to proclaim their faith, reinterpreting them according to their beliefs. The study of Fatimid inscriptions has led to the identification of such verses in the Isma'ili context, but the equivalent research remains to be undertaken for the Deccan, as indeed for Iran. However, the most quoted example, "People of the House, God only desires to put away from you abomination and to cleanse you" (Sura 33:33), does not seem to occur in the published inscriptions of the Deccan. On the other hand, a fascinating Qur'anic quotation is to be found in the Nau Gumbaz in Bijapur, a mosque which probably dates from the 1620's.[110] Above its mihrab is a superb calligraphic roundel (Pl. 2.20) containing the Qur'anic phrase *nasr min allah wa fath qarib*, "victory from God and swift conquest" (Sura 61:13). This Qur'anic verse is of course used in Sunni inscriptions, so the question arises as to whether it has special Shi'i significance. First of all, it should be pointed out that it is found in the most important place, over the central niche, in the Baadshahi Ashur Khaneh (1593–1596), alongside the name of the patron, Muhammad Qutb Shah, and his title *Ghulam 'Ali*, "slave of 'Ali".[111] As the royal ashur khaneh, and the focus of

[108] Bilgrami 1927, p. 81.
[109] Bilgrami 1927, pp. 53 and 54 n. 1.
[110] Cousens 1916, pp. 88–89 and pls. LXXI and LXXIII. Cousens translates its names as "Mosque of the Nine Domes" but it only has six. The paint in the picture in the present work is a later addition, but does in some way serve to bring out the calligraphic designs.
[111] Bilgrami 1927, p. 21.

the Qutbshahi dynasty's Muharram mourning rituals and processions, this is the most important Shi'i building in Hyderabad, and the positioning of this inscription cannot be accidental. We must therefore consider its possible religious or political meaning.

The primary Sunni interpretation of the verse is that it refers to the Prophet's impending victory over the Quraish, and it was also used as one of the proofs of the validity of *jihad* (holy war), and developed a role as some sort of battle cry, hence presumably its appearance on flags in miniature painting.[112] However, the early Imami *mufassir* (Qur'anic exegesist), 'Ali b. Ibrahim al-Qummi (d. around 919), while recognizing that some thought it referred to the conquest of Mecca by the Prophet (i.e. God promising the Prophet a speedy victory over the Quraish), interpreted it as meaning that help will come from Allah in this world through the victory of the Qa'im (i.e. the 12th Imam's return—"when he will fill the earth with justice just as it is now filled with oppression and darkness" as the hadith describes it).[113] This interpretation was followed by subsequent Shi'i *mufassirs*, who quote it almost exactly.[114] Today, it is believed that these words were inscribed on Husain's banner at the battle of Kerbala.[115]

This is important, since we find this verse on a number of other buildings in the Deccan. For example, in Bijapur, an unnamed building known as "mosque no. 213" after its Archaeological Survey number appears to be heavily decorated with the verse. Rehatsek records two large circular inscriptions taken from the mosque bearing this verse apparently in a style almost identical to that in the Nau Gumbaz.[116] In Hyderabad, in the Mosque of Rahim Khan (1643) it is included in the inscription running along the entire façade of mosque, an inscription which also includes the Shi'i *shahada*.[117] In Hyderabad's Kali Masjid (1702) it is used twice on the polished black basalt prayer niche.[118] In Golconda's cemetery (1666) it is placed in the medallions which decorate the façade of the Great Mosque.[119]

That being the case, the use of this Qur'anic verse may need some reassessment in the literature. As a first example, Maddison and Savage-Smith, in their Khalili collection volume, include an extremely useful table of Qur'anic verses occurring on magical artefacts.[120] Sura 61:13 appears on two 'Sunni' objects, but the authors point out that: "Items listed under Sunni are those with no overtly Shi'i or 'Alid prayers or invocations". In fact, of these two items, the bowl no. 38 could well be Deccani, while the bazuband no. 101 is most likely to be Qajar, so both are probably Shi'i. The verse also appears on six objects listed as Shi'i, three magical-medicinal bowls, a talismanic shirt, a stamp in the form of a hand, and a further (unidentified) object.

A second example concerns the Sarbadarid dynasty, which held power in Khurasan between 1336 and 1381. Smith, in his monograph, discusses in some detail the essentially incompatible duality within the Sarbadarid state, described by the 15th century historian Hafiz-e Abru.[121] He notes how they were above all politicians—rebels, yet maintaining a position within the Il-Khanid system, officially Sunni, yet co-operating with Shi'i dervishes, who followed an extreme Mahdist ideology. Their coin issues of 759/1358 and subsequent years include the names and epithets of the twelve Imams,

[112] E.g. Dickson and Welch 1981 vol. 2, no. 186.

[113] 'Ali b. Ibrahim al-Qummi, *Tafsir al-Qummi*, vol. 2, p. 366. I am grateful to Robert Gleave for all the information about the Shi'i interpretation of this verse.

[114] See e.g. Muhsin Fayd al-Kashani, the Safavid polymath, in his *Tafsir al-Safi*, vol. 7, p. 184. This reference is also thanks to Robert Gleave.

[115] Chelkowski and Dabashi 2000, p. 116; hence no doubt its appearance on flags on Iranian stamps representing the war with Iraq, idem pls. 13.16 and 13.19. See below Pl. 3.31.

[116] In Cousens 1890, p. 99. Another such circle has Sura 7:54 and a smaller one the name of God and some of his epithets.

[117] Bilgrami 1927, p. 53.

[118] Bilgrami 1927, p. 96.

[119] Bilgrami 1927, p. 167.

[120] Maddison and Savage-Smith 1997, Part 1, pp. 61–62.

[121] Smith 1970. For 1359–60 coin issue see p. 64, for a summary of his views see p. 89.

and one particular issue of 759/ 1358 is in the name of Muhammad al-Mahdi. However, Smith makes no comment on the coin issue of 1349–50, which has on its obverse the names of the four caliphs, and on its reverse Sura 61:13, asserting in his discussion that the Sarbadarids in their earlier phase were Sunni. Of course the Qur'anic quotation is common on Sunni coins so he may well be right, but, given the Shi'i Mahdist interpretation of the verse concerned, this issue could point to the duality of the dynasty during its earlier as well as its later phase.

Shi'i inscriptions also appear in Deccani dargahs, sufi shrines, such as that of Hazrat Gesu Daraz at Gulbarga (Pl. 2.21). Built after the death of the saint in 1422, during the Bahmanid period, it was redecorated in Adilshahi times. Its doorway bears two designs typical of the period—the roundel supported on an elephant trunk bracket, in the left spandrel, and the pendant in the blind arch above the door. I shall return to the pendant design, but here we should notice the inscription written around it (Pl. 2.22), which includes the names of the Panjetan—the Prophet, 'Ali, Fatima, Hasan and Husain.

Inside dynastic mausolea, such inscriptions are usually written on the cenotaph. The mausoleum of the Qutbshahi Sultan, Muhammad Quli, who died in 1602, is typical of the mausolea built by the Qutbshahi sultans in their dynastic cemetery in Golconda.[122] Along with Qur'anic inscriptions, the cenotaph in the tomb is inscribed with an invocation to the 12 Imams (Pl. 2.23). This reads as follows:

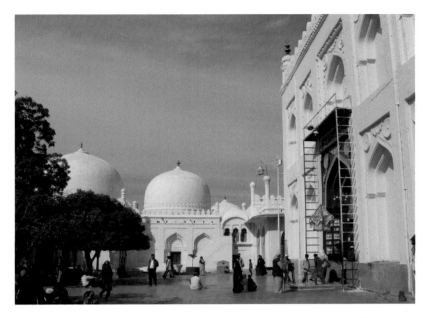

Pl. 2.21: Buildings in the dargah (sufi shrine) of Hazrat Gesu Daraz, Gulbarga, India, 15th century and later. Photo: J. W. Allan.

Pl. 2.22: 16th century inscriptions above the door of the mausoleum of Hazrat Gesu Daraz, Gulbarga, India. Photo: J. W. Allan.

[122] Bilgrami 1927, pp. 129–30.

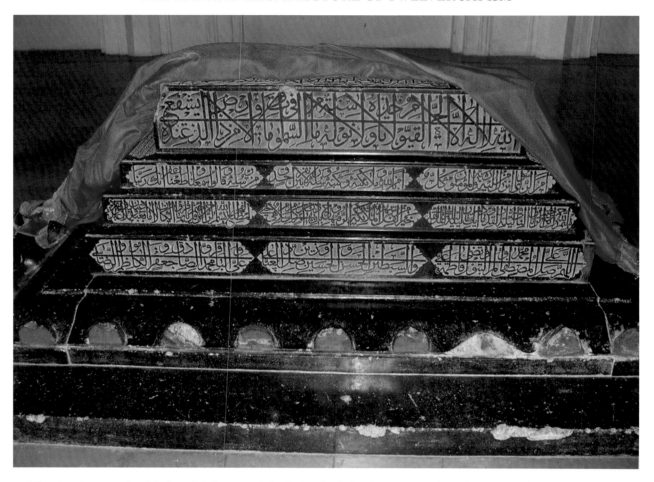

Pl. 2.23: Cenotaph of Sultan Muhammed Quli Qutb Shah (d. 1602), Golconda, India. Photo: J. W. Allan.

> O God, bless Muhammad al-Mustapha, ‘Ali al-Murtaza, Fatima al-Batul, the two offsprings Hasan and Husain, and bless ‘Ali Zain al-‘Abidin, Muhammad al-Baqi, Ja‘far al-Sadiq, Musa al-Kazim, ‘Ali al-Reza, Muhammad al-Taqi, ‘Ali al-Naqi, Hasan ‘Askari al-Zaki, and bless the standing proof of God, the worthy son, the noble leader, the expected, the victorious, Muhammad Mahdi, the lord of the time, the vice-regent of God, the manifestation of the faith, the lord of mankind and genii, may God's blessing and peace be upon him and upon them all.

The same inscription is found on the earlier tomb of Sultan Quli Qutb Shah (1543),[123] while the cenotaph in the tomb of Sultan Ibrahim Qutb Shah (1580) nearby has an inscription which includes the *nad-e ‘Ali*: "Call upon ‘Ali that causes wonders to appear: thou shalt find him thy help in distress. Every care, every grief shall be dispelled through thy trusteeship. Oh ‘Ali! Oh ‘Ali! Oh ‘Ali!"[124]

Occasionally the Shi‘i phrases are more difficult to find, or less easy to read. For example, in the same cemetery, on the mosque next to the tomb of Hayat Bakshi Begum, wife of Muhammad Qutb Shah, who died in 1667, are roundels in the spandrels of the arches which bear names of Shi‘i Imams. They are almost impossible to read from the ground, but fortunately one is shown in the museum of the Golconda royal acropolis, and bears the names of the Prophet, ‘Ali, Fatima and other Imams.

[123] Bilgrami 1927, p. 113.
[124] Bilgrami 1927, pp. 123–24.

Occasionally too Shi'i inscriptions appear in secular architecture: for example, on the Makka Darwaza (Mecca Gate), which is one of the gateways of the magnificent fort at Golconda. Here we find a neat comparison between the gate of the fort and 'Ali as the gate:

> In the name of God, who made the word of his unity an impregnable fort, the gates of which have been opened to us through his mercy, and whoever entereth therein shall be safe; and blessings be upon Mustafa [i.e. the Prophet], in whose person the forts and defences of prophecy have been completed and he is the town of learning and 'Ali is the gate of the town, and upon his descendants through whom the towers of vice-regency and religious leadership have arisen, and upon his friends the custodians of qualities and truth and integrity ...[125]

On the fort's western wall is to be found an inscription which reads: *la fata ila 'Ali la saif ila Dhu'l-Faqar*, "There is no soldier like 'Ali and no sword like Zulfaqar", another well-known Shi'i saying.[126]

Shi'i inscriptions are also found on the fortifications at Bijapur. On a bastion inside the south gateway is the Shi'i *shahada*, on the Ark Qal'a gateway is the *nad-e 'Ali*, and on a tower behind the Chini Mahal is the inscription noted above, "There is no soldier like 'Ali and no sword like Zulfaqar",[127] while an inscription of 1658–59 on the Sharza Burj includes the following description of Ali II Adil Shah: "He who, by his love for the Murtaza [i.e. the Imam 'Ali], possesses evident victory".[128] Shi'i phrases also occur in Adilshahi inscriptions associated with provision of water for their subjects. Thus on a stone in the Gumat Baori in Bijapur we read:

> The water of this baori is a *waqf*. Whoever prohibits or causes obstruction (in its use) may he not be blessed with the sight of God and his Prophet, and (may he) have no share in the intercession of the Prophet of God, upon whom be the blessing of God, and of the well-guided Imams ...[129]

Perhaps the most emphatically Shi'i building of Bijapur, if its inscriptions are to be taken as evidence, is a partially surviving pavilion near the Arsh Mahal, known as the Pani Mahal, which appears to be dated to 1669. Here are some of the texts recorded on what remains of the building. "Fatima was the light of the fountain of religion"; "Mahdi was the guide to the benefits of purity"; "Ali Naqi our guide is light"; "He by whom religion obtained affection, and light brilliancy, Shah of Kerbala and prince of religion, Husain. (He) was the light of the eye to the Prophet and to the *wali* (i.e. the Imam 'Ali). 'Ali the son of Husain is an Imam likewise"; "From Ja'far Sadiq who knows subtleties, all science has departed to a place not manifest"; and "Amir of the brave, Hasan 'Askari". Moreover, one further inscription may be read, "These verses were composed by his majesty 'Ali 'Adil Shah Ghazi", suggesting a very personal role for the sovereign, and that these verses illustrate his own personal beliefs.[130]

In some Deccani buildings, however, the Shi'i attribution would be difficult to substantiate if we did not know about it from historical texts. Take, for example, the Gol Gumbaz in Bijapur, which is the mausoleum of Muhammad Adil Shah, completed in 1659, the size of whose dome competes with that of St. Peter's in Rome. Here the only religious names in the building seem to be those of God and Muhammad, and they are only in the eaves: there is no sign of any of the Shi'i Imams.[131] It is known from the texts, however, that Muhammad Adil Shah's grave beneath the dome is set in earth brought from Kerbala.

[125] Bilgrami 1927, pp. 120–22.
[126] Bilgrami 1927, pp. 133–34.
[127] Nazim 1936, pp. 47–49.
[128] Nazim 1936, p. 55.
[129] Nazim 1936, p. 65.
[130] Cousens 1890, pp. 92–93.
[131] Cousens 1916, pl. XCI. (The poor calligraphy is probably due to the fact that these eaves were renovated in the British period.)

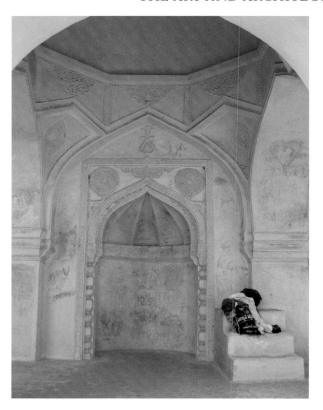
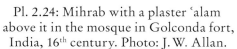

Pl. 2.24: Mihrab with a plaster 'alam
above it in the mosque in Golconda fort,
India, 16th century. Photo: J. W. Allan.

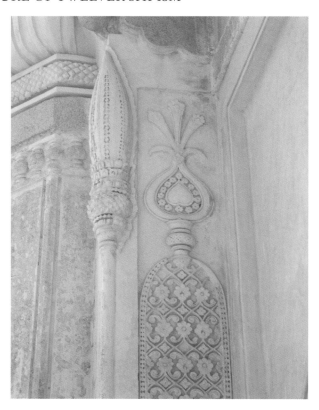

Pl. 2.25: Plaster 'alam in the mosque in Golconda
fort, India, 16th century. Photo: J. W. Allan.

We have concentrated largely on inscriptions to identify Shi'i element in the architecture of the Deccan, but there is another possible route, through symbols. The most obvious of these is the 'alam, the standard which is paraded through the streets of Shi'i towns in India and Iran in the Muharram processions. I shall deal with 'alams in more detail in Chapter 4. Here, however, we should notice that the Qutbshahis used this device on their architecture, for example on the outside and above the mihrab of the mosque high up on Golconda fort, and in the mosque at its foot (Pls. 2.24–25). So too on the inside of the Char Minar (Pl. 2.26), built in 1592 as a major feature of the newly founded city of Hyderabad. 56 m high, the upper levels were used as a madrasa and mosque, from where royal proc-lamations were read out to the assembled public. All the more important must have been the 'alam symbols used above the arches. It also appears in the mihrab of the Nizamshahi Damri Mosque in Ahmednagar (1568). Given the importance of the 'alam in Shi'i devotion, often relating to relics, and in Muharram processions, and indeed the fact that buildings (ashur khanehs) were specially built to house them, as we shall see below, their religious symbolism need not be doubted.

This raises a very interesting point about another symbol, commonly found in the Adilshahi ar-chitecture of Bijapur, the medallion-and-chain. This decorative design is widespread in Bijapur, and is to be found, for example, in the plaster tracery of Ain al-Mulk's tomb (c. 1556), on the vault of the Ali Shahid Pir Masjid (c. 1560–80), both on the interior and exterior of the Jalamandir (c. 1580–1630), under the eave of Malika Jahan Begum's mosque (c. 1586), in the mihrab, in the neck of the dome and flanking the entrance in the Anda Masjid (1608), in the mihrab of the Mihtar-e Mahal mosque (c. 1620), under the cornice of the Gol Gumbaz, completed in 1653, on a basalt tombstone of un-

Pl. 2.26: 'Alams in plaster inside the Char Minar, Hyderabad, 1592. Photo: J. Fritz.

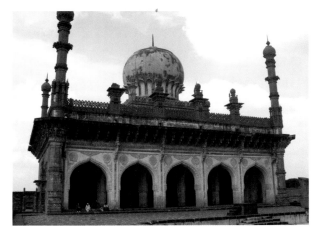

Pl. 2.27: Mosque of the Ibrahim Rawza, Bijapur, c. 1625–28. Photo: J. W. Allan.

Pl. 2.28: Pendant stone chain and medallion, Mosque of the Ibrahim Rawza, Bijapur, c. 1625–28. Photo: J. W. Allan.

known origin (c. 1620–30), and on the mihrab of the Makka Masjid (1669).[132] It also occurs in three-dimensional form at the Ibrahim Rawza, built as the mausoleum of Ibrahim II's queen, Taj Sultana, and probably completed by the king's death in 1037/1627–28. There we find that the mosque (Pls. 2.27–28) is decorated under the eaves with both carved pendants and three-dimensional hanging medallions-and-chains.[133] Three-dimensional medallions-and-chains are also found on a tomb at Rauza, near Dawlatabad (Aurangabad area), and further south from Bijapur on the Kali Masjid in Lakshmeswar.[134] In the latter example the chains around the minaret seem to have lotus bud ends, whereas those hanging from the eaves have medallions.

[132] Cousens 1916, Fig. 12, pls. XXVII, XXIX, XXXI, XXXVII, XL, XLIX, LVII–LVIII, XCI, XCIX, CII. The design also occurs in the carpets of the Jami Masjid (Cousens 1916, pl. XXIV) but the date of these is uncertain.

[133] Cousens 1916, pl. XLIX.

[134] Cousens 1916, Figs. 16–17, pl. XLI.

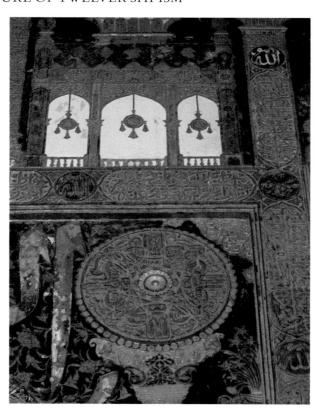

Pl. 2.29: Chain and medallion motif in
the mihrab of the Jami Masjid, Bijapur,
India, 1636. Photo: J. W. Allan.

Pl. 2.30: Roundel and tassel motifs in
the mihrab of the Jami Masjid, Bijapur,
India, 1636. Photo: J. W. Allan.

The most striking use of chain-and-medallion designs, however, is to be seen on the vast, painted mihrab of the Jami Masjid in Bijapur (Pl. 2.29). The Jami Masjid was begun by Ali I in 1576, but the mihrab dates from 1636, and the reign of Muhammad Adil Shah. On the mihrab there are two main forms of chain-and-medallion. One form utilises a variety of pointed oval medallions; the other has a round disk, from which three tassels seem to hang (Pl. 2.30).[135] The inscriptions on the mihrab lack any Shi'i emphasis, but 'alams are depicted on it, and the domed edicules on either side and at the top are of a form which is closely comparable to the tabuts or taziyas carried in Muharram processions in Shi'i India (see below p.). The pendant may therefore have been a symbol of the Shi'i beliefs of the Adilshahis, as the 'alam was of the Qutbshahis. On the other hand, Mark Brand[136] has suggested that the hadith inscribed on the mihrab, and the rest of the mihrab's iconography, may point to the Adilshah's use of the cult of the Prophet as a way of holding together the Sunni and Shi'i groups within the court. The cult of the Prophet in Bijapur would have focussed on the two hairs of the Prophet's beard, for which, he suggests, the Jalamandir was originally built, though they were later moved to the Ashar Mahall.

The pendant is also found in Nizamshahi architectural decoration, where, however, it has a slightly different form. For example, on the tomb of Ahmad Bahri Nizam Shah (1509) it is to be seen on the façade within deeply lobed blind arches, and has the form of a central bud between two widely

[135] Cousens 1916, pl. I.
[136] In a paper given at the conference on Deccani art, held in Oxford in 2008.

extended leaves.[137] On the façade of the Damri mosque (1568) its body is elongated, rather like a large insect, and it gives the impression of having eight "legs". As Nizamshahi architecture has been even less studied than that of the Adilshahis, it is even more difficult to assess its original purpose in such buildings.

A comparable motif, but much earlier, is found further west in the Islamic world, in Mosul.[138] This motif occurs five times, on each of the five flat sides of a mihrab niche. It is carved in stone, and stands out in high relief. It is approximately in the form of a figure of eight, the upper part a knotted rhomb, and the lower part more heart-shaped, with a vegetal form somewhat akin to a mosque lamp. It appears to date from the 12th or 13th century, but its significance has never been seriously discussed.

Hairs from the Prophet's beard have already been mentioned, and it is perhaps appropriate here to bring in the subject of relics. Relics are not commonly associated with Islam. Since Islam focuses on worship of the one God alone, worship of any person or thing created by God is particularly inappropriate. Yet relics existed and exist both in Sunni and Shi'i Islam. The most famous group in the Sunni world are the swords and other items associated with the Prophet kept in the Topkapi Palace treasury in Istanbul,[139] though there are others associated with the Prophet in India, and Qadam Rasuls (buildings housing footprints of the Prophet) are relatively widespread in the sub-continent.[140] No group of relics equivalent to that in Topkapi remains in the Shi'i context, but there are a number of records of Shi'i relics, especially in India, and individual relics still survive. What is clear is that, especially in the Indian subcontinent, relics had a key role in legitimising a ruler or dynasty.

In Iran, there is an unexpected record of relics associated with the Masjid-e Shah in Isfahan. According to Chardin, a cupboard in the mihrab of the mosque contained a Qur'an copied by the Imam Reza, and the blood-stained shirt of Husain.[141] Both had talismanic significance and were taken out only in case of invasion. There is also evidence of a relic in Ardabil. In the 1647 edition of his book Olearius includes an engraving of a firework display at the Shrine of Shaikh Safi in Ardabil. This shows what must be the "standard of Shah Isma'il" on a tall pole held by a courtier. Olearius discusses its origin:

> it is reported [that it] was made by the daughter of Fatima, who caus'd the iron work to be made of a horse-shoe, which had belonged to one of the horses of 'Abbas, Uncle to Mahomet by the Father side, which Schich Sedredin, the son of Schich-Sefi, had brought from Medina to Ardabil.[142]

This is important, for it makes clear that by the mid 17th century relics from the battle of Kerbala had been set into 'alams in Iran. Indeed, assuming Olearius is correct, this relic was already in Ardabil by the mid 14th century. Another relic in Iran is the footprint of the Imam Reza, which is housed in the Safavid Qadamgah near Nishapur: others are said to exist in Iran but no work seems to have been done on this subject.[143]

In India, on the other hand, relics and buildings designed to house relics are relatively common. In the Qutbshahi period several pilgrims brought relics from Kerbala which were incorporated into

[137] Michell and Zebrowski 1999, fig. 50.

[138] Sarre and Herzfeld 1911–20, vol. 2, Abb. 268; Janabi 1983, pls. 166–68.

[139] Öz 1953.

[140] The most famous are the Tughluqid shrine in Delhi (Welch 1997), and the qadamrasul in Ghaur in Bengal, (Asher 1984, pp. 80–81). More generally see Burton-Page 1978.

[141] Necipoglu 2007, p. 72.

[142] Morton 1975, pl. Ic.

[143] Mechkati n.d., pp. 104–5; Golombek and Wilber 1988, vol. 1, p. 52; Farhat 2002 pp. 217–18; for Qadamgah see Adamec 1976–81, vol. 2, p. 550, and for a cave called Qadamgah Ilias, north of Kirmanshah, see Adamec 1976–81 vol. 1, p. 507. A qadamgah was evidently built at Kashan in the early 14th century, see below p. 81.

'alams, and ashur khanehs were built to display them. The earliest was the *na'l-e mubarak* ("the blessed horseshoe'), which was obtained by Ibrahim Qutb Shah (1550–80). This consisted of a piece of iron in the shape of a horse-shoe which had been used as a nasal, and was said to have belonged to Husain's helmet. In the reign of Yusuf Adil Shah (1490–1510) it was brought to Bijapur by a pilgrim from Kerbala. Ibrahim Qutb Shah then acquired it, together with a certificate authenticating it: he made it into the shape of the name of God (Allah), and kept it in Golconda. His successor, Muhammad Quli (1580–1612), put it in the royal palace area known as the Ilahi Mahal in Hyderabad. The *na'l-e mubarak* procession became part of the Muharram rituals. From Medina another pilgrim brought a sword ascribed to Ja'far al-Sadiq. Muhammad Quli gave it a royal reception, and the pilgrim constructed an 'alam and affixed the sword to it. This was known as the Husaini 'alam, and the Sultan built an ashur khaneh for it. During Muhammad Quli's reign a pilgrim brought two other relics from Kerbala—a piece of 'Abbas's armour and the head of Qasim's spear. He claimed that Husain had appeared to him in a vision and had told him where the relics were buried. The pilgrim made them into 'alam crests. The first was called the 'alam-i Abu'l-Fazli'l 'Abbas, and the other the hazrat Qasim's

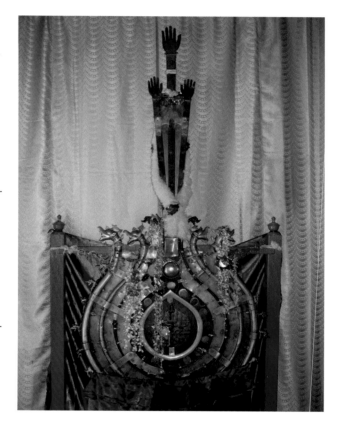

'alam. Another Hyderabad relic is the Bibi Ka 'alam, Fatima Zahra's 'alam. It is made from a piece of the wooden plank on which 'Ali is said to have washed his wife Fatima, prior to her burial. Initially the wood was cut into a tughra reading Allah, Muhammad and 'Ali, then it was set in a gold-plated 'alam. It was housed in an ashur khaneh outside the Dabipur quarter.[144]

The importance of the trade in relics and 'alams comes to light in correspondence in the 1660's between the Nawab of Golconda and son-in-law of Abdullah Qutb Shah, Mirza Nizam ud-Din Ahmad, and Uttaqi Efendi, Shaikh al-Haram in Mecca.[145] The Nawab's letter cites an earlier letter from the Shaikh in which he had mentioned sending *tabarruk-e 'alamha-ye fath o zafr*, presumably sacred relics in some sort of victory 'alams. Abdullah Qutb Shah had been delighted to hear this and was eager to receive the two 'alams and keep them in the royal treasury for good omen. However, the boat bringing the *tabarruk*, the sacred relics, had been caught in a storm, strayed off its course, and nothing more had been heard of it.

Another relic is the so-called *sartooq* (lit. "standard-head") in the Darush-Shifa in Hyderabad (Pl. 2.31). A firman of Abdullah Qutb Shah includes the following information:

Pl. 2.31: '*alam-i sar-tawq mubarak*, Daru'sh-Shifa, Hyderabad, India, mid 17th century. Photo: J.W. Allan.

[144] All this information comes from Rizvi 1986, vol. 2, pp. 347–48. In vol. 1, p. 307 he gives the inscription on the Husaini 'alam: "and a speedy victory: so give the Glad Tidings to the Believers", with the name of the ruler, Ghulam-i 'Ali, Muhammad Quli Qutb Shah, and the date 1001 Hijri (1592–93).

[145] Islam 1979–1982, vol. 2, pp. 176–77.

Haji Agha Muhsin Khurasani came from Syria along with the certified document to confirm that the piece of iron with him was a part of that fetter in which Imam Zain-ul-Abideen was imprisoned. Abdullah Qutb Shahi inspected the document and then issued the *Firman* that the piece should be preserved in an *'alam* raised in the large building of *Darul Shifa*, so that the sick could recover their health with the blessing of the Imam. He assigned a *hon* a day towards the expenditure of *ud* (aloes-wood) and *gul* (flowers) to the Mutawalli (superintendent).[146]

The fact that the fetter had belonged to Zayn al-'Abidin, who was too sick to take part in the battle of Kerbala, and therefore spared by the Umayyads, was no doubt significant in its miracle-working claims. When Awrangzib conquered Golconda, he closed all the ashur khanehs, with the exception of those containing miracle-working 'alams or relics. One Mirza Hashmat 'Ali Beg told the Emperor about this relic, and the Emperor then assigned it to his care, and issued a firman in 1699 that two *huns* should be paid daily to the Mirza out of the hospital budget to meet his expenditure on aloes-wood and flowers for the relic.[147] The 'alam is known in full as the *'alam-e sar-tawq mubarak*, and it is now kept in a two-room ashur khaneh built by Asaf Jah VII in 1938–39 to the south of the Daru'sh-Shifa.[148]

A fascinating firman from Awrangzib concerns another relic, part of Fatima's head-scarf or *chador*. The firman shows that Timur brought to India a piece of the head-scarf belonging to Imam Husain's mother, Fatima, which he had obtained from the grave of Hurr ibn Riyahi. This later passed into the possession of the Nizams in the Deccan, and Awrangzib's firman and the relic were preserved by the last Nizam, Mir 'Usman 'Ali-Khan, Asaf Jah VII (1911–47), in an ashur khaneh he had built. The translation reads:

> This great blessing comprises a piece from the head-covering of Fatima Zahra. Imam Husain gave it to Hurr ibn Riyahi on the battle-field of Karbala. Amir Timur, Lord of the Happy Conjunction, took it from Hurr's grave with the Imam's permission (through some miraculous inspiration) and the (local) Sayyid's consent. He (Timur) brought this relic to India. The Sayyids and their descendants, who are responsible for its care, deserve the revenues from Kalawra village for its maintenance. When the Emperor Jahangir (now seated in paradise), ascended the throne, he, like his ancestors, was fortunate to be able to pay his respects to it. He enhanced the *madad-i ma'ash* grant for its keeper.
>
> We (Awrangzib) obtained *fatwas* from Qaziu'l-Mulk Mulla Ahmad and from the *'ulema'* and *muftis* in other towns regarding the relic. They wrote that the *Tabut-i Sakina*[149] was the legacy of the progeny of Moses and Aaron. The Qur'anic verse "Surely the sign of the Kingdom" refers to this story. The piece of head-scarf is the patrimony of Prophet Muhammad's children and is spiritually superior to the *Tabut-i Sakina*. Those who possess this relic should consider it a Divine favour, a source of blessing and an emblem of victory and success. Almighty God's unlimited favours would be associated with this relic. When we (Awrangzib) took the reigns of government we, according to our ancestral custom, went to pay respects to it and thanked God for this felicity. On that occasion we increased the rank of its keeper by 500. He and his descendants will preserve it and will benefit by the gifts and the *mansab*. The *Bakhshiu'l-Mamalik* has been warned against committing the sin of preventing the Sayyid from obtaining the benefits of this grant on the pretext of the *farman's* renewal.[150]

Relics are also to be found in Lucknow under the Nawabs. The *very 'alam* in Lucknow claims to be the metal crest of the standard that was carried by Husain at the battle of Kerbala. It is enshrined in a dargah built specially by Nawab Asuf al-Dawla. An Indian pilgrim at Mecca had a vision in which 'Abbas, Husain's standard bearer, revealed the exact spot where this relic would be found at Kerbala.

[146] Naqvi 1987, p. 41.
[147] Rizvi 1986, vol. 2, p. 339.
[148] Rizvi 1986, vol. 2, pp. 348–49.
[149] The Ark of the Covenant, see Sura 2:249.
[150] Rizvi 1986, vol. 2, p. 295–96; Naqvi 2006, p. 62.

The pilgrim took it to Asuf al-Dawla who had a shrine built and put the pilgrim in charge of it. Later, Sa'adat Ali Khan, in gratitude for recovering from an illness, built a finer dargah for the same 'alam. Here, on the fifth day of Muharram, local Shi'is bring their 'alams to touch the 'alam with the relic.[151]

We have already mentioned in passing *qadamgahs* containing a footprint of the Prophet, known in India as Qadam Rasuls.[152] *Qadamgahs* with the footprint of 'Ali are also widespread in India. Thus, a Qadam Sharif with the footprint of 'Ali is to be found in the dargah of Shahi Mardam (1750–51), in Aliganj in south Delhi, which was once part of the estate of the Awadh Nawabs.[153] Another *qadamgah* of 'Ali is in Karad, in Maharashtra.[154] Further south, near Hyderabad, the hill of Mawla 'Ali has an ashur khaneh dating from 1823, though the site goes back to Ibrahim Qutb Shah's reign when a eunuch had a vision of 'Ali seated on the summit of the hill. The following morning he ascended the hill and found the hand and side marks of 'Ali. Various buildings grew up on the hill, and the sandal of 'Ali is carried on an annual pilgrimage to its summit from the cemetery of Rang Ali Shah.[155] In Hyderabad itself, is the Ashur khaneh-e-panj-e-Shah-e-Villayat, which preserves an impression of 'Ali's hand on a black stone, a relic which was said to have been obtained by Abdullah Qutb Shah from Iraq with the help of the Safavid Shah, and the Ashur khaneh Kadm-e-Rasool, which houses an impression of the Prophet's footprint, brought by Sayyid Ali Isfahani from Medina in 1693.[156]

We have mentioned ashur khanehs in connection with 'alams and relics, and to these buildings we now turn, for they are the outstanding Shi'i monuments of the Deccan. They not only house 'alams, but also act as the focus of the Muharram processions. Some of them were also used, and still are today, for the Thursday *majlis*, mourning ceremony, of the local Shi'i community (Pl. 2.32).

About ashur khanehs in Ahmednagar, the capital of the Nizamshahis, almost nothing seems to be known. At Bijapur on the other hand, there is textual evidence of two Adilshahi ashur khanehs, one in the fort, which was built by Ali I Adil Shah (1558–80), and one built outside the fort by Muhammed Adil Shah (1627–56) to re-

Pl. 2.32: *Majlis*, Lucknow c. 1800. Chester Beatty Library, In 69.18.

place the former and make it more accessible. Neither of them has survived. But two Adilshahi dargahs also acted and continue to act as ashur khanehs—that of Aminuddin A'la, and that of Hasheem Peeran, an interesting commentary on the relationship between Shi'ism and Sufism in this part of the world.

The Qutbshahis in Hyderabad, however, were responsible for a large number of ashur khanehs in both the city and the surrounding countryside.[157] Those built during Muhammad Quli's reign include the Baadshahi Ashur Khaneh, the Husaini 'alam Ashur Khaneh, the Sartooq Ashur Khaneh,

151 Hollister 1953, p. 171.
152 See Arnold 1978; Burton-Page 1978.
153 Peck 2006, pp. 127–28. This is presumably the one referred to by Rizvi 1986, vol. 2, pp. 300–301.
154 Desai 1999, no. 1270.
155 Bilgrami 1927, pp. 12–17; Naqvi 2006, pp. 29–38.
156 Naqvi 2006, pp. 70, 74.
157 Naqvi 2003, p. 184; Rizvi 1986, vol. 1, p. 307.

the Barg-i-Abul Fazal Abbas, and the Ashur Khaneh of the Kadm-e-Rasool ("footprint of the Prophet", which we have already mentioned). We will not discuss them all in detail, but the most splendid is undoubtedly the Baadshahi Ashur Khaneh, dating from 1592–96 (Pl. 2.33).[158] The complex consists of a central hall opening onto a courtyard, with a *naqar-khaneh* on the east side of the courtyard, and two *diwan khanehs* on the north and south sides. The hall itself is forty yards long and thirty yards wide, and some 36 feet high, and is open along one of its long sides, facing onto the courtyard. Its flat roof is supported on the open side by four stone pillars. The three walls of the hall are

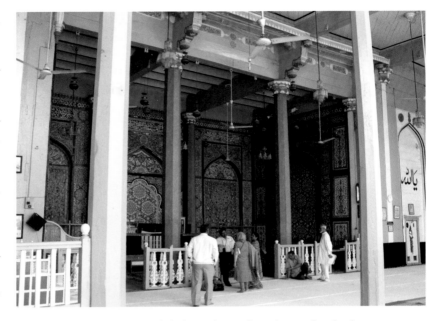

Pl. 2.33: Baadshahi Ashur Khaneh, Hyderabad, 1592–6. Photo: J. W. Allan.

decorated with highly ornate polychrome tiles, which illustrate some of the 'alams kept in the building (Pl. 2.34). The tilework also contains inscriptions. Above the mihrab arch is a cartouche with the words: *nasr min allah wa fath qarib wa bashshir al-mu'minin* (Sura 61:13) "Help is from God, and success is near, so give these glad tidings to the faithful", which we have discussed above, together with the words "*ghulam-e 'Ali* (slave of 'Ali), Muhammad Qutb Shah in the year 1001". In the spandrels are the words, *ya miftah al-abwab*, "O opener (or key) of the gates", referring to 'Ali. In the great roundel are the words *qul kullu ya'mil 'ala shakilatihi*, "Say (O Muhammad) each one doth according to his rule of conduct" (Sura 17:84, Sura Bani Israil).

A continuing feature of Qutbshahi ashur khanehs is a central hall, open along its long side, with its roof supported along that side by a row of columns or piers and an arcade. Examples are the ashur khanehs of the Husaini 'alam, the Sartooq-e mubarak, the Na'l-e Mubarak, and the Panj-e-Shah-e-Villayat, although the dating of these buildings is not always certain.[159] Another ashur khaneh, called the Allava-e Bibi, built originally in the reign of Abdullah Qutb Shah, but rebuilt by one of the Nizams in the 19th century, indicates a

Pl. 2.34: 'Alams in the tilework of the Baadshahi Ashur Khaneh, Hyderabad, 1592–96. Photo: J. W. Allan.

[158] Bilgrami 1927, pp. 21–25 no. 5; Naqvi 2006, pp. 18–26.
[159] Naqvi 2006, pp. 30, 45–46, and 68.

slightly different, but important political face of Shi'ism in the Deccan: religious tolerance and a tendency towards synchretism, which will be further discussed in Chapter 3 (below).

We have looked at the impact of Shi'ism on the religious architecture of the Safavids in Iran, and we have compared that of the Nizamshahis, Qutbshahis and Adilshahis in the Deccan. Now let us look at the architecture of another dynasty in the Indian subcontinent which was strongly Shi'i: that of the Nawabi dynasty of Awadh, or Lucknow. Although the Nawabs did not formally renounce their allegiance to the Mughals until 1819, they were effectively independent nearly a century earlier, from 1728. Defeated by the British in 1764, the Nawabs had increasingly little power and the dynasty finally came to an end in 1856. During this period, however, Lucknow flourished to a unique degree and was considered without exaggeration, "the last example of the old pomp and refinement of Hindustan, and the last momento of earlier times".[160] The increasing fame of the glittering Awadh court brought poets, painters, writers, musicians and artists from all over India and beyond.

Until 1819, Nawabi coins were struck in the name of the Mughal emperors, but even after that they do not include any Shi'i legends.[161] However, there are two outstanding groups of specifically Shi'i buildings which survive from Nawabi Lucknow—the imambaras, which are the focus of the Muharram processions, and the buildings where 'alams are kept and displayed, and the kerbalas, copies of the holiest Shi'i shrines. The origin of imambaras, or at least of the name, seems to be in Bengal. For the word combines *Imam* with *barhi*, the Bengali for mansion. The earliest example recorded seems to be a building known as the Husaini Dalan in Dacca, built in 1642, and the second an early 18th century building in Hughli, also in Bengal.[162] Imambaras were subsequently built elsewhere, for example in Nager[163] (Pakistan), in Delhi,[164] Murshidabad,[165] and most important of all, in Lucknow,[166] to which we now turn.

Of those in Lucknow, the largest and most famous is the Bara Imambara, or Great Imambara, built by Asuf al-Dawla in 1784 (Pl. 2.35).[167] The site is so huge that a major road runs through the lower part of it. There are altogether three

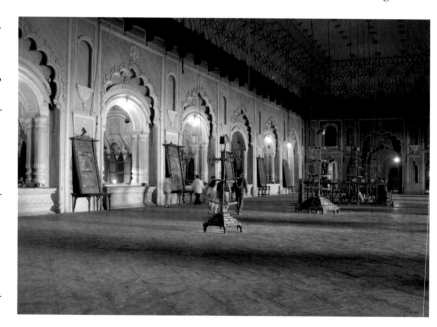

Pl. 2.35: Interior of the Great Imambara, Lucknow, India, 1874. Photo: J. W. Allan.

160 Llewellyn-Jones 1999, p. 5.
161 Mitchiner 1977, p. 434.
162 Rizvi 1986, vol. 2, p. 351; Calmard 2004, p. 517.
163 Frembgen 2005, figs. 108–12.
164 Peck 2006, pp. 127–28.
165 Davies 1898, p. 309.
166 Tandan 2001, pp. 30–43.
167 Tandan 2001, pp. 31–36; Keshani 2006; Chelkowski 2006; Alkazi 2006/1.

interlocked forecourts, each with high, impressive gateways, and a central court which holds not only a huge imambara building, but also the large and very finely decorated Asafi mosque. At the time it was built, the Great Imambara contained the largest hall with an unsupported vault in the world: it measures some 50 m. in length × 15 m. in width, while the two galleries on either side of it are the same length but half the width. It is said to have been built at a time of famine as a way of distributing money within the local community, and must certainly have employed many hundreds of individuals. Asaf ud Dawla is buried in the centre of the hall, and the arched recesses around it are used for display of the 'alams and tabuts used in the Muharram processions. The imambara relies totally on its physical size for its architectural and artistic impact. There are no inscriptions on the outside of any of the buildings, and scarcely any inside the imambara itself: indeed the only striking ornaments are the fishes, presumably dynastic in intent, which decorate the great entrances to the complex.

Another fine example is the Shah Najaf Imambara, built by Ghaziu'd-Din Haydar (1814–27).[168] William Knighton comments on the way in which, "The collection of lustres and chandeliers accumulated on these occasions, the glare of the lights, the sparkling of the rich embroidery and gilding, the glittering of the brilliant fringes, cords, and tasels, ornamenting the banners with which the Imamabarha is hung" reminded him of the "Arabian Nights' entertainments". He goes on to describe the processions with their silver elephant trappings and their banners.[169]

Another imambara of particular note is the Husainabad Imambara, which was built by the Nawab Muhammad Ali Shah (1837–42).[170] This complex has a forecourt and a main court. The main court is largely garden, and contains the imambara itself, a mosque and two mausolea. The two mausolea are those of Muhammad Ali Shah's daughter and her husband. Muhammad Ali Shah's tomb and that of his mother are in the imambara. The glory of this imambara lies not so much in its chandeliers, though they are many, as its inscriptions (Pl. 2.36). For the outside is covered with Shi'i messages: the names of the Panjetan, for example, in the form of a taziya, and the prayer to 'Ali in a balcony-like surround.

Alongside these magnificent imambaras, we find kerbalas. These buildings as a general rule represent and commemorate the battlefield and the burial place of Husain in Iraq i.e. Kerbala. The finest is the Talkatora, which was probably built during the reign of Nawab Saadat Ali Khan (1798–1814) (Pl. 1.19).[171] Such buildings are meant to be copies of the original shrines in Iraq, and there are general features which remind us of the shrine of Husain at Kerbala, but in many features, both general and detailed, it is imaginative rather than exact. This kerbala has two domes, rather than the original one, twin minarets in front, and a minaret

Pl. 2.36: Calligraphic design on the façade of the Husainabad Imambara, Lucknow, India, 1837–42. Photo: J. W. Allan.

[168] Tandan 2001, pp. 37–39.
[169] Rizvi 1986, vol. 2, p. 316.
[170] Tandan 2001, p. 40; Alkazi 2006.
[171] Tandan 2001, pp. 46–48.

attached to the surrounding wall, all three of which are reasonable copies of the minarets of Kerbala, the minaret by the wall being a copy of the Minarat al-ʿAbd. A particularly interesting difference is its lack of a *tarima*, or porch, as noted above, since it was built before the porch was added to the Iraqi shrine. The courtyard around the shrine is filled with graves, which spill over to the surrounding area. The inside of the building, however, is a precursor of the Husainabad Imambara which we have just seen, heavily decorated with Qurʾanic and Shiʿi inscriptions in white on black, some in the form of taziyas. The shrine is part of a very large site, with a handsome gateway, a small Zainabiya beyond the kerbala and its courtyard, and a mosque with fine stucco decoration of the period.

Another important kerbala in Lucknow is Kazmain,[172] which dates from sometime in the first half of the 19th century. It is indeed meant to be a copy of the shrine of al-Jawad and al-Kazim in Baghdad, hence the two domes—though covered in this case with what appears to be brass, rather than gold tiles. Its surrounding area is much smaller than Talkatora, but nevertheless its gateway is impressive. Inside, the zereh (the grille around the cenotaph) is designed as a copy of that at Kazimain.

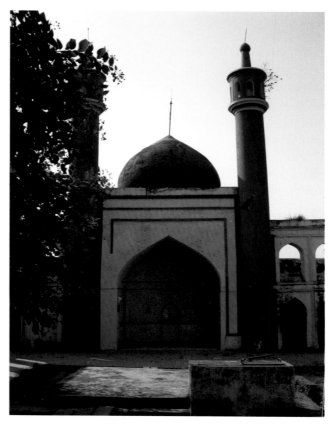

Pl. 2.37: Ivan and dome of the Azimullah Kerbala, Lucknow, India, 1827–37. Photo: J. W. Allan.

A third example, the Azimullah (Pl. 2.37), dating from the reign of the Nawab Nasiruddin Haidar (1827–37), is based not on any Shiʿi shrine from Iraq, but on the shrine of the Imam Reza in Mashhad. It is surrounded by a huge graveyard scattered with palm-trees, to recall the site of Kerbala itself, so the allusions are in fact mixed. It is an extremely austere building, from which Iranian tilework and gilding are totally lacking, though the courtyard gives one something of the impression of the Mosque of Gawhar Shad, though on a diminutive scale.

If it is true that culture flourishes in the twilight of a dynasty's political power, then it is certainly true of Nawabi Lucknow. Here, in a city dominated by the British, a local court poured its energies into building imambaras, the largest and grandest buildings ever dedicated to the memory of the Shiʿi Imams. Here too a local court poured its energies into the much smaller kerbalas. Copies of the great Shiʿi shrines of Iraq and Iran, they gave local the Shiʿi community a sense of the imminence of their religious tradition, and confirmed for all to see the centrality of Twelver Shiʿism, of the martyrdom of Husain, for the Nawabi dynasty. Importantly, they were also built as the focal points of the Muharram processions.

[172] Tandan 2001, pp. 51–52.

Conclusion

This chapter has surveyed the impact of patronage, both Sunni and Shi'i, on the structural and artistic development of the shrines of the Imams. It has also looked at the way Shi'i dynasties in Iran and the Indian sub-continent expressed their Shi'i beliefs in their buildings, in particular in their use of inscriptions. Perhaps the most surprising element is the use of very long and detailed hadiths on buildings to bolster the Twelver claims of the Safavids. It has also become clear that buildings with an identifiable form and an identifiable Shi'i purpose arrived relatively late in both geographical contexts. In the Deccan, ashur khanehs appeared in the 16th century, and were developed on a staggering scale as imambaras in 18th century Lucknow, but in Iran there was apparently no comparable development. Why this should be so is unclear. Perhaps it relates to the popularity of Kerbala dramas in Iran, where they remained the most important feature of the Muharram ceremonies. However, such dramas were never adopted in the sub-continent. And that is certainly the reason for the rise of the *tekiyeh* in Iran—the need for a building in which, or against the background of which, the Kerbala dramas could be played. The growth in secondary buildings within an Iranian *tekiyeh* complex, *husainiyehs*, *'abbasiyehs* and so on, seems to be part of the widespread growth in *tekiyehs* in the late 19th and early 20th centuries, though there is unfortunately very little published material on the subject. In contrast, the Indian taste was for kerbalas, copies of the shrine of Husain or one of the other Imams, to which pilgrimage may be made instead of visiting Iraq. Again this appears to be a Nawabi development, beginning in the 19th century. It may have owed its origin to the unwillingness of the British to allow the Nawabi rulers or their court to visit the shrines,[173] but even if that is so, it evidently worked well with the love of pilgrimage which is so deeply enshrined in the Hindu and Jain traditions of the sub-continent.

[173] Tandan 2001, p. 44.

CHAPTER 3

Shi'ism and the Craft Industries

In Chapter 1 we looked at the history of the great Shi'i shrines; in Chapter 2 we focussed on the way Shi'ism expressed itself through art and architecture when its adherents achieved political power. In this chapter we shall investigate the craft industries under Shi'ism, in order to discover how they have reflected Shi'i beliefs. We shall at the same time try to discover whether they have been driven in particular directions by the demands of the faith. This chapter divides into five sections. In the first we shall look at what may be a unique phenomenon of the Il-Khanid period, a tilework industry apparently dedicated to the decoration of Shi'i shrines and mausolea. In the second we shall assess the effect of the major Shi'i shrines on the craft industries, through the donating and display of objects, and the production of tourist items for sale. In the third we shall consider the use of inscriptions on Shi'i objects. In the fourth we shall look at one specific craft industry, steel, which may have owed much of its popularity to the Shi'i faith of the Iranian population. Finally, we shall look at the effect of Shi'ism on the painting industry, be it miniature paintings for book illustrations, single page miniatures, or large-scale paintings relating to the Kerbala story and the *ta'ziyeh* dramas.

The Kashan ceramics industry in the 13ᵗʰ and early 14ᵗʰ century

Let us start with the ceramics industry in Iran around the time of the Mongol invasions. It is well known that the ceramic products of Kashan reached extraordinary technical and artistic heights in the last quarter of the 12ᵗʰ century through to the early 14ᵗʰ century, producing a wide range of objects and tilework in a variety of techniques. What is perhaps less appreciated is that this industry had a very strong Shi'i emphasis: indeed a survey of Kashan lustre tiles brings to light an extraordinary number associated with Shi'i shrines and imamzadehs, spread over the period from 1203–1339.[1] Three of these sets decorate major Shi'i shrines. The earliest are the lustre tiles from the cenotaph of Fatima at Qum.[2] The panel which lay on the top of the tomb was the work of Muhammad ibn Abi Tahir, dated 602/1206, and is the earliest surviving example of a Shi'i lustre tombstone. Next in chronological order is the mihrab in the shrine of the Imam Reza in Mashhad, made by Abu Zaid, dated 612/1215,[3] and other undated lustre tiles by him on the walls around. Last is the large mihrab in the shrine at Mashhad, made by 'Ali ibn Muhammad, dated 640/1242.[4] Other groups of tiles decorate lesser Shi'i imamzadehs, e.g. the mihrab of the Imamzadeh Yahya at Varamin, now in Hawaii, signed by 'Ali ibn Muhammad ibn Abi Tahir, dated 663/1265 (Pl. 3.1), another smaller mihrab signed by 'Ali ibn

[1] For what follows I am greatly indebted to Oliver Watson and the research included in his thesis and his later book on Persian Lustre-Ware, see Watson 1977 and 1985.
[2] Watson 1985, pl. 103.
[3] Watson 1985, pl. 104a, b.
[4] Watson 1985, pl. 109.

Muhammad and Yusuf ibn 'Ali, and a group of star tiles from the same shrine, dated 661/1262, of which numerous examples are distributed among European museums;[5] a small mihrab, now in Tehran Museum, which once lay on the tomb of the Imamzadeh of Habib ibn Musa in Kashan, unsigned, but bearing the dates 667 and 670 (1268 and 1271);[6] a large mihrab from the Imamzadeh 'Ali ibn Ja'far in Qum dated 734/1334, signed by Yusuf ibn 'Ali ibn Muhammad ibn Abi Tahir, now in Tehran Museum;[7] and tiles from the Imamzadeh 'Ali ibn Ja'far in Qumm, also in the Tehran Museum, dated 738/1337.[8]

The significance of these mihrabs and tiles is enhanced by a pair of lustre plaques, dating from 711/1312, in the Museum at Sèvres (Pl. 3.2).[9] The text on one of them describes the dream of a *sayyid*, i.e. a descendant of the Prophet, by the name of Fakhr al-Din Hasan Tabari from Kashan, on the night of 10th February, 1312. In his dream he met 'Ali and the Mahdi, who said that they were travelling to India to convert unbelievers. 'Ali was sitting in his tent, and outside it was 'Ali's horse, the Mahdi's camel, and a spear stuck in the ground. 'Ali told Fakhr al-Din Hasan to build an oratory there, in the Bagh-e Amir. The oratory was intended for those who were unable to go and see them in India. The Sayyid woke up, walked to the garden, marked the spot where 'Ali had been sitting and drew the plan of a square oratory 25 bricks (approximately 3 m) long. He also marked the spot where the horse and the camel had left their footprints. The oratory was duly built, and casts of the footprints were made to prove that the miracle had actually taken place. The garden is almost certainly the cemetery known today as the Mazar-e Qadamgah-e 'Ali, north-west of Kashan.

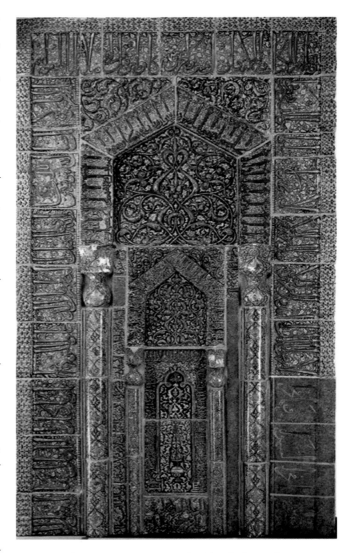

Pl. 3.1: Lustre-painted mihrab from the Imamzadeh Yahya, Varamin, signed by 'Ali ibn Muhammad ibn Abi Tahir, dated 663/1265, 384.5 × 228.6 cm. Hawaii, Shangri La. Photo: Courtesy of the Doris Duke Foundation for Islamic Art

[5] Watson 1985, pp. 132, 179, 186.

[6] Watson 1985, pl. 103–4, p. 186.

[7] Watson 1985, pl. 120.

[8] Watson 1985, pl. 121.

[9] Adle 1982. Both pieces are now in the museum in Sèvres, the second having been acquired on the art market, see Lucien Arcache Paris, Hôtel Drouot, sale catalogue, 18–19 March 1996, lot no. 159; *L'Etrange et les Merveilleux en terres de l'Islam* 2001 nos. 186–87.

The second tile is decorated with a picture showing the tent, the spear, the horse and the camel. The tent is decorated with the words: "Power belongs to the one God. Husain. ʿAli is the friend of God. Muhammad. The Master of Time, ornament of worshippers." The latter title belongs to the Mahdi. Tents and canopies were sometimes decorated with inscriptions,[10] and tents with Shiʿi inscriptions were presumably available for those who wanted them. Not only therefore do we have a large number of lustre tiles from buildings, but we also have them being used to commemorate the founding of an oratory on the direct orders of the Imam ʿAli.

The question then arises as to how close is the connection between these Kashan lustre tileworkers and Shiʿism. Watson is of the opinion, first, that all the known lustre tiles were made by Shiʿi potters in Kashan and were destined for Shiʿi buildings; secondly, that the Shiʿi buildings concerned were almost certainly mausolea and imamzadeh i.e. funerary buildings; and thirdly, that the existence of *Shah-nameh* scenes amongst the surviving tiles indicates not that these tiles were used in secular buildings, but that the *Shah-nameh* had a role in the funerary practices of the Shiʿi community of the 13th and 14th centuries. The remains of this tradition can in fact be heard among the Bakhtiari to this day, in the recitation of *Shah-nameh* stories at funerals. Watson notes, however, that there are possible exceptions, e.g. the use of such tiles at Abaqa Khan's palace at the site known as Takht-e Sulaiman, the medieval town of Shiz. However, he takes these as an exception on the grounds that Abaqa Khan was not a Muslim, and as supreme ruler could commandeer whoever he wanted to fulfil whatever he desired. He also notes a second possible exception—their use in the Masjid-e ʿAli at Quhrud, i.e. in a mosque

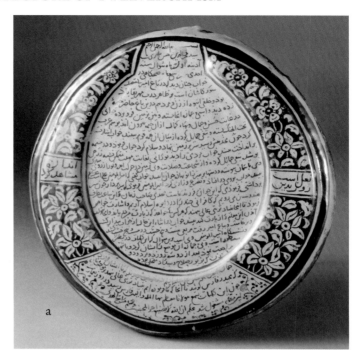

a

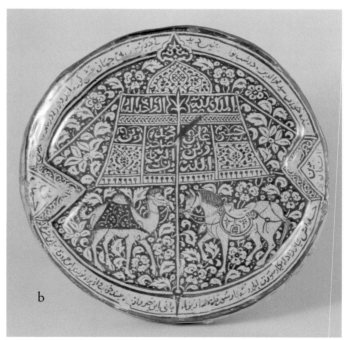

b

© RMN/Martine Beck-Coppola

Pl. 3.2: Pair of lustre plaques, Kashan, Iran:
a) dated 711/1312, diam. 28.5 cm; b) diam. 32.8 cm.
Sèvres, Cité de la Céramique, MNC22688 and 26903.

10 E.g. Lukens-Swietochowski 1979, pl. 111.

rather than in an imamzadeh. However, he takes this as an exception because, in his opinion, the Masjid-e 'Ali was founded as much as a shrine in memory of 'Ali as a mosque: it has a carved wooden door dated 700/1300, on which it is recorded that the foundation of the mosque came about because the founder saw 'Ali in a vision, and 'Ali ordered him to build the mosque. He notes a third possible exception in the lustre mihrab in the Friday Mosque in Kashan, but since the present Friday Mosque in Kashan appears to be a 15th century building, he concludes that the mihrab could have come from somewhere else. In Watson's view, therefore, it is possible that in 13th–14th century Kashan we are in the presence of a unique phenomenon: a group of Shi'i potters making lustre tiles specifically for Shi'i shrines and mausolea.

The problem with this theory is Watson's use of the evidence. Regardless of Abaqa Khan's power, tiles were used in his palace, and a palace is a secular building. Whatever the reasons for its foundation, the Masjid-e 'Ali at Quhrud is called a *masjid*, i.e. a mosque; hence tiles were used in mosques. Moreover, the Kashan industry's survival would have depended on continuing production of tiles, so there must have been numerous other buildings which were decorated with tiles even though we do not know what they were. Hence, the lack of other secular buildings or mosques decorated with such tiles is most likely to be due to the destruction of the buildings which housed them: an imamzadeh, through its function as a focus of local piety, may well survive war in ways which other buildings do not.

There is, however, another facet to the Kashan industry which is worth noting here. Caiger-Smith has written about the relationship between lustre-painting and alchemy, and the alchemist's desire to turn base-metals into gold.[11] He points out a number of interesting facts. Thus, some of the alchemical works attributed to Jabir ibn Hayyan, who lived from c. 721–813, are now believed to have been written by Shi'i mystics of the 9th–10th centuries. Moreover, there is often a close connection between alchemy and artisans, since both might be involved with relevant experiments. Indeed, Abu'l-Qasim Kashani, the brother of Yusuf of the Abu Tahir family of Kashan potters, begins his chapter on ceramics in his book on stones and substance with the words: "The final chapter about knowledge of the art of *kashi-gari* [tile-making] … This art is in truth a type of 'philosopher's stone' [i.e. a kind of alchemy]." In addition, we should note that Abu'l-Qasim Kashani was also conscious of the alchemical relationship between the sun and gold, for he writes: "[the lustre pigment] that has been evenly fired reflects like red gold and shines like the light of the sun". As Caiger-Smith observes, "so little is known of early Islamic alchemy, it would be unwise to lay too much emphasis on any one aspect", but the possibility of a link between the Shi'i lustre tiles and the science of alchemy cannot be ignored.

Be that as it may, the vast majority of the ceramic products of Kashan show no obvious connection with Shi'ism, or even the broader world of Islam. However, there is one group of objects which should be brought into the picture here. In the 1970's, Bagherzadeh drew attention to a group of *minai* (or over-glaze painted) bowls, by the Kashan potter Abu Zaid (Pl. 3.3).[12] These bowls bear inscriptions saying that they were made in the month of Muharram of a particular year, and are decorated with scenes which Bagherzadeh interpreted as *ta'ziyeh* events, in other words recitations or dramas relating to the commemoration of the death of Husain at the battle of Kerbala. He noted the evidence of Olearius, one of the embassy sent by Frederick Duke of Holstein to Iran in 1637. Olearius' arrival in Shamakhi, capital of the Safavid province of Shirvan, coincided with the 21st day of the month of Ramadan, the anniversary of the martyrdom of 'Ali, and the embassy was invited by the Khan to be present at a ceremony to commemorate the event. The ceremony commenced with a long *rawza* (funeral oration) followed by a *ta'ziyeh* spectacle, in a building specially built for the purpose. At the end of the *rawza*, when the *khatib*, the reciter, had finished his speaking/reading, the Khan sent him

[11] Caiger-Smith 1985, chapter 11, "Alchemy and Symbol", pp. 186–96.
[12] Bagherzadeh 1989; see also Watson 1994, who discusses the Abu Zaid signatures and shows which objects are stylistically his work.

a silk coat. According to Bagherzadeh, this is the scene depicted on the bowls of Abu Zaid. The *naqib*s, or heads of the sayyids, were extremely important and influential in the 12th century in western Iran. Hence for such men the only *khil'at* (robe of honour) suitable for them was the robe of a prince, in the tradition of the Prophet himself. On one of the bowls, now in Los Angeles, the *naqib* has received a royal robe from the monarch's vestiary: it is like the monarch's in quality and design but not identical. On a second bowl, in the British Museum, the *naqib* has received the royal robe of the monarch himself. The two moments of the monarch wearing the robe, and then the *naqib* wearing it, are superimposed on each other, and the role of the tree is to separate the *ta'ziyeh* ceremony from the moment when the *naqib* receives his robe. Close scrutiny of other bowls made in the month of Muharram could well bring to light other *ta'ziyeh* images.

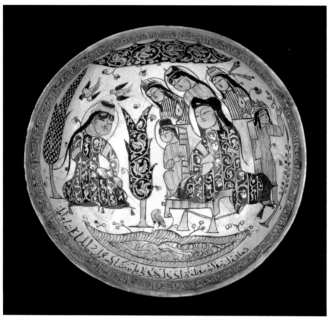

Pl. 3.3: Minai bowl with a Muharram scene, made in the month of Muharram, 583/1187, probably Kashan, Iran. British Museum acc.no. 1945,1017.261.

These ceramic bowls are not the only objects from the Islamic world bearing inscriptions relating their manufacture to the month of Muharram. Two very fine 12th–13th century pieces of inlaid metalwork also bear inscriptions stating that they were made in the month of Muharram: the famous Bobrinski bucket in the Hermitage Museum, St. Petersburg, which was made in Herat in Muharram 559 (December 1163), and an aquamanile in the form of a zebu and calf, which was made in Muharram 603 (August 1206).[13] Neither of these appears to have been made for a Shi'i patron. Indeed, the patron of the bucket gives the impression of being staunchly Sunni, for he uses the title "ornament of the pilgrimage and the two sanctuaries [Mecca and Medina]". The month of Muharram, of course, includes the most important day of the Shi'i year. The 9th is a fast day for Shi'i ascetics, but the 10th is the day of 'Ashura, the anniversary of the death of Husain at the battle of Kerbala, and the focus of all the mourning ceremonies and pilgrimages of the Shi'i world. However, the 10th of Muharram, the day of 'Ashura, is also an important fast day throughout the Sunni world, and how special and important it is, can be seen from the fact that the fast takes place from sunset to sunset, not from sunrise to sunset, as in the month of Ramadan. The Sunni festival probably originates in the Jewish Day of Atonement.[14] Moreover, the 16th day of Muharram commemorates the day of the selection of Jerusalem as *qibla* (direction of prayer), and the 17th the day of the arrival of "the people of the elephant". This latter tradition refers to Sura 105, the Sura of the Elephant, which recalls an attack on Mecca by the Yemeni king, Abraha, whose aim was to destroy the Ka'ba.[15] His stratagem came to nothing when the elephant in the army knelt down at the edge of Meccan territory and refused to go further, and his army was then decimated by a smallpox epidemic. The date of this event is likely to have been in the mid 6th century. One cannot help wondering whether the passage of Ibn al-Athir in which the

[13] *Arts of Islam* 1976, nos. 180 and 178.
[14] Wensinck 1960.
[15] Beeston 1965.

Sunnis carry an elephant, quoted in Chapter 1 (see p. 15), although located in the month of Sha'ban, may not indicate deliberate rivalry on the part of the Sunnis to the Shi'i custom of carrying various Shi'i items, like 'alams, in their processions. Be that as it may, it is clear that the month of Muharram was not special to Shi'is alone, but also to Sunnis. Hence, an object which proclaims its origin in the month of Muharram of a particular year is not thereby necessarily Shi'i.

Shrines and the craft industries

Pilgrimage to the shrines of the Imams was not organised in the same way as the Hajj, the pilgrimage to Mecca and Medina. The Hajj has always been an annual event, at a prescribed time of year, and from early times it included money, called *surre*, destined for the Sharif of Mecca, and the residents of the two holy cities. (The Sharifs were the protectors of the holy cities, and were descended from the Prophet's grandson, Hasan ibn 'Ali.) This tradition goes back to the 'Abbasid caliph al-Muqtadir Billah (908–932),[16] and was continued, albeit sometimes intermittently, by the Fatimids, Ayyubids, Mamluks and Ottomans, as rulers of the Hijaz. In addition to money, the Ottoman *surre* procession included various precious items destined for the holy places, for the resident descendants of the Prophet, or for the Sharif of Mecca: a new *kiswa* ("veil" or textile covering), together with other textiles, to decorate the Ka'ba in Mecca;[17] textile covers for the graves of the Companions of the Prophet in Medina;[18] carpets and prayer rugs; chandeliers, candlesticks, censers and a variety of hanging ornaments; Qur'ans and other books (e.g. biographies of the Prophet), and Qur'an stands; Chinese ceramics, caftans, swords, locks and keys, and prayer beads. The caftans were to be worn on special days associated with the departure and arrival of the *surre*.[19]

Nothing comparable to this organised giving existed for the Shi'i shrines. In their case, giving seems to have been largely haphazard, and dependent on the individuals, royal, noble or common, who made their pilgrimages throughout the year.[20]

Nevertheless, the existence of the major Shi'i shrines, regularly visited by large numbers of Shi'i people, must have had a marked effect on the craft industries, in four particular ways. Firstly, provided their treasures were displayed or otherwise visible, they would have served as models of taste, quality and design, especially if they were donated by royalty. For they would have been seen by huge numbers of people, and most importantly by other artisans, and we can be confident that one specialist artisan would have given close scrutiny to an object made by another craftsman working in the same industry. Secondly, as with the Hajj to Mecca, pilgrimage to the Shi'i shrines would have had the effect of distributing a vast number of lesser artistic goods throughout Iraq and Iran, and indeed further afield. For many pilgrims would have carried transportable goods for sale on the way and the way back, in order to raise money for their journey, as well as carrying their own lesser gifts to the shrines. Although we cannot assess the precise results of this activity, it is only logical to assume that they left their mark on the art and tourist industries. Indeed, one effect would have been to unify, or at least mix together, the artistic styles in the areas from which the pilgrims came. Thirdly, there would have been tourist items on sale at the shrines which would have been taken home by the

[16] Bayhan 2008, p. 29.

[17] Bayhan 2008, pp. 41–65.

[18] Bayhan 2008, pp. 65–67.

[19] For the rich variety of objects sent, see Bayhan 2008 throughout; for the caftans see particularly p. 26.

[20] Kaczmarczyk, Hedges and Brown 1977 note the production of mercury-coated dirhems at Mecca during the pilgrimage season, undoubtedly designed to defraud pilgrims. There seems to be no textual evidence of this practice at the Shi'i shrines, though fraud has a habit of appearing wherever opportunities present themselves.

pilgrims, again leading to unification or at the very least mixing of artistic styles. Finally, the religious importance of the main Shi'i shrines led to their being copied in miniature. This copying activity gave rise to Indian models, tabuts, carried in Shi'i Muharram processions in the sub-continent, and sometimes to extremely accurate models made of more precious materials, kept in Indian shrines or palaces. We shall deal with each of these aspects in turn.

Let us first detail the way in which Shi'ism provided standards for the craft industries through the accessibility of shrines, and the visibility of their treasures. In Chapter 1, from textual evidence, we saw how shrines were full of furnishings in the form of carpets, textiles, and lamps. For example, Ibn Khallikan describes Kazimain in his *Biographical Dictionary* entry on Musa al-Kazim. He writes: "His tomb is a well-known object of pilgrimage; over it is erected a large chapel containing an immense quantity of gold and silver lamps, with divers sorts of furniture and carpets."[21] It is evident that visitors to shrines were conscious of the richness of the objects around them. Moreover, some of them were very aware of the origins of the objects concerned. For example, Yaqut, in his *Dictionary of Learned Men*,[22] records that the scholar Abu Hasan 'Ali b. 'Abdallah b. Wasif al-Nashi'i, a poet of the family of the prophet *(ahl al-bayt)* (d. 975–976), was a master craftsman who worked in brass openwork, and that he had made a magnificent square lamp for the shrine at Kazimain. The fact that Yaqut knew about the lamp shows that it must have been well known and widely appreciated by pilgrims.

There is no doubt too that the shrine treasuries were the focus of royal donations, and hence of the highest quality objects available at the time. Literary evidence again makes the point: Wali Quli Shamlu records waqfs of 1604–6 which show that Shah 'Abbas I wished to endow his "jewels, silver, and inlaid untensils" to the shrine at Najaf for its embellishment and refurbishment, though until he could make the pilgrimage (the shrine was under Ottoman control) the valuables were to be stored at Ardabil.[23] It is interesting to see here how the objects could be used—either as ornaments or as a source of money.

Many of the precious metal objects donated to shrines over the centuries must have been sold for such purposes as this, and subsequently melted down. But a small number have survived. In the shrine of the Imam Reza in Mashhad, for example, is a gold lock given in 1064/1653–54 by one Javad al-Husaini,[24] while in the shrine of 'Ali at Najaf there is a gold lamp which was presented in 945/1538–39, a gold *ziyarat-nameh* (pilgrimage prayer plaque) dated 1162/1749,[25] a gold lampstand which was a gift of 'Ali Murad Zand in 1197/1782–83, and a gold lamp presented by a lady by the name of Najm al-Sultana in

Pl. 3.4: Tomb finial, gold with enamel and precious stones, dated 938H/1531–2, ht. 75 cm. Treasury of the Shrine of 'Ali, Najaf. After Mahir 1969, pl. 84.

[21] De Slane 1868, 3, p. 466. The Arabic word translated as furniture here is *al-alat*, which might better be translated as "items", see Abbas 1977, 5, p. 310.
[22] Yaqut 1929, p. 237.
[23] McChesney 1981, pp. 172–73.
[24] Tanavoli and Wertime 1976, p. 109.
[25] Mahir 1969, pl. 88.

Pl. 3.5b: Aberconway carpet fragment, 145 × 259 cm, Iran, early 17th century. Victoria and Albert Museum no. T.36-1954. Photo: Victoria and Albert Museum.

Pl. 3.5a: Part of a silk carpet, Iran, early 17th century. Treasury of the Shrine of 'Ali, Najaf. After Aga-Oglu 1941, pl. I.

1301/1883–84.[26] More important is the gold tomb finial, inlaid with blue enamel and with precious stones, which dates from 938/1531–32 (Pl. 3.4).[27] This is a piece of exceptional quality, and is almost certainly one of those to be seen in the painting of the shrine of 'Ali by Matrakçi Nasuh, who took part in Suleyman the Magnificent's Iraq campaign in 1533–36. Such tomb finials also existed at the Shrine of Husain in Kerbala, as Matrakçi's painting of this shrine shows.[28] The wonderful quality of the Najaf tomb finial may be judged by comparing it to a silver and zinc bowl with gold filigree and precious stones, from the early 16th century, now in Topkapi.[29]

As was clear from the evidence provided in chapter 1, carpets and textiles were regularly donated to shrines, and widely appreciated by pilgrims, and it is possible to have some idea of the wealth of the Shi'i shrines from surviving examples. From the shrines at Kerbala and Kazimiya nothing has been published, and the Kerbala treasury was almost certainly emptied at the time of the invasion of the Wahhabi Arabs in 1801. Fortunately, however, the carpets which survived in the shrine of 'Ali at Najaf have been published.[30] Among them is an enormous silk carpet, now in two parts, which must have been commissioned by Shah 'Abbas the Great in the early 17th century: its original size was 14.03 × 9.56 m (Pl. 3.5a).[31] It is of silk, brocaded with silver and silver gilt thread, and has a crimson ground. An extremely close parallel is provided by the Aberconway fragment in the Victoria and Albert Museum (Pl. 3.5b).[32] In addition, there is a group of Safavid prayer rugs in the Shrine of the Imam Reza, among which is a triple prayer rug which bears an inscription giving the donor's name as "the dog of the shrine, 'Abbas".[33] Aga-Oglu has convincingly attributed this to the patronage of Shah

[26] Mahir 1969, pls. 73–75.
[27] Mahir 1969, pls. 84–85.
[28] Yurdaydın 1976, pls. 58b, 64b (Najaf), pls. 57a, 62b (Kerbala).
[29] Allan 2003/1, pl. 8.2 p. 204.
[30] Aga-Oglu 1941, though all the photographs are in black and white.
[31] Aga-Oglu 1941, pl. I.
[32] Aga-Oglu 1941, fig. 4; Bennett 1988, p. 43; Canby 2009, no. 121.
[33] Aga-Oglu 1941, pl. III.

'Abbas the Great: it is similar in technique, colours and design to two carpet fragments in the collection, one of which in fact contains a dedicatory inscription of Shah Abbas I.[34] The quality of carpets like these from Najaf leaves no doubt that the shrines were recipients of the very highest quality of carpet, and we may be confident that observant visitors would have taken note of them.

Turning to the Shrine of the Imam Reza at Mashhad, we know that in 1589–90, the Uzbeks looted the shrine. Iskandar Munshi wrote:

> The holy shrine was plundered, and the jewelled chandeliers of gold and silver, the candlesticks, the rugs, and the china bowls and vessels were carried off. The shrine library, which housed a collection of books from all parts of the Islamic world, including precious copies of the Koran in the writing of the immaculate Imams and masters of the calligraphic art such as Yaqut Mostasemi and the six masters, and other learned works of priceless value, was pillaged; and the Uzbeks sold these masterpieces to one another like so many potsherds.[35]

In 1598–99, however, Shah 'Abbas I restocked the shrine with the necessary functional and decorative items: "jewelled chandeliers of gold and silver, candlesticks, magnificent Kirman and Jawshaqan carpets, and essential pots and utensils".[36] A number of carpets from the collection of the Shrine of the Imam Reza have been published. A superb, late 16th century, floral carpet with arabesques, measuring 5.60 × 3.54 m, has a catalogue note saying that it was commissioned for the sanctuary by Shah 'Abbas I.[37] Other extremely high quality carpets include a late 17th century floral example, 9.24 × 4.22 m, which may be Persian or Indian, a wonderful Indian floral ogival-lattice carpet, 8.02 × 5.73 m, and a splendid Mughal carpet, 5.50 × 4.00 m, with an ogival lattice with a large flower in each compartment.[38] A further example was in the 1931 London exhibition[39]: a small silk carpet, measuring 1.40 × 1.13 m, decorated with a cusped niche and a cruciform arrangement of water-channels with a small pool in the centre. The ground is filled by blossoming trees, cypresses and flowering plants, and the carpet is inscribed with the information that it was "made by the least of the humble slaves of God, Muhammad Amin Kirmani" in 1651.

The shrine of Fatima at Qum was also the recipient of splendid carpets, and a group from the mausoleum of Shah 'Abbas II in the shrine has been published. This includes a silk floral carpet enriched with metal thread, 2.86 × 1.71 m., which may be 17th century or slightly later, and more importantly a group of silk floral carpets made specially for the mausoleum. The main floor was covered by a duodecagonal carpet, c. 4.6 m in diameter, and on each side lay a small carpet fitting into each of the twelve bays. Each of the latter examples is just under 2 m in length. According to the inscription on one of the small carpets, the set was produced in 1671 by Ustad Ni'mat Allah Jawshaqani.[40]

Moving on to textiles, the treasury of the shrine of 'Ali at Najaf contains a large number of superb pieces: five velvet panels, five silk tomb covers, and two silk hangings of the Safavid period, an 18th century silk panel and silk tomb cover, and six silk covers of 17th–18th century date.[41] Of particular importance is one of the velvet panels, which dates from the 16th century (pl. 3.6).[42] It has a dark

[34] Aga-Oglu 1941, pls. V–VI.

[35] Savory 1978–1986, vol. 2, p. 590.

[36] Savory 1978–1986, vol. 2, p. 764. For further information see McChesney 1981 p. 167, n. 4–5. I have been unable to locate a copy of his source.

[37] Gans-Ruedin 1978, pp. 82–83, also illustrated in Aga-Oglu 1941, fig. 8.

[38] Gans-Ruedin 1978, pp. 152–55; Gans-Ruedin 1984, pp. 132–33.

[39] Royal Academy of Arts 1931, p. 224, no. 517; Tattersall 1931, fig. IV. It is described in Kendrick 1931, p. 21, where however it is not illustrated. The inscription is read in the 1931 catalogue with the name Amin, but by Minorsky in Kendrick 1931, p. 21 without.

[40] Pope 1938, vol. 3, pp. 2398–99; vol. 6, pls. 1257–60.

[41] Aga-Oglu 1941, pp. 33–41, pls. VII–XXVIII.

[42] Aga-Oglu 1941, pl. VII and p. 33.

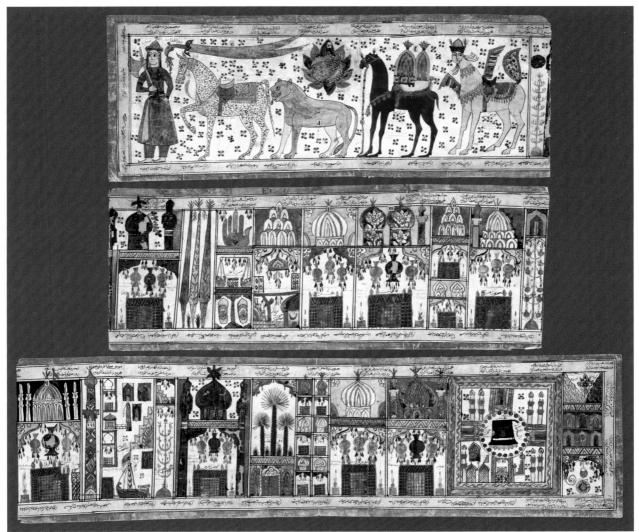

Pl. 3.11: Cardboard roll (cut into three pieces), purchased at Kerbala by Niebuhr, 1765, 192 × 22 cm.

the Ibrahim Rawza in Bijapur, one would suspect that many pieces related to those above are actually Deccani, rather than Persian, but detailed research is urgently needed to pursue this question.

The third impact of the Shi'i shrines on the craft industries would have resulted from the production of 'tourist tat', the sort of cheap (and expensive) objects sold by any shrine or tourist centre, objects which would be taken home by pilgrims as memorabilia, perhaps to prove that they had made the pilgrimage, or as presents to family and friends, and would provide a useful source of income for the shrine or local people, and other items which might have been used as votive offerings by pilgrims at the shrine. For example, at Kerbala Niebuhr bought a roll of paper, something over 6 ft long and 8 inches wide, bearing a large number of representations (Pl. 3.11). These include the Ka'ba, Muhammad's tomb, the tombs of the principal Imams, Buraq (the creature which Muhammad rode on his night journey into the heavens), the camel which carried the *mahmal* (the textile litter carrying a Qur'an which was the focus of the annual pilgrimage caravan to Mecca), a lion (presumably symbolising

'Ali), Duldul ('Ali's horse), Ghanbar (his faithful slave), Dhu'l-Faqar (his sword), and Muhammad's seal. The roll is now in the National Museum, Copenhagen.[77] This was presumably a typical type of 18th century tourist object, designed to be purchased by pilgrims as proof that they had been to the shrine. Prayer tablets (mohreh-ye namaz) made of Kerbala clay would also have been popular items to purchase and carry home, bearing with them whatever design happened to decorate them. Niebuhr illustrates two inscribed 18th century examples, and Mahir a wide variety used in Najaf in the 1960's.[78] Prayer tablets in contemporary Iran (Pl. 3.12) are usually decorated with images of the Dome of the Rock, though Shi'i inscriptions, like the names of the 12 Imams, or pictures of other shrines are also used.[79] An 18th–19th century Iranian carved wooden stamp in Frembgen's collection bears talismanic inscriptions including the Nad-e 'Ali, together with magic numbers and a picture of the Prophet on Buraq, and might have been used for pro-

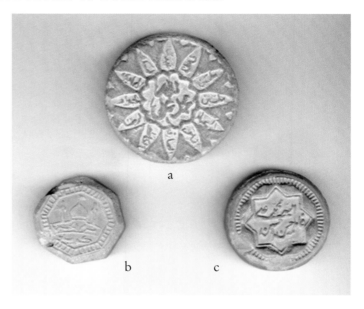

Pl. 3.12: *Mohrehs* (prayer tablets) of Kerbala clay, from Mashhad: a) with the names of God, Muhammad and 'Ali, and the 12 Imams around, diam. 6.2 cm; b) octagonal, with the shrine of Huasin at Kerbala, diam. 4 cm; c) with the names of God and the Panjetan, diam. 4.8 cm. In the possession of the author.

ducing tourist items at a shrine.[80] Little is known about votive objects (nazar), but in Tabriz, at the Sahib al-'Amr Mosque (i.e. the Mosque of the Mahdi), votive objects are nailed up on the door as part of the prayers of pilgrims visiting the building (Pl. 3.13). They include small hands and faces made of sheet silver, and are said to represent the hands and face of 'Abbas, though the hands are also said to represent the Panjetan. Silver sheet votive offerings in the form of different parts of the body are offered by pilgrims at shrines in the hope of a cure for particular ailments in the corresponding area of the body.[81]

The precise relationship of shrines to the types of tourist object just mentioned remains for the most part unclear. However, there is one intriguing record which suggests that shrines benefited in a direct financial way from such local crafts. For a *manshur*, a confirmation document issued in 1668–69 for the shrine at Mazar-i Sharif, describes the revenue rights that the shrine then controlled. Among them was income from artisans and craftspeople connected with the shrine. McChesney suggests that these probably included shrine concessionaries as well as artisans who rented working space within the shrine precincts, and that the artisans probably included calligraphers, book-binders, weavers and tile-makers. "The shrine", he continues, "may have paid the workers a salary and entered their earnings into the accounts as those of the 'trades and crafts' (asnaf wa muhtarifah) of the shrine,

[77] Niebuhr 1776, vol. 2, p. 223; reproduced in von Folsach, Lundbaek and Mortensen 1996, no. 38.
[78] Niebuhr 1776, vol. 2, pl. XLII D and E; Mahir 1969, pls. 22–25.
[79] Frembgen 2003, Abb. 62; Tanavoli and Porter 2007/2, p. 115 top right.
[80] Frembgen 2003, Abb. 32.
[81] I am grateful to Arezou Azad for the image; see Beny and Nasr 1975, pl. 156, and Tanavoli and Porter 2007/1, pls. 40–41 and p. 113; for the mosque see Sultanzade 1997, pp. 174–77.

or perhaps the workers or groups of workers simply paid a percentage of their earnings or a fixed fee to the shrine for the right to work there."[82]

The fourth impact of the Shi'i shrines on the craft industries is to be seen in the production of models for use in Muharram processions. Such models have for long been produced in Iran, but almost nothing has been written about them. However, Aghaie illustrates a model of the shrine of Husain being carried in front of the entrance to the Masjid-e Karbala'i-ha in Tehran, and an elaborately decorated replica of a ship, symbolizing the household of the Prophet, kept in the same mosque, which is pushed along in the public procession in front of the Tehran bazaar.[83] Other items carried in present-day Muharram processions in Shiraz include *tabaqs* (large festive platters), decorated with pictures of the Imams and other items, which represent the bridal chamber of Qasim (Husain's nephew), who was killed at Kerbala on his wedding day; the coffin of Husain; and the cradle of 'Ali Asghar (Husain's baby son). Re-creations of the grave of Ruqayya (Husain's little daughter) sometimes adorn the homes of the participants. Victory arches or booths are also constructed in Shiraz to celebrate the birth of the 12th Imam on 15 Sha'ban.[84] All these Shirazi items are constructed for the ritual season and then dismantled.

Pl. 3.13: Votive silver plaques, Sahib al-'Amr mosque, Tabriz. Photo: Arezou Azad.

Better known are the models manufactured in Shi'i India, which are locally known as tabuts, or taziyas. (This type of taziya is not the same as the Kerbala dramas *(ta'ziyeh)* of Iran, though it uses the same word, and there is confusion in the Indian context over which objects are tabuts and which are taziyas. We shall use tabut to describe a model made in permanent materials [such as metal], and taziya to describe those made of impermanent materials [such as paper]. In both cases the models are designed to reflect with more or less accuracy the tomb of Husain at Kerbala,[85] though tabuts are also modelled on other Shi'i shrines.) We will discuss taziyas in more detail in Chapter 4, but here let us simply notice that tabuts can be made of many different materials—wood, ivory, base metal and precious metal, for example. In the early 19th century Mrs. Meer Hasan 'Ali describes tabuts (which she calls taziyas) as follows:

> [The taziya] is formed of every variety of material, according to the wealth, rank, or preference, of the person exhibiting, from the purest silver down to bamboo and paper, strict attention being always paid to preserve the model of Kraabaalah [i.e.Kerbala], in the exact pattern with the original building. Some people have them of ivory, ebony, sandal-wood, cedar, & c., and I have seen some beautifully wrought in silver filigree. The handsomest of the kind, to my taste, is in the possession of his Majesty the King

[82] McChesney 1991, p. 145.
[83] Aghaie 2004, colour pls. (unnumbered).
[84] Betteridge 1999, p. 551; Aghaie 2005, p. 76, figs. 3.5, 4.3, 4.4, and colour pls. (unnumbered); Micara 1979, fig. 4 shows one such model used in processions in Schoucha in the Caucasus in the mid 19th century.
[85] Rizvi 1986, vol. 2, p. 198.

of Oude, composed of green glass, with brass mouldings, manufactured in England (by whom I could not learn). All the Tazias are fixtures, but there are temporary ones required for the out-door ceremony, which, like those available to the poor and middling classes, are composed of bamboo frames, over which is fixed coloured uberuck (lapis specularum, or tulk); these are made in the bazaar of various sizes and qualities, to suit the views of purchasers, from two rupees to two hundred each.[86]

Pl. 3.14: Model of the shrine of ʿAli at Najaf, lg. c. 70 cm, Hyderabad 1951–54. Ashur-khaneh-ye Khalwat, Hyderabad. Photo: J. W. Allan.

Not all tabuts are of artistic interest, and some bear little relation to the shrines which they claim to represent, but there is a group of outstanding quality in the Ashur-khaneh-ye Khalwat complex in Hyderabad (Pl. 3.14).[87] The individual ashur-khanehs in this complex date from 1951–54, and were sponsored by the seventh Asif Jahi Nizam, Mir Osman Ali Khan Bahadur. Amongst the tabuts which are kept in these buildings are a group of exceptional gold (or perhaps silver gilt) models of the shrines of the first Imams.

The craft industries and Shiʿi inscriptions

We have already noted the use of Shiʿi inscriptions on religious textiles from Safavid Iran and the Deccan (see above p. 94). The Shiʿi inscriptions vary: they include the *Nad-e ʿAli*, such invocations as *ya Husain shahid*, "Oh Husain, the martyr", or *ya imam mazlum*, "Oh, innocent Imam", and animal faces hidden in the calligraphic design which may reflect the idea of ʿAli as "lion of God". In addition, Shiʿi hadiths are occasionally to be found e.g. on a textile sold recently on the art market bearing the words, "The Prophet, may God pray for him peace be upon him, said, 'I am from Husain and Husain is from me'."[88] Textile items other than tomb covers might also be embroidered with Shiʿi inscriptions. For example, the Qutbshahi ruler, Qutb al-Mulk, had a handkerchief which was embroidered with the name of the twelve Imams.[89]

Vast numbers of textiles, as we have seen, were produced as coverings for the cenotaphs of the deceased. Not surprisingly many tombs of more humble Shiʿi people also bore such inscriptions.[90] However, such inscriptions are widespread in other media, particularly on metalwork, where they appear as the main decorative elements in the overall designs of numerous objects. Perhaps surpris-

[86] ʿAli 1832, pp. 30–32.
[87] Naqvi 2006, pp. 61–63.
[88] Sotheby's 1.4.2009 lot 115.
[89] Rizvi 1986, vol. 1, p. 296.
[90] At a seminar on the Iranian mortuary landscape held in Oxford in 2007, P. Khosronejad showed images of a number of such tombstones from the cemetery in Fal.

ingly, this was already a feature of Iranian metalwork in the late 15th century, before the rise to power of Isma'il I and the Safavids. For example, one of the units of a bronze lampstand commissioned by Timur for the shrine of Ahmad Yasavi in Turkistan city bears some of the names of the Imams,[91] while a late 15th century Turkoman dervish vessel, or *kashkul*, from North-west Iran is decorated with the prayers for the fourteen Immaculate Ones.[92] On the lid of a jug, dated 889/1484, made by Husain ibn Mubarak Shah, previously in the Nuhad es-Said collection, is the *Nad-e 'Ali* (the well-known prayer to 'Ali),[93] though it is always difficult to be certain whether lids are contemporary with their parent objects. In fact the first definitely datable use of the prayer to 'Ali on metalwork is on an inkwell in the V&A dated 1513.[94] The *Nad-e 'Ali* then becomes very common on metalwork, another early 16th century example being a fine inkwell and pen-case in the Benaki Museum, signed by the craftsman, Mirak Husain Yazdi.[95] Numerous other examples of Shi'i inscriptions can be seen in museums or on the art market: a late 15th century bowl in the Aron collection[96] and a lidded bowl of 1678–79 in the V&A[97] are both decorated with the prayer for the fourteen protected ones, and the latter also has the *Nad-e 'Ali*, while a magic bowl dated to 1655–56 in the Ashmolean Museum also has prayers for the 14 Immaculate Ones,[98] while another dated to 1725–26 has the prayer and the *nad-e 'Ali*.[99]

Although the metalwork produced under the Shi'i dynasties of the Deccan is much less well-known, these same inscriptions are equally common on published pieces. Thus, for example, a Deccani salver is decorated with the Shi'i *shahada* and the Qur'anic words, *nasr min allah* (Sura 61:13), while a gilt bronze or brass, openwork Indian *'alam* in the shape of a hawk is actually composed of the *Nad-e 'Ali* (Pl. 3.15).[100] A stem bowl manufactured in the Mughal empire, which was Sunni, but decorated with Shi'i inscriptions, may have been destined for a member of the Safavid royal family.[101] The forms of a group of Deccani bronze pieces in the David collection, Copenhagen, decorated with this same selection of inscriptions, contrast markedly with traditional Indian forms used for other bronzes of the period, like the Hindu style of fountain in the same collection.[102] And similar inscriptions find their way onto Deccani artillery pieces. A cannon barrel which stands outside the Gol Gumbaz in Bijapur has its mouth decorated with the names of the twelve imams in twelve large roundels.[103]

Pl. 3.15: Openwork gilt bronze 'alam in the shape of a hawk, ht. 35 cm, w. 20 cm, India, 17th century. Victoria and Albert Museum no. I.M.163-1913. Photo: Victoria and Albert Museum.

91 Komaroff 1992, p. 249.
92 V&A 755–1899, Komaroff 1992, no. 23.
93 Allan 1982, no. 25.
94 Melikian-Chirvani 1982, no. 118, pp. 282–83.
95 Allan 2003, pl. 8.14 p. 219.
96 Allan 1986, no. 40, pp. 146–47.
97 Melikian-Chirvani 1982, no. 155, pp. 336–37.
98 Savage-Smith 2003, pl. 9.4 p. 244.
99 Sotheby's 1 April 2009 lot 98.
100 Welch 1985, no. 209, pp. 310, 312–13; no. 220, pp. 324–25.
101 Welch 1985, no. 119, pp. 190–91.
102 von Folsach 2001, pls. 549–50.
103 Cousens 1916, pl. III.

Steel objects were also decorated with Shi'i inscriptions, especially when they had talismanic significance. Thus, for example, a steel *bazuband* (armlet) in the Tanavoli collection bears the *Nad-e 'Ali*, and may well have been used by a wrestler *(pahlavan)*—in Shi'i popular belief, 'Ali was a great wrestler, so the prayer to 'Ali would have been particularly appropriate.[104] A late 18th century axe-head in the same collection bears the names of God, Muhammad and the next six Imams, and another of its inscriptions calls on 'Ali for help.[105] Inscriptions on a butcher's balance call on 'Ali for forgiveness for the owner's sins, and reminds him that he is the rescue ship for all,[106] and the head of a dervish staff consists of the name of 'Ali with its mirror image.[107] Inscriptions were also used to decorate the silver pilgrim tokens produced in Mashhad, as already noted above (Chapter 2).

Ceramics decorated with Shi'i inscriptions, on the other hand, are rare. One example is a blue and white jug in the Godman collection, dating from 1697–98, which bears the words, "Drink water, and pray God to curse Yazid".[108] This inscription indicates that the piece was made to be used at a public drinking fountain, or *saqqa-khaneh*. In Shi'ism, sharing water commemorates the story of Abu'l-Fazl at the battle of Kerbala, who insisted on getting water for the women and children on Husain's side, despite having both his hands severed by the enemy. An 18th century Chinese porcelain bowl inscribed with the *Nad-e 'Ali* and the saying, 'There is no conqueror except 'Ali, and no sword except for Dhu'l-Faqar', suggests that such items were specially ordered from the Far East by Iranian Shi'is.[109]

Talismans were also decorated with Shi'i inscriptions. Some may simply have the names of God, and the Panjetan, i.e. Muhammad, 'Ali, Fatima, Hasan and Husain, or the names of the Imams.[110] However, there are also more elaborate examples e.g. an agate talisman in the Bibliothèque Nationale in Paris, which has in the centre the words, "Muhammad is the prophet of God, and 'Ali is the friend of God", and around it the *Nad-e 'Ali*.[111] The names of Imams and the *Nad-e 'Ali* also appear on seals.[112]

And numerous everyday objects were decorated with similar inscriptions. For example, an Iranian 18th or 19th century wooden comb is carved with the names of the Prophet, Fatima, 'Ali, Hasan, Husain, Ja'far and Musa,[113] while clay prayer tablets may also be decorated with such inscriptions.[114]

Unfortunately, we know very little about shrine libraries, and research into their holdings could yield an immense amount of information about the tastes of their patrons and users. A visit to the library of the shrine of the Imam Reza some years ago left a lasting impression on the author of the richness of that collection. The only two Qur'ans which seem to have been illustrated from any of these libraries are two superb Saljuq examples from the library of the shrine of Fatima in Qum.[115]

In concluding this section of the discussion, it is important to stress that the quality of the objects in the shrines was not confined to those particular objects. The palaces of the rulers of Iran would have been just as richly stocked. However, objects kept in palaces were not visible to the general public: the local shop-keeper or artisan's only hope of seeing the treasures of the age was to visit the shrines of the Imams.

[104] Allan and Gilmour 2000, no. G.4, p. 310.

[105] Allan and Gilmour 2000, no. G.12, pp. 316 and 529.

[106] Allan and Gilmour 2000, no. J.1, pp. 332 and 530–31.

[107] Allan and Gilmour 2000, no. G.11, p. 314. Another published example has a head in the form of *Ya 'Ali*, see Frembgen 2003, Abb. 20.

[108] Godman 1901, pl. 48, no. 242.

[109] Porter and Barakat 2004, no. 94.

[110] Kalus 1986, nos. II.1.15, 16.

[111] Kalus 1981, nos. III.1.18–22, pp. 82–84, III.1.26, p. 86. See also Kalus 1986.

[112] Kalus 1981, nos. I.2.2.14, p. 43, I.2.1.4, p. 36. See also Kalus 1986.

[113] Frembgen 2003, Abb. 46.

[114] Frembgen 2003, Abb. 62.

[115] Pourjavady 2001, pp. 62–63, 64–65.

Shi'ism and the steelworking industry

Let us now turn to another material: steel. One of the most intriguing aspects of the art history of Islamic Iran concerns the Iranian love for steel not just for weapons, but for a huge variety of other objects, both religious and domestic. In no other culture that I am aware of has steel been such a popular medium for such a rich variety of artefacts. The question then is this: is there a link between steel and Shi'ism, or is this a nationally or culturally rather than religiously focussed interest?[116]

In early Islamic Iran, although there are references to steel mirrors, and occasionally to other steel objects, the primary use of steel was for armaments. The first recorded use of steel in quantity for other purposes occurs in the mausoleum of Sultan Oljeitu at Sultaniyya, built between 1307 and 1314.[117] Here, according to contemporary and later descriptions, the doors were of smooth sheets of steel or steel-faced wood, alternating with areas of steel lattice work: the lattice consisted of a geometric arrangement of bars joined by loaf-sized bosses, which in their turn enclosed smaller bosses the size of oranges. In addition there was a huge grille which separated the main area of the mausoleum from that containing the body of Sultan Oljeitu, again in lattice work, which according to one account was "made in the form of big apples on a sword". There were smaller lattices in the doors through the grille. The grilles and doors were heavily inlaid with gold and silver. According to Olearius, the bars were "about the bignesse of a mans arm, and so neatly wrought that the Junctures are hardly discernible". If one tallies up the amount of steel in the mausoleum, it comes to some 20,000 steel cakes, or five tons—enough to provide all the equipment for a Mongol army.

The mausoleum was an immensely important and influential building. The size of its dome was never surpassed in Iran, and it stood for the ensuing centuries as a landmark, geographically, historically, and architecturally. There seems little doubt that, at the time, the use of steel on this scale was to emphasise the glory, power, wealth and military might of the Il-Khanid ruler, but there are interesting overtones. First, according to Rashid al-Din, the Mongols had their own annual festival commemorating their own, mythical, discovery of iron.[118] Moreover, Ghazan Khan (whose name in Mongolian incidentally means "metal-pot"), according to a 14th century Byzantine historian, "was very fond of the mechanical arts; no one surpassed him in making saddles, bridles, spurs, greaves and helmets; he could hammer, stitch, and polish, and in such occupations employed the hours of his leisure from war."[119] So the Mongols evidently had more than a passing interest in this metal. It is also interesting to note that Shah 'Abbas the Great, 300 years later, was noted for his ability as an armourer.[120]

The way in which Shi'i shrines from the 15th century onwards are kitted out in steel, suggests that Oljeitu's mausoleum had a major role in setting the standards for future shrines, and probably other mausolea too. The first record of a steel cage or grille (Arabic *darih*, Persian *zarih*, in India *zereh*) surrounding a cenotaph in a shrine comes from a century later, not through a literary text but through a surviving object. In the museum of the Shrine of the Imam Reza in Mashhad is the door of a steel *zarih* commissioned by Shah Rukh, signed by Ustad Shaikh Ali Khudgar Bukhara'i, and dated 817/1414–15.[121] It continued to be in use there for at least 150 years, for another inscription on it records its repair in 1545–46. We know that in the early 20th century the cenotaph of the Imam Reza at Mashhad was surrounded by three such steel grilles, the innermost plain, the middle one decorated

[116] The section on steel following is based on Allan and Gilmour 2000, to which the reader should turn for details.

[117] Allan and Gilmour 2000, p. 285

[118] DeWeese 1994, pp. 274–75. I owe this reference to Teresa Fitzherbert.

[119] Polo 1993, vol. 2, p. 478, n. 2. I owe this reference to Teresa Fitzherbert.

[120] Allan and Gilmour 2000, pp. 81–82.

[121] *Arts of Islam* 1976, no. 245.

Pl. 3.16: Shrine door signed by Kamal al-Din
Nazuk, 144.3 × 39.7 cm, probably Isfahan,
dated 1110/1698–99. Photo: J. W. Allan.

Pl. 3.17: Steel zereh door in the shrine
of Sayyid Muhammad Shafti, Isfahan,
dated 1260/1844. Photo: J. W. Allan.

with gold and jewels, and the outer one inscribed with the whole of Sura 76,[122] so there is no doubt
that at Mashhad the tradition continued. Sadly, in recent years, steel *zarih*s at the shrines have all too
often been replaced by modern silver ones. Some ten years ago, on the art market, there was a *zarih*
door reputed to have come from a shrine in Iraq (Pl. 3.16). It is signed by the famous Isfahani Safavid
steel-smith, Kamal al-Din Nazuk, and is dated to 1698–99, during Shah Husain's reign.[123] We know
that in 1694 Shah Husain put a steel grille into the shrine at Samarra, though that was renewed in
1868–69 by Nasir al-Din Shah. He must have also been busy at Kerbala or Najaf.

There is an interesting record of the installation of a new steel *zarih* at Kazimain.[124] Shah Abbas I
apparently ordered one or more huge steel *zarih*s to be installed around the two wooden cenotaphs,
in order to protect them against theft and plunder. Following the interrupting of diplomatic relations
between the Safavids and the Ottomans, transport of the *zarih*s was delayed a long time and they
finally arrived some 70 years later, in November 1703. They were accompanied by an Iranian delega-
tion that included a large number of people of high religious rank, ministers and others, preceded by
the Shaikh of Islam, the Shaikh Ja'far al-Kamra'i. After the installation of these steel *zarih*s over the
two graves there was a big celebration, which included thousands of Iranians and Iraqis.

The continuing popularity of steel *zarih*s in Iran is shown by a 19th century *zarih* in Isfahan, in
the shrine of Sayyid Muhammad Shafti (Pl. 3.17). It dates from 1844, though its upper part was only
added in 1904–5.[125]

[122] Allan and Gimour 2000, pp. 286–87.
[123] Allan and Gilmour 2000, pp. 290–92.
[124] Al-Yasin 1963, pp. 164–65.
[125] Allan and Gilmour 2000, pp. 288–89.

Other steel items which embellished shrines were steel door plaques,[126] in which the openwork was probably set against a gilt copper sheet, as in an example in the David collection, Copenhagen (Pl. 3.18). It bears part of a longer inscription, which is known from other such plaques, the words here reading: *wa akhihi asadallah musamma bi-'Ali*, "and his brother, Lion of God, named 'Ali".[127] Other Shi'i inscriptions originally spread over sets of door plaques include in one case blessings on the twelve Imams, and in another case blessings on the Prophet, 'Ali, Hasan, Husain, Fatima and Khadija (one of the wives of the Prophet).[128]

Pl. 3.18: Door plaque, steel against a gilded copper ground, 42.5 × 14.8 cm, Iran, 17th century. David Collection, Copenhagen no. 17.2-25-1994. Photo: David Collection.

Steel was used for other shrine items too, for example, *ziyarat-namehs*. A *ziyarat-nameh* bears a prayer which the pilgrim recites in the shrine, asking for God's peace upon the Imam buried there and upon the rest of the family of the Prophet. One from Kerbala is in the Tanavoli collection.[129] With its openwork inscription, this is an extremely laborious item to make of steel, and illustrates the strong link between steel and Shi'i shrines. Steel objects were also donated to shrines: for example, in the early 18th century, Sultan Husain donated a number of steel objects to the shrine in Mashhad, including a pen-box and a ewer.[130] And there was wide selection of other Iranian religious objects made of steel, including dervish crutches, dervish axes, bazubands, and *kashkuls* (dervish begging bowls)[131] and of course *'alams* (religious standards). These are discussed in Chapter 4.

However, perhaps the most important group of objects associated with Shi'i shrines in Iran are steel padlocks.[132] There are two sorts of padlock in this context. First, is the shrine padlock, which is used to fasten the door of the *zarih*. The door is opened by the guardian of the shrine to extract money and any other small offerings or religious notes that have been inserted through the grille by pilgrims. One of the principal officials of the shrine is indeed known as the Keeper of the Key. He is responsible for the key to the lock of the *zarih*, and hence the cleaning of the inside of it, and is usually part of a hereditary family. It is customary for pilgrims to shrines to kiss the grille, the pavement, and especially the padlock that hangs from the door. Sykes writes that "every pilgrim, after holding and kissing the lock on his own account, must do so likewise on behalf of his living relations and friends, whose petition to visit the shrine in person is thereby placed before His Highness" (i.e. the Imam).[133] The importance of this lock spills out into common parlance, for Tanavoli notes that the expression, "By such and such an Imam, whose lock I have grasped (so many times)" is a way of swearing to the

126 Allan and Gilmour 2000, pp. 292–302.
127 von Folsach, Lundbaek and Mortensen 1996, no. 265.
128 Allan and Gilmour 2000, pp. 296–97.
129 Allan and Gilmour 2000, p. 306.
130 Allan and Gilmour 2000, pp. 524–25.
131 Allan and Gilmour 2000, pp. 307–20.
132 Allan and Gilmour 2000, pp. 402–20.
133 Sykes 1910, p. 253.

truth of something, among those who have made an important pilgrimage.[134]

Another pilgrimage practice is making a request and a corresponding vow. For example, a pilgrim might pray for success in a business venture and make a vow to pay so much to the shrine if he is successful. As he makes the vow the pilgrim tears off a small piece of fabric from his clothing, or takes a piece of wool or thread of some sort, and ties it to the grill. Alternatively he attaches a padlock to it (Pl. 3.19). This action signifies the binding of the pilgrim to his intercessor, i.e. the Imam buried there, and acts as a reminder to the intercessor of the pilgrim's request and promise. Locks are also attached by pilgrims to other grilles, e.g. the steel window in the shrine of the Imam Reza in Mashhad, which faces the tomb chamber and separates it from the outer part of the shrine complex. It is a favourite place to hang locks, especially as it is now forbidden to do so on the grille around the tomb. A further, specifically Shi'i use of steel padlocks is also worth noting. In the 19th century at least, lock-wearers were one of the groups who participated in the Muharram processions.[135] The locks were physically attached to the lock-wearer's skin, a way of entering into Husain's sufferings through mortification of the flesh, and also a reminder to the wearer of the role of the Imam as intercessor.

The mechanisms used in Iranian padlocks are numerous: barbed-spring, bent-spring, helical-spring, shackle-spring, notched shackle, hook and revolving catch, notched shackle and rotating disks, and combination. Many have multiple mechanisms. The importance of locks for Iranians until the 20th century cannot be overestimated. Almost every town bazaar included a locksmithing section, and in Zanjan alone, for example, in the late 19th century there were 300 locksmiths. The names of most Iranian metalworkers have disappeared from the pages of history, indeed they were never there. But some locksmiths have remained famous. Yaqut, for example, records a locksmith by the name of Abu Bakr 'Abd al-Rahman ibn Ahmad ibn 'Abdallah al-Marwazi al-Qaffal, who was a famous locksmith and legal scholar in Merv in the 10th century. According to the same author, a Tashkent locksmith made a padlock which, with its key, only weighed a *daniq* (1/6 *mithqal*). This work excited universal admiration, and Abu Bakr, not to be outdone, made a padlock

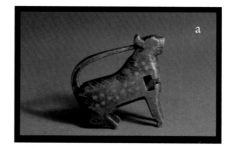

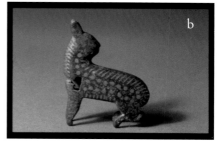

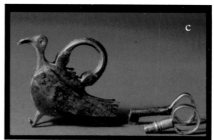

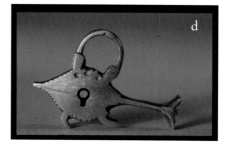

Pl. 3.19: Steel padlocks: a) lg. 5.5 cm; b) lg. 4.6 cm; c) lg. 10 cm; d) lg. 5.4 cm; Iran, 19th–20th century. Tanavoli collection.

weighing only a quarter of a *daniq*.[136] Much later, in the mid-16th century, the Safavid prince Sam Mirza, described a contemporary locksmith, Maulana Ustad Nuri Quflgar, "He was among the great ones of his time and rare ones of this age. In the craft of lockmaking he was so outstanding that he made twelve locks of steel, [each one of which] would fit inside the shell of a pistachio nut. And there

134 Tanavoli and Wertime 1976, p. 24.
135 Tanavoli and Wertime 1976, illus. 9.
136 Yaqut vol. 4, pp. 511–12, trans. p. 532.

was a key for each of the locks."[137] As the inscription on an Isfahan lock in the Mashhad Shrine Museum says: "The fashioning of a lock like this requires effort and skill. All crafts when compared to lockmaking are nothing."[138]

This is not of course to say that Shiism was the only driving force behind the extraordinary popularity of steel padlocks in Iran: padlocks have an obvious use in securing valuables, and they were widely used in other popular religious, or superstitious, contexts.[139] But in no other society do padlocks seem to have been produced in such number, and such variety, and that must have been for the most part due to Shi'i pilgrimage.

Shi'ism and the arts of the book

Behnd the arts of the book in the Shi'i tradition, both in terms of calligraphy and painting, stands the figure of 'Ali ibn Abi Talib, and his importance should not be under-estimated. The treatise on calligraphers and painters, composed by Qadi Ahmad Qumi c. 1606, has an Introduction which is headed: "On the appearance of the *qalam* (reed pen) and the first appearance of writing, with the tracing of the origin of the latter to His Holiness the King of the Throne of Sanctity, the Amir of all Amirs, 'Ali ibn Abi Talib".[140] Dust Muhammad's Preface to the Bahram Mirza Album affirms the importance of 'Ali: "(the kufic script) reached perfection at the glorious hand of the Prince of the Faithful and Imam of the Pious, the Conquering Lion of God, 'Ali ibn Abi Talib. The reed-riding fingers of no creature have ever passed through the field of writing like the miraculous, cavalier fingers of that majesty."[141] In addition, Qadi Ahmad relates a number of traditions containing 'Ali's comments on writing, e.g. "Your duty is to (acquire) good writing for it is the key to your subsistence", "Learn a good style of writing, writing is an adornment of the possessor of accomplishments", and "The beauty of writing is the tongue of the hand and the elegance of thought".[142] He also includes in his work a versified treatise by Sultan-'Ali Mashhadi, written in 1514, which includes the following words:

> The foundation of the name of writing consists in the practice of virtue,
> In which case Murtada 'Ali is (present) from the beginning,
> As he is present in all sciences.
> He is the *imam* of sciences for those learned in science …
> The aim of Murtada 'Ali in writing
> Was not merely characters and dots,
> But fundamentals, purity, virtue;
> And he pointed to this by the beauty of his writing.[143]

Qadi Ahmad relates that examples of 'Ali's calligraphy existed in his day, and he comments that "None wrote better than that holiness, and the most excellent *kufi* is that which he has traced." Dust Muhamad adds that "the distinguishing characteristic of that majesty's script, after its clarity and loveliness, is that the head of the *alif* as written by him is split in the value of half a dot, and wherever letters are parallel to each other on the front and back of a page, black is on black and white on

137 Tanavoli and Wertime 1976, p. 19.
138 Tanavoli and Wertime 1976, p. 108.
139 Tanavoli and Wertime 1976, pp. 20–22.
140 Minorsky 1959, p. 48.
141 Thackston 2001, p. 7.
142 Minorsky 1959, p. 51.
143 Minorsky 1959, pp. 107–8.

white."[144] Qur'ans ascribed to 'Ali evidently existed in Safavid times, and a Qur'an transcribed by 'Ali was also reported to be in the possession of Burhan Nizamshah.[145] Qadi Ahmad also notes that the calligraphic tradition was handed down through the family of the Prophet

> Thereafter the one who wrote excellently was His Holiness, the magnanimous Imam, the chosen one of the Lord of the Heavens, the commander of the faithful, Hasan, who used to transcribe the Qur'an. One Qur'an in the writing of His Holiness was in the library of the King … Sultan-Shah Tahmasp.

Further on he mentions the fourth Imam, Zain al-'Abidin, and the eighth Imam, 'Ali Reza, both of whom "wrote excellently and set standards in writing. There exist copies of the Qur'an in their noble writing."[146]

'Ali also holds a key position in the painting tradition. Dust Muhammad writes[147]:

> It has been recorded that the first person to adorn with painting and illumination the writing of the Word that is necessarily welcomed was the Prince of the Faithful and Leader of the Pious, the Conquering Lion of God … 'Ali ibn Abi Talib, and the gates of this commodity were opened to this group by that majesty's pen. A few leaves, known in the parlance of painters as *islami* [the vine-and-tendril illumination motif], were invented by him.

Qadi Ahmad too makes this point:

> The portraitists of the image of this wonderful skill trace this art to the marvellously writing *qalam* of the Frontispiece of the Five Members of the "Companion of the Cloak" i.e. 'Ali … and they cite the fact that among the miracle-working pictures from the *qalam* of that Holiness, which are adorned by his gilding, they have witnessed with their own eyes the signature: "This was written and gilded by 'Ali ibn Abi Talib."[148]

Qadi Ahmad then proceeds to a versified story about Chinese artists and 'Ali[149]:

> I have heard that Chinese artists,
> When they became "producers of likenesses" for the first time,
> Mixed paint with the heart's blood
> And sketched images of roses and tulips.
> Their brush of hair became like a hair
> From their desire to split hairs.
> They adorned one page with flowers
> According to the manner and beauty which they wished.
> The painting was called *khita'i* ("Chinese"),
> Because the Chinese reed had succeeded in producing it.
> When the cycle of prophetic mission reached Muhammad,
> (And) he drew a line across all other faiths,
> The Chinese wrong-doers
> Traced the first images;
> Provocatively they embellished a page
> And asked the king of Prophets to produce something similar.
> It was not a page embellished,
> It looked like a tray filled with tulips and roses.

[144] Thackston 2001, p. 7.
[145] Rizvi 1986, vol.1, p. 285.
[146] Minorsky 1959, pp. 53–55.
[147] Thackston 2001, p. 11.
[148] Minorsky 1959, p. 174. The same story is provided by Dust Muhammad, see Binyon, Wilkinson and Gray 1933, p. 183.
[149] Minorsky 1959, pp. 174–75.

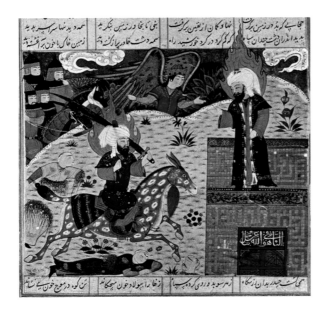

Pl. 3.20: Gabriel shows the prowess of 'Ali to the Prophet Muhammad, Ibn Husam's *Khavar-nameh*, Shiraz c. 1480. Museum of Decorative Arts, Tehran, fol. 112. After Gray 1961, p.105.

From the very infidelity of their hearts,
They carried the painting as a challenge
To the Shah of Men, 'Ali.
When the King of Holiness saw what they had painted,
By miraculous power he took the *qalam* from them,
And made an Islamic world-ravishing tracing,
Which struck dumb the Chinese people.
As the original fell into their hands,
Their other images grew inferior.

It has long intrigued observers that the tradition of figural painting is far stronger in Iran than in the rest of the Arab world, and some have attempted to link that with Shi'ism. This is a complex problem. First, although the above quotations establish a link between painting and 'Ali, it is by no means clear how and when that link came about. Certainly it gives the impression of reading back into history a much later cultural situation. Secondly, it should be noted that there is an abundance of miniature painting in Iran prior to the rise of Twelver Shi'ism as the state religion. Thirdly, painting arguably reaches its greatest heights, not in religious manuscripts, but in Firdawsi's *Shah-nameh*, or "Book of Kings". Fourthly, the religious element in Persian miniature painting is as much, or indeed more sufi that it is Shi'i. It is worth noting, however, that the holiness and other special qualities attributed to the 12 Imams in Shi'i theology, and the redemptive role of the Imam Husain, when combined with their obvious humanity, may well have encouraged artists to depict these individuals, in the same way as Christians choose to depict Christ—God come to earth as a man, redemptive Saviour of mankind.

However, rather than enter into a theological debate, let us turn to the development of the painting of Shi'i Imams and Shi'i themes during the Safavid and Qajar periods, and see the extent to which these developments mirror the developing role of Shi'ism in Iran during those times. Peterson, in his doctoral thesis, explored the way in which Shi'i perspectives appear in Timurid and early Safavid painting.[150] He distinguished two phases, the first under the Timurids, in which representations of 'Ali show him as one of the orthodox Sunni caliphs, and as a central figure of the original Sufi fraternities. Hence, according to Peterson, he represents Islamic esotericism within the Sunni world. More important for the purposes of this book is the second phase, which starts in the late 15th century, and continues strongly in the 16th, in which 'Ali's role is revised to being the first Shi'i Imam, the hero of the Shi'i community. It is first to be seen in a Turkman copy of the *Khavar-nameh* of Muhammad ibn Husam, painted in the Shiraz style c.1489.[151] Many of its original 155 miniatures have been dispersed, but predominant among their subjects are 'Ali and his followers. Particularly noteworthy are pictures of 'Ali's apotheosis, and of the angel Jabra'il showing 'Ali's prowess to the Prophet (Pl. 3.20).[152] 'Ali's role is central to both illustrations, and both he and Muhammad are given haloes.

[150] Peterson 1981, pp. 1–56.
[151] Peterson 1981, p. 24–25, where he quotes Rypka, who describes the work as an epic poem "in which the victory of the Safavid Shia being already imminent the epic tradition becomes Shiitic and the Imam Ali takes the place of the chief hero".
[152] Peterson 1981, p. 24, figs. 10–11; Gray 1961 pp. 106–7.

The developing role of 'Ali in the Shi'i consciousness is best demonstrated by a 1595 manuscript of the *Rawzat as-Safa*, "Garden of the Pure", by Mirkhwand, which has 13 illustrations with a strong Shi'i slant. In 5 of them, Muhammad and 'Ali are given flame halos and veils, and in these 'Ali takes up conspicuous positions. Of the other three orthodox caliphs, only Abu Bakr is depicted, and only in one miniature, where he is shown carrying Muhammad on their approach to Mt. Sawr; in another miniature 'Ali is shown on Muhammad's shoulders, destroying pagan idols (Pl. 3.21). It is not difficult to read into these an order of precedence which places 'Ali first.[153] Other indications of the growing impact of Shi'ism can be seen in the 1521 manuscript of the *Ahsan al-Kibar*, "The Best of the Greatest", in the St. Petersburg Public Library. This has 39 miniatures,

Pl. 3.21: 'Ali on Muhammad's shoulders destroying pagan idols at the Ka'ba, Muhammad ibn Khwand-shah's *Rawzat al-Safa*, ?Shiraz 1595. Chester Beatty Library, Dublin, Per 254 fol. 83b.

most of them portraying the lives of the Imams, and it shows yet more contempt for the caliphs with a picture of them burning in hell.[154] In a 1567 copy of Nizami's *Asar al-Muzaffar* the Ka'ba bears the Shi'i *shahada*.[155] In these sorts of ways, 16th century Safavid painting moves into a strongly Shi'i phase.

Nevertheless, it is one of the surprises in the cultural history of Iran that religious painting does not seem to have developed more comprehensively during the Safavid period. It was not in fact until the 19th century that Qajar artists produced representations of Shi'i histories intended for the viewing of the entire Iranian public. The vehicle for this was the Safavid *ta'ziyeh*, but now the expression became popular instead of aristocratic, and the theme of 'Ali as the chief hero gave way to the martyrdom of Husain. Let us trace, as far as we can, the way in which these changes came about.

First of all we know that by the 18th century there had developed Muharram processions which illustrated moments in the Kerbala narrative. Salmons and van Goch in 1737 described the procession they saw:

> Triumphal arches here and there display victory and honor with their decorations showing Hussein's every attribute. Outstanding in the large public processions are the big theatrically arranged wagons showing scenes of his life, his deeds, his battles, and his death. These wagons are often pulled about accompanied by people in armor, flags, and emblems of war and victory, depicting some of Hussein's deeds. For example, a wagon representing the death of Hussein has a deck-like cover coated with sand to represent the arid battlefield. Underneath people are lying thrusting their heads, arms, and hands through holes in the cover so they will lie on the sand above to appear as dismembered limbs, sprinkled with blood or red paint and colored with a deathly pallor so as to look most natural. Hussein, pallid and bloody, is lying on another wagon. Several living doves sit on his body, while others are nesting in his blood. After a while, the men under the cover release their bonds, two at a time, so that they can "fly to Medina" to announce Hussein's death to his sister. Wherever this wagon passes, the people set up such wailing to show their grief in so many ways and with such conviction, imitation and naturalistic representations that one wonders at their capacity to give vent to such appropriate signs of suffering so realistically.[156]

[153] Peterson 1981, p. 25ff; Arberry 1962, pp. 30–31 and pls. 21–23; Wright 2009, fig. 9; Peterson discusses the veil further on pp. 34–35.

[154] Stchoukine 1973, pp. 45, 47.

[155] Arberry 1962, pp. 13–15: the miniature concerned is not illustrated.

[156] Chelkowski and Dabashi 2000, p. 51.

they are translations of the *ta'ziyeh* into visual art (Pl. 3.23).[170] These include a scene with 'Abbas on horseback presumably seeking water, Husain and his horse covered with arrows, 'Ali Akbar in battle, Husain holding the dying 'Ali Akbar in his arms, Husain demanding water from the enemy for his youngest son, 'Ali Asghar, and the heads of the martyrs mounted on spears.

Such paintings are to be found in numerous other buildings in Iran. Thus, for example, the hall in the Harun-e Velayat was decorated round about AD 1900 by the same artist, Sayyid 'Abbas Shahzadeh, as the *buq'a* of the Imamzadeh Zaid[171]: his paintings here include the figures of 'Ali with his sons Hasan and Husain, and of Husain, and separate battle scenes of 'Abbas and 'Ali

Pl. 3.23: Husain at the battle of Kerbala demanding water for his son, 'Ali Asghar, who is then shot with an arrow, painting in the Imamzadeh Zaid, Isfahan, 1905–6. Photo: P. Chelkowski.

Akbar. The late Qajar *buq'a* of the Imamzadeh Ibrahim in Kashan has pictures of Husain cradling 'Ali Akbar, and of Husain's death,[172] while the *buq'a* of Agha Husain Khvansari, in the Takht-e Pulad cemetery in Isfahan, has paintings of 'Ali, seated, with Hasan and Husain in neighbouring niches; Fatima, seated, holding Hasan and Husain as children; 'Abbas mounted as standard-bearer; and 'Ali Akbar in a battle scene.[173] The *buq'a* of the Imamzadeh Sayyid Taj al-Din Ghareb in Shiraz, dated 1310/1892–93, has pictures in tilework.[174] These include the seated figure of 'Ali, and a number relating to Kerbala, including Husain on the battlefield of Kerbala, and three pictures of 'Abbas seeking water from the Euphrates. Other buildings with pictorial tilework are the Husainiyeh Mushir in Shiraz (1876), where they decorate the pediment above the box where important spectators watched the *ta'ziyeh* plays,[175] and the Imamzadeh Ibrahim in Shiraz which dates form 1315/1897–98.[176] This has scenes from the Kerbala story arranged in a large lunette-shaped panel, and separate images of other Imams. All these Kerbala paintings either served as the back-drop to the recitation of the Kerbala story, or as the back-drop to actual performances of the *ta'ziyeh* dramas.

A number of shrines (*buq'a*) in Gilan, usually square with low, pyramidal roofs, and a portico on one or more sides, are decorated with Kerbala scenes, inscriptions and Shi'i symbols.[177] These are usually painted, but in at least one case are in tilework. Particularly noteworthy are a group

[170] Godard 1937; Newid 2006, pls. F3–5, G.1, G.4, H.1–2, I.1–2, J.1–6, J.12, J.14, L.5; Chelkowski and Dabashi 2000, pls. 3.14–16, 3.18; Mirzaee Mehr 2006, figs. 42–43. For the correct dating see Peterson 1981, p. 146, quoted by Chelkowski 1989, p. 104, and Honarfar 1965, p. 389.

[171] Honarfar 1965, p. 389 n. 2; Newid 2006, pls. D.1–2, F.2, G.2, H.3.

[172] Newid 2006, pls. F.8, H.5.

[173] Newid 2006, pls. C.4, D.4, D.9, E.1, F.1, G.5, H.4; Honarfar 1965, pp. 657–59.

[174] Newid 2006, pls. C.5, F.6, G.6–8.

[175] Chelkowski and Dabashi 2000, pls. 3.17, 19–20; Chelkowski 2001, p. 326.

[176] Newid 2006, pls. D.5–7, G.10, H.6, J.7, L.4, L.6.

[177] Sutudeh 1977, pls. 19–21, 63–64, 113–15, 127, 147, 149, 159, 167, 169–70, 191, 196, 201, 207, 209–10; Chelkowski and Dabashi 2000, p. 61, and p. 65 n.21; Mirzaee Mehr 2006, throughout.

of shrines in Lahijan and its surrounding district.[178] Dated tombstones suggest that there may have been shrines on some of the Gilan sites in the Il-Khanid or Timurid period,[179] but those standing today appear to be Safavid or later, and most probably Qajar. Unfortunately, many of these shrines are reported to have been destroyed. Certainly, their full significance remains to be determined.

The best known series, however, is to be found in south-west Iran, in the tilework decoration of the Tekiyeh Mu'avin al-Mulk in Kirmanshah,[180] mentioned above (p. 59). The tiles are the work of the Tehrani tile-maker Sayyid Muhammad Hasan.

There are eleven tilework plaques representing the Kerbala story. In one of them (Pl. 3.24), the battle of Kerbala is over, and the family of the Prophet who have survived the battle are shown held captive at Yazid's court in Damascus. To the left of the ruler are a European ambassador and his private counsellor, recognised by their dress and by being seated in the western-type chairs which customarily were offered to European guests at Qajar receptions. At the foot of the throne stands the new imam, Zain al-'Abidin, followed by Husain's sister, Zainab. The three small figures beneath Zainab probably represent

Pl. 3.24: The court of the Caliph Yazid, tile plaque by Sayyid Muhammad Hasan, Tekiyeh Mu'avin al-Mulk, Kirmanshah, 1918–19. Photo: J. Golmohammadi.

Husain's daughters, Sakina, Ruqayya and Fatima. In accordance with the *ta'ziyeh* characterisation of the caliph Yazid, which was designed to instil in the audience violent repudiation of Yazid as arch villain, Yazid is dressed in bejewelled clothes and surrounded by such symbols of luxury and vileness as bottles of wine and gaming boards. Radiating from a gold plate placed on the throne at Yazid's knees is a multi-coloured flame to represent the halo for the Imam Husain's head, which is presented at court as the prize trophy of the Syrian troops. In Yazid's left hand is a cane with which he strikes the mouth of Husain and knocks out his teeth in a single blow, to which Zain al-'Abidin laments: "Dost thou with thy cane, oh tyrant, strike the very lips that the Prophet himself did kiss?"

There are various stage devices shown here which emphasise the way *ta'ziyeh* painting derives directly from the dramas themselves. For example, the wine bottle, the cane, the chairs and clothes of the European envoys, the veils of 'Alid women (to disguise the men enacting female roles)—all these are stage devices which have been reproduced literally by the artist. So, too, the single tile pictures of

178 In addition to sources quoted in the previous footnote, see Rabino 1915–16, pp. 293–98.
179 E.g. Rabino 1915–16, pp. 309–10.
180 For a discussion of the building and its tilework see Peterson 1981, p. 107–19, from which much of the following description is taken, and for further images see Newid 2006, pls. B.4, C.6, F.7, G.9, H.7–8, I.3–4, J.8–10, J.17–18, K.1, M.2.

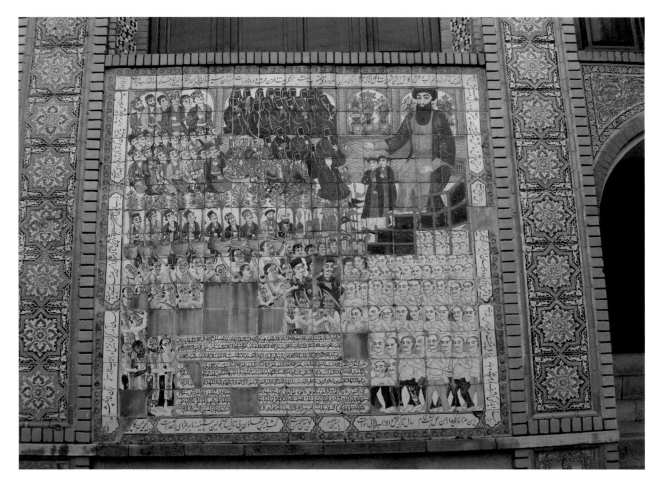

Pl. 3.25: *rawzeh-khani* (public recitation of the Kerbala story), tile plaque by Sayyid Muhammad Hasan, Tekiyeh Mu'avin al-Mulk, Kirmanshah, dated 1337/1918–19. Photo: J. Golmohammadi.

Husain mounted on his horse holding Ali 'Asghar, with the words *Ya Husain mazlum*, "Oh Husain, the innocent", and of 'Ali Akbar/Qasim his body pierced by arrows dying in the arms of Husain, with the words, *ya Qasim ibn Hasan*, "Oh Qasim, son of Hasan", are based on the way the scene was shown in the live drama.

Another tilework plaque depicts the arrival of the *ahl al-bayt* at Medina, and a further nine represent events in the Kerbala story as dramatized in the *ta'ziyeh* repertory: Za'far the jinni offering to assist Husain; Qasim and 'Ali Akbar fighting; Husain and 'Abbas fighting the Syrians; the martyrs' death on the Kerbala plain; the *ahl al-bayt* delivered from the ruins; the *ahl al-bayt* led to Damascus; Sulaiman ibn Bard Khuza'i burying the dead; and Mukhtar avenging the martyrs' death. Incidentally, in the image of Sulaiman ibn Bard Khuza'i burying the dead, there is a flag on the ground bearing the words we have seen before, the slogan, *nasr min allah wa fath qarib*, "victory from God and swift conquest".

A further tile plaque illustrates the Muharram mourning rituals on the Day of 'Ashura (Pl. 3.25). The preacher is seated on the minbar, addressing groups of men and women, while below is a procession with groups of men engaged in beating their chests or slashing their foreheads with swords, the blood running down their faces and chests. Also to be seen in the procession are banners topped with

Pl. 3.26: Gold medal of Muhammad Reza Shah at the
Shrine of the Imam Reza, dated 1349/1971:
a) obverse, the Shah praying by the zarih;
b) reverse, dome and minarets of the shrine.

'alams in the form of a hand. At the lower left is inscribed in Arabic the *Ziyarat-e Imam Husain*, a prayer greeting the Imam, and around the edge of the panel is an inscription in Persian, a mourning poem focussing on Kerbala, ending with the name of the patron and the date.

Perhaps surprisingly, recitation of the Kerbala story supported by one or more narrative paintings was never adopted in India. In the late 19th century Mawlawi Mihdi Husain introduced painted curtains in the mourning session, and the women in his household even staged dramas similar to Iran's *ta'ziyeh*, but these never caught on, the more so since the Awadh *'ulema*, or religious scholars, ruled against the use of religious paintings as backdrops for mourning sessions.[181] However, portraits of Imams were produced: a canvas portrait of 'Ali was brought from India and ceremoniously conveyed to Tehran on the orders of the ruler of Iran, Nasir al-Din Shah Qajar (1848–1896),[182] and in the Khalili collection are a group of twelve 19th century Indian paintings of the Imams, together with a painting probably from 19th century Lucknow which shows 'Abbas, Husain's standard-bearer, on horseback, following the tradition of portraits of the Mughal emperor Shah Jahan.[183]

The Pahlavi dynasty in Iran was strongly Shi'i and devoted to the 8th Imam, the Imam Reza. Reza Shah, Muhammad Reza Shah, and other members of the family bore the Imam's name, and in 1971 Muhammad Reza Shah issued a medal showing him praying by the *zarih* of the 8th Imam, with the dome and minarets of the shrine on the reverse (Pl. 3.26). However, it was the Iranian Revolution which seriously redeveloped art in its service—indeed art proved to be among its greatest allies. "The story of the Islamic Revolution in Iran is the story of carefully and deliberately constructed images, drawn from the depth of Persian historical memory, orchestrated towards specific political ends."[184] Nowhere more so than in the design of revolutionary posters,[185] where a number of themes and propagandist techniques stand out. Among them, and particularly interesting in the light of earlier discussions, is the use of the calligraphic message. As Chelkowski and Dabshi point out, the overwhelming majority of Iranians do not speak, read or understand Arabic, but the aura of sanctity which the use of Arabic gave to posters made the Iranian Revolution of 1978–79 "the Islamic Revolution".[186] Persian texts on posters generally consisted of a revolutionary message, and were usually written in *nasta'liq* without diacriticals. Arabic was always used for a Qur'anic passage or for a *hadith*, i.e. a tradition relating to the Prophet or the Imams, and was almost invariably written in *naskh* and with diacriticals. Since there is a doctrinal injunction against making a mistake in reading the Qur'an, the Qur'an is always written with its full vowelling. The greater legibility

[181] Cole, quoted by Chelkowski 1989, pp. 110–11 n. 11.
[182] Wilson 1896, p. 213.
[183] Vernoit 1997, nos. 33–34.
[184] Chelkowski and Dabashi 2000, p. 41.
[185] Hanaway 1985, though his corpus of posters consists of examples with military themes or themes relating to Ayatollah Khomaini and the Shah; Chelkowski and Dabashi 2000, pp. 194–211 discuss posters more fully.
[186] Chelkowski and Dabashi 2000, p. 98.

Pl. 3.27: Iranian poster, Iraq-Iran War (1980–88). Photo: P. Chelkowski.

Pl. 3.28: Poster of ʿAbbas, purchased in South Beirut, 2007. Photo: J. W. Allan.

Pl. 3.29: Poster of Husain, purchased in South Beirut, 2007. Photo: J. W. Allan.

of *naskh* and the use of diacriticals thus emphasises that whatever is written in Arabic is the word of God. Moreover, the calligraphy provides the caption by which the images can be interpreted.

> A mere rising sun in red, over a dark horizon, would yield a … range of multiple and conflicting readings. It is only when the caption reads, in Arabic, "Verily! Life is belief and fighting [for that belief]" that the red and the black, the shapes and the postures, begin to register their intended meanings.[187]

The second point to emphasise is that graffitis and posters were for ever referring to the battle of Kerbala and the martydom of Husain. A poster from Qazvin provides an instructive example (Pl. 3.27).[188] A Revolutionary guard, rifle in hand and a gun-turret behind him, wears a green head-band bearing the words *allahu akbar*, "God is the greatest", he wears a red arm band, red being the colour of martyrdom, bearing the words *nasr min allah wa fath qarib*, "help is from God, and swift conquest", and he carries a red flag bearing the *shahada*, while above him floats an image of the shrine of Husain at Kerbala surrounded by an aura of light. And the Iran-Iraq war, too, becomes an object of Shiʿi propaganda, as for example two posters depicting the Behesht-e Zahra Cemetery south of Tehran, where so many of those who died in the war are buried.

> Above each tombstone is a metal stand housing a photograph of the soldier-martyr. The mood of the poster is seraphic rather than tragic; the cemetery is bathed in a gold and crimson glow, above which is a flight of souls into the deep blue. The brightly colored bandannas floating around their heads invoke the Shiʿi heroes and heroines and the vengance of God. In another Behesht-e Zahra poster, intended to comfort the bereaved women, a group of women veiled in *chador* sit around a flower-strewn tomb; they are joined by the radiant veiled apparition of either the sainted Zeynab or that of Fatima Zahra herself, come to commiserate with them.[189]

[187] Chelkowski and Dabashi 2000, p. 105.
[188] Chelkowski and Dabashi 2000, p. 116, pl. 7.16.
[189] Chelkowski and Dabashi 2000, p. 162, pls. 9.30, 9.31.

Pl. 3.30: 1,000 rial banknote, show-
ing the Madrasa Faiziyeh in Qum.

a b c d

Pls. 3.31a–d: Iranian postage stamps showing a. the Shrine of Fatima, Qum; b. flag
with Sura 61:13; c. and d. Madrasa Faiziyeh, Qum. Photo: J. Curtis.

Pl. 3.32: 10,000 rial banknote, Chel-
kowski and Dabashi 2000, pl. 12.9.

Also directly relevant to Shi'ism are the numerous posters depicting the Prophet, 'Ali and/or Husain which continue to have such wide distribution today in countries with Shi'i populations: Iran, India, Syria and Lebanon, for example (Pls. 3.28–29). One particular poster of the Prophet as an adolescent has recently been shown to be based on a photograph made by Lehnert in Tunis c. 1904–6, later used in a postcard circulating in the early 1920's. To the postcard image has in some instances been added a Persian inscription:

> Blessed portrait of the venerated Muhammad, at the age of eighteen during his journey from Mecca to Damascus when accompanying his venerated uncle on a trade expedition. The portrait due to the paint-brush of a Christian priest; the original painting is at present in a "Muze-ye Rum".

Muze-ye Rum is used to suggest a museum in a city in the west. The attribution conveniently deals with the problem of Muslim piety objecting to images, and specifically the portrayal of the Prophet, and suggests that Christians recognise the prophethood of Muhammad, which of course they do not.[190] The surprising willingness of the Revolution to adopt western models for its images is also to be seen in a picture of Khomaini which was based on a painting of the Virgin Mary by the Spanish artist Murillo (1617–82).[191]

The Islamic Revolution also brought changes in the public art associated with banknotes and stamps, which now bear images of Shi'i buildings and personalities. Soon after the revolution, the portrait of Ayatollah Muddarres appeared on the 100 rial note, the Shrine of Fatima at Qum on the 5,000 rial note, and the Madrasa Faiziyeh in Qum on the 1,000 rial note (Pl. 3.30), the latter to be replaced, after his death, with a portrait of Ayatollah Khomaini. The Madrasa Faiziyeh was particularly important to the Revolution, since it was there that Ayatollah Khomaini delivered the anti-Shah and anti-American sermons which precipitated the 1963 uprising: both the Madrasa and the Shrine of Fatima were used too on postage stamps (Pl. 3.31). A revolutionary form of the Muharram procession was also depicted on the 5,000 and 10,000 rial notes (Pl. 3.32).[192] Stamps in Iran are not permitted to portray living heroes, but with the death of Khomaini his portrait appeared on numerous stamps, as did a number of other heroes or martyrs associated with the revolution. In particular there was issued a series of fourteen stamps devoted to the Ayatollah, showing the most important events of his life. Many others bore images which were essentially political, but included Shi'i ideas, colours or symbols designed to rally the country behind the government, particularly in the war against Iraq.[193]

The Shi'i painting tradition in India is less well known. It is certainly there in the early 17th century, for Muhammad bin Amir Wali, a traveller from Bukhara, saw placards showing the twelve imams in the Muharram celebrations in Lahore in 1635–36:

> All the princes, officials and aristocrats prepare two sets of placards, one consisting of beautiful paintings representing the 'imams. The other contains repulsive figures representing Ibn Muljam. ... From the sixth to the tenth of Muharram ... they form processions displaying their placards and, along with their mourning songs, abuse and condemn the Imam's enemies. ... The organizers of the placards then rush to the *nakhkhas* (cattle market), where the holders of the two different sets of placards, joined by the crowds there, come to blows with each other.[194]

Flimsy representations of Buraq are also often carried in Indian Muharram processions.[195]

The Iranian type of portrait poster is today widely distributed among Shi'i communities in India, but in India there have also been various local painters who depicted Kerbala or related scenes. For example, in the conference on "The Art and Material Culture of Iranian Shiism", held in Oxford in 2006, Sadiq Naqvi presented a paper illustrating works by 20th century Hyderabadi artists, presently hanging in the Aza Khana-e Zehra in Hyderabad. The artists included Chand, Baqar Amanat Khan, Gul Mahar, Muhammad Ali Jawadi, and Syed Ahmed Nawaz Abidi. Some of the paintings were of Muharram processions, but most were of Kerbala scenes.[196]

[190] Centlivres and Centlivres-Demont 2006.

[191] Chelkowski and Dabashi 2000, pp. 172–73.

[192] For banknotes see Chelkowski and Dabashi 2000, pp. 194–211.

[193] For stamps see Chelkowski and Dabashi 2000, pp. 214–29.

[194] Quoted by Rizvi 1986, vol. 2, p. 199.

[195] Rizvi 1986, vol. 2, p. 350.

[196] The proceedings of the conference are due to be published under the editorship of Pedram Khosronejad.

Conclusion

Although we have looked in some detail at the impact of Shi'ism on the craft industries, there are particular areas which we have not considered in any depth. One of them is the use of colour, about which very little has been written. Black is certainly the colour of mourning and the colour associated with Muharram and its mourning processions. Kerbala paintings are replete with women dressed and veiled in black, those attending the mourning ceremonies wore black, Indian 'alams are usually displayed with black cloth wrappings, and in India in Muharram other furniture, like minbars, are also dressed in black. White too is a mourning colour, for it is the colour of the shroud used for burial, and hence a colour associated with maryrdom. Green is the colour associated with the Prophet and his family. Contemporary pictures of the Prophet, 'Ali and Husain show them with green head-scarf or turban, and green was also significant historically. For example, a white royal umbrella given by the Sultan of Gujerat to Burhan Nizamshahi was dyed green as a result of Burhan's conversion to Shi'ism,[197] and in the early 19th century Mrs Meer Hasan Ali mentions green canopies for processional taziyas.[198] Particular colours were associated by the medieval Shi'i scholar, Alem Majlesi, with the Prophet's daughter, Fatima *az-Zahra*, "the radiant": her light was white in the morning, yellow at midday and red in the evening.[199] Post-Revolutionary Iranian posters showing Fatima in red may therefore relate not only to the blood of martyrdom but also to her particular radiance.[200] Another use of red is to represent the enemy.

Another area needing research is Shi'i costume. We have mentioned talismanic jackets, but particular headgears may also have reflected Shi'i belief. Thus Shah Ni'matullah, the founder of the Ni'matullahi order of dervishes, who died in 1431, invented a woollen piece of headgear with five gores, indicating devotion to the Panjetan. He later replaced this with one of twelve gores, to indicate devotion to the twelve Imams. It was this which Haidar, father of Isma'il I, adopted, and in its crimson form it became the symbol of the early Safavids, giving them the name *qizil-bash*, "redheads". Isma'il I is also reported to have had a seal with 12 sides.[201] Under Isma'il I's influence, Isma'il Adilshah (1510–34) ordered his soldiers to wear similarly-decorated headgear.[202] Abdullah Qutb Shah, for the Muharram ceremonies, wore garments embroidered with the names of the Prophet's descendants,[203] but how widespread this type of approach was it is at present impossible to say. Such areas of study need more research.

Headgear also reminds us of the association of Shi'ism with particular numbers, five for the Panjetan, twelve for the twelve Imams. How far we can push this link is impossible at present to say. Schroeder suggested that twelve-sided tomb towers might be due to the impact of Twelver Shi'ism, but Hillenbrand has convincingly discounted this theory.

> Firstly, since towers with sides numbering between four and forty-four are known, it would be odd if the number twelve did not turn up occasionally … If it had been customary to proclaim one's Shi'ite belief through one's choice of tomb, 12-sided mausolea should occur much oftener than they do and thereby reflect the strength of the Shi'ite minority … It is certain that Shi'ites had no preference as regards the ground plans of their mausolea—so much so that the Fatimids built, so far as is known, no 7-sided tombs … It cannot be proved that all those buried in the few surviving 12-sided tombs were

197 Rizvi 1986, vol. 1, p. 287.
198 Rizvi 1986, vol. 2, p. 328.
199 Shirazi 2005, pp. 97–98.
200 Chelkowski 2005, colour pl. opposite p. 173.
201 Anon 1873, p. 206, quoted by Hillenbrand 1974, p. 185.
202 Rizvi 1986, vol. 1, pp. 161, 188, 266–67.
203 Rizvi 1986, vol. 2, p. 335.

the pair, and closer study reveals standards with inward facing dragons' heads, standards in the form of a stirrup, and two rather plainer types.[8] By the end of the 14th century the name of God appears as a finial.[9] In a *Khamseh* of Nizami written for Shah Rukh in Herat in 1431, we find a long-necked serpent, an equally long-necked dragon, a lion's head and a single, spear-shaped leaf, or trefoil with a crescent around its base.[10]

Sometime in the mid 15th century, however, the design destined to dominate standard style for the next 200 years was introduced—a flat, pear-shaped centre, an ornamental point, and double dragons with their heads turned outwards rather than inwards. In a miniature from the 1475–81 *Khamseh* of Nizami, produced in Tabriz, there are no less than 13 examples of this type of standard[11]: it was clearly the style favoured by the Turkoman rulers and their armies.

Further east, however, fashion was different. Bihzad's painting of the battle between Daryush and Iskandar, added to the manuscript of the *Khamseh* of Nizami c. 1493, shows a very different approach: a beautiful, cruciform, arabesque design.[12] Its continuing popularity in the east is confirmed by its depiction in a 1553 Bukhara manuscript in the Bodleian.[13]

Returning to Tabriz it is worth noting in passing the use of dragons as handles and ornaments in drawings and paintings associated with Siyah Qalem.[14] The next important source of information is Shah Tahmasp's copy of the *Shah-nameh*, which was the work of Tahmasp's court atelier in Tabriz in the second quarter of the 16th century. In it are depicted at least 30 different varieties of 'alam,[15] including the name of God, the lion mask, the dragon, flaming haloes (some with dragons hanging from them), together with arabesques and sun faces.

Qazvin painting of the 1570's and 1580's suggests a continuing development. Long-necked, single dragon's heads are still popular, circular or pear-shaped plaques with paired dragons and a variety of finials are widespread, and a trident design becomes increasingly popular. An all-over, probably pierced, arabesque design on a pointed oval disc is also found.[16]

Visual evidence in miniature painting of the first half to the 17th century is much rarer, probably due to the reduced numbers of royal commissions of luxury manuscripts, and the increasing taste for single-page drawings or paintings. From the middle of the century onwards, however, there is some evidence, notably in a group of manuscripts dating from the third quarter of the 17th century: for example, a *Shah-nameh* of 1654 in the Sadruddin Agha Khan collection, and one from c.1650 in the Chester Beatty Library.[17] From these it seems that interest in designs of military standards was on the wane. A thin-leaved trident design is now the commonest.

The pictorial evidence outlined so far demonstrates the use of standards in battle. Textual evidence also suggests that they could be indicators of the presence of the sovereign. Thus, Eskandar Beg Munshi describes Shah Tahmasp's personal banner at a battle against the Ottomans in 1534–35 as being surmounted by a gilded globe,[18] and soon after that Membré gives a detailed description of the banners which went in front of the king:

[8] Ipsiroglu 1980, pls. 19–20.
[9] E.g. Pope 1938, pl. 857; Gray 1979, pl. 116; Lentz and Lowry 1989, no. 46.
[10] Adamova 1996, p. 105.
[11] Gray 1979, pl. 134.
[12] Titley 1983, pl. 8.
[13] Robinson 1958, pl. XXIII.
[14] Ipsiroglu 1976, pls. 56A and B.
[15] Allan and Gilmour 2000, figs. 39a–b.
[16] Lowry and Beach 1988, p. 111 no. 120, p. 114 no. 130, p. 115 no. 137, pp. 183–86 no. 209; *Persian and Mughal Art.* 1976, nos. 19xv and 19xx.
[17] Arberry, vol. 3, 1962, mss nos. 270, 279, though the relevant miniatures have not been published.
[18] Savory 1978–1986, vol. 1, p. 114.

> In front go the banners, which they call 'alam, which are lances covered with red broadcloth, with two points, and on the top of the lance a circle, and, inside the circle, certain letters of copper, cut out and gilded, which say, *"'Ali wali Allah; la ilah illa Allah; 'Ali wali allah wa Allahu akbar ..."* They are carried in the hand on horseback.[19]

These 'alams clearly had a decisively Shi'i character.

So far, all the paintings and texts have suggested military use for these elaborate 'alams. However, by the early 17th century, if not earlier, standards had taken on a religious role as well. Kotov, in Isfahan in 1624–25, writes:

> In the mosque [unspecified] lie poles with flags, [which], like our church banners, are not used for anything except to be carried on festivals with the ikons, and among them these poles are carried on festivals and in front of the dead. And these poles are vine rods, long and thin, about 20 sazhen in length, and when they lift them the poles bend; and tied to the tops of them long narrow streamers about 3 sazhen long and half way down the poles and on top of the poles there are iron things like scissors or like a stork's beak and on other poles there are wicker crosses and spikes.

And in another passage he writes about the 'Ashura festival:

> the procession carries coffins decorated all over with strips of copper and tin and glass ... in front of those same coffins they carry the long poles described above; and in front of these coffins they lead horses with complete harness, and they bear helmets and armour, bow and quiver, sword and lance.[20]

There is also the evidence of Olearius. In the 1647 edition of his book there is an engraving of a firework display at the Shrine of Shaikh Safi in Ardabil. This shows what must be the "standard of Shah Isma'il" on a tall pole held by a courtier. The standard appears to be circular, with a central circular hole surrounded by a series of roundels, and is surmounted by some sort of pointed finial with a pair of dragons facing outwards, one either side of it.[21]

Turning now to surviving Iranian standards of the Safavid period, i.e. the 16th–early 18th centuries, three particular shapes stand out. First is the flat almond-shaped 'alam, on a steel shaft. The body of the 'alam has an ornamented blade rising above it between two projecting leaves. A dragon-head projects on either side of the body, and the decoration of body and central blade is pierced. A fine 16th century example has a pierced inscription, in mirror-writing, which calls on God, the Prophet and 'Ali, and, as happens in textiles, gives the impression of an animal, presumably lion, mask.[22]

Other examples of this form are common, but the Shi'i emphasis of their inscriptions varies. For example, a piece in the Tanavoli collection has the following: in the centre the names of God, Muhammad and 'Ali, in the trilobed medallion *ya fattah*, "Oh Opener", and in the trilobed palmette at the top, *huwa Allah subhanahu*, "He is God, praise be to Him".[23]

There is a large group of steel 'alams in the Topkapi Museum, Istanbul.[24] These have never been published in detail, and how many such objects actually reside there is unknown. Four of those illustrated here (Pl. 4.4) have round or almond-shaped bodies with projecting dragon-heads and a variety of leaf and/or medallion finials, while the fifth belongs to a second group, which will be discussed below. These Topkapi 'alams are of considerable interest. With their explicitly Shiite messages, especially the inclusion of roundels with the names of the twelve Imams on two of them, they are hardly likely to have been gifts from Safavid rulers to the Ottomans. There were a number of Ottoman vic-

[19] Membré 1994, p. 24.
[20] Kemp 1959, pp. 25, 31.
[21] Morton 1975, pl. Ic for the engraving, Olearius 1669, p. 175 for the description.
[22] Allan 2003/1, pl. 8.17.
[23] Allan and Gilmour 2000, p. 265 E.1.
[24] Allan and Gilmour 2000, fig. 41.

tories over the Safavids in the 16th century, of which the most famous was the battle of Chaldiran in 1514, in which Isma'il was so badly defeated by Sultan Selim that he even lost the royal harem. From which Ottoman victory each 'alam came is unknown, but this were presumably the mechanism by which they reached Istanbul.

A second group has a flat pear-shaped body, with projecting dragon-heads, and an ornamented top. The Topkapi example, with its projecting medallion bearing in openwork the names of God, Muhammad and 'Ali, and its body the phrase "victory from God and swift conquest", illustrates well the Shi'i beliefs of the early Safavid empire. The head of an example in the Tanavoli collection bears the slogan, *tawakkil 'ala Allah,* "Trust in God".[25] It has a magnificent set of openwork half-palmettes, culminating in a single palmette at the apex, forming a flaming nimbus. A maker's name is found on the shaft, one Haji Muhammad, who bears the *nisba* Ardabili and must therefore have been connected with the town of Ardabil in north-west Iran.

Pl. 4.4: Steel 'alams, Topkapi Museum, Istanbul. Photo: J. W. Allan.

Another example of this general style is, interestingly enough, to be found in the shrine of Shaikh Safi at Ardabil (Pl. 4.5). This 'alam has two additional projecting dragons where the blade joins the upper openwork medallion. The upper medallion bears the names of God, Muhammad and 'Ali, while the openwork inscription on the body reads *wa ma tawfiqi illa billah,* "My welfare is only in God", (Sura 11, "Hud", v. 88), followed by two epithets of God, the first concealed by the supporting bracket, the second reading, *al-'adhim,* "the mighty". The 'alam has been remounted at some stage, since its inscriptions face in different directions.

The 'alams from Topkapi give us the clue to the design of twelve roundels, for on two of those the twelve roundels hold the names of the twelve imams. In the Ardabil 'alam the names have not been included, but the roundels have been retained, providing a visual though non-inscriptional symbol of the Shi'i faith to believers.

Pl. 4.5: Steel 'alam, Shrine of Shaikh Safi, Ardabil. Photo: J. W. Allan.

The provenance of this group is likely to have been somewhere in north-west Iran, most likely Tabriz or Ardabil. First, the maker, or if not the maker, the repairer, of the Tanavoli 'alam was a native of Ardabil. Secondly, as if to back this up, one of the most notable examples of the style stands today in the Ardabil shrine.[26] Thirdly, this may have been the form of the standard of Shah Isma'il

25 Allan and Gilmour 2000, p. 271 E.4.
26 Allan and Gilmour 2000, fig. 42.

himself, as shown in the engraving of Olearius. Given too the richness of the illustrations of 'alams in the Shah Tahmasp *Shah-nameh*, which is generally agreed to have been produced in Tabriz, it is surely legitimate to suggest north-west Iran as the likely source.

A third group of 'alams is almond-shaped in form but unadorned either by dragon-heads, or leaf or blade finials. In the Tanavoli collection is a fine example of the type with a revolving unit in the centre (Pl. 4.6).[27] It is signed by the craftsman, Ustad Ibrahim, and dated to the year 1123/1711. The Qur'anic inscription is Sura 48, Surat al-Fath ("Victory") vv. 1–3:

> Lo! We have given thee [O Muhammad] a signal victory, that Allah may forgive thee of thy sin which is past and that which is to come, and may perfect his favour for thee, and may guide thee on a right path, and that Allah may help thee with strong help.

Another Qur'anic inscription appears on an example in Stuttgart dated 1124/1712[28]: Sura 110, "Succour":

> When Allah's succour and the triumph cometh and thou seest mankind entering the religion of Allah in troops, then hymn the praises of the Lord, and seek forgiveness of Him. Lo! He is ever ready to show mercy.

The first Qur'anic quotations, with its reference to victory, reminds us of the military background to 'alams,

Pl. 4.6: Steel and brass 'alam, probably Isfahan, signed by Ustad Ibrahim, dated 1123/1711. Tanavoli collection no. 57.

whereas the second, with its reference to mankind entering the religion of Allah in troops, is highly appropriate to Muharram processions involving vast numbers of local people.

Other Qur'anic quotations used are Sura 112 "Unity", and Sura 108 "Abundance". Neither of these has a message particularly appropriate to Shi'ite belief. A later example, dated 1203/1788 and hence likely to be Zand or Qajar in date, on the other hand, bears a saying attributed to the Prophet: "He who weeps over Husain is humble and [will go to] Paradise".[29] There is no doubting its Shi'i emphasis.

Turning to the provenance of this group, an example dated 1126/1714 has on its central shaft an inscription giving a slightly later date (1137/1725) signed by a craftsman named 'Abd al-Vahhab Isfahani[30]. Isfahan was well known as a steel making centre in Safavid times, is today a centre for the manufacture of steel 'alams, and another example of the style, dated 1705–6[31], is in one of the *mahalla* mosques in Isfahan, suggesting that it too is of local workmanship. This group is thus almost certainly of Isfahani origin. Their stylistic uniformity and homogeneity not only point to the same city for their production but also the same early 18th century workshop, while the piece dated 1203/1788 mentioned above shows the continuity of the style, almost unchanged, into the later part of the 18th century.

27 Allan and Gilmour 2000, p. 275 E.7.
28 Kalter 1987 frontispiece.
29 Sotheby's, 17 October 1984, lot 181; 25 April 1990, lot 117.
30 Sotheby's, 16 April 1986, lot 184.
31 Allan and Gilmour 2000, fig. 47.

Standards of this group all have sockets both above and below them on the shaft. This indicates that they decorated not the top, but the shaft, of an 'alam pole. These 'alams thus appear to have had no military function, but to have been purely religious, for use in Muharram processions. The lack of earlier examples, and the relatively large numbers of surviving pieces dating to the early 18th century, suggests that they may exemplify a fashion introduced at this period. It is perhaps significant that Shah Husain (1694—1722), from whose reign many date, was a Shi'ite Muslim of notable piety, and it may well be that his devotion was behind their manufacture. The fashion does not seem to have continued into the 19th century.

The piece belonging to an Isfahani mosque is decorated with a cuboid element on the shaft, which may be a lantern. Another 'alam has a cuboid element which is evidently meant to represent a building, for it has an arched window containing a grill on each side.[32] Moreover, the inscriptions on this latter piece are strongly Shi'i, those on the blades of the 'alam consisting of blessings to the twelve Imams, together with phrases saluting the Prophet, 'Ali and Husain, and Sura 61:13, while the inscriptions above the doors and windows of the building read: "O the innocent Imam Husain, martyred in Kerbala, lead me to the Truth." Surely we have here a stylised image of Husain's tomb at Kerbala.

Two later types deserve mention. First is the 'alam in the form of a hand. In Niebuhr's time, the dome at Najaf was surmounted by the representation of an open hand, presumably in metal, "which", he comments, "must represent that of 'Ali".[33] Drouville records its use for military purposes: "The flags (of the Qajars)," he says, "are red, surmounted by a silver hand, that of 'Ali",[34] and a steel 'alam in the form of a hand, bearing the words "Oh God" and "Oh Husain" in mirrored form making a small central animal face, was recently on the art market.[35] Small 'alams in the form of hands are popular today,[36] and the author saw large numbers for sale in recent years in the Tehran bazaar, though they are even more popular in the Indian sub-continent. The motif is also common on contemporary Iranian banners made of cloth.[37] The interpetation of the hand is various. To some Shi'is it is the hand of 'Abbas, to others it is the hand of 'Ali, while its five fingers can be taken as symbols of the Panjetan.[38] On a Safavid or Deccani tomb cover it appears as a border pattern, each hand bearing the words *rabbi allah*, "God is my Lord".[39]

Many 19th and 20th century Iranian standards are very different from those discussed so far, for they have not only a vertical axis, but also a horizontal one. On the horizontal one stands an array of steel items, lions and other animals, birds, vases, axes and so on. Where this idea came from and how it reached Iran is as yet uncertain, though it may have come from the Central European Schellenbaum. The Schellenbaum, or bell-tree, was a standard used by German troops as a musical instrument in the 19th century, and probably derived originally from Ottoman military bands.[40]

Before leaving Iran, a number of features of the contemporary use of 'alams and of the Muharram processions in general are worth noting. As we shall see, in Hyderabad 'alams are dressed up in textiles throughout the year, but especially during Muharram. In Iran they are only dressed up for the Muharram processions, but then not only with textiles (Cashmere shawls for example), but also with feathers. These apparently symbolise soldiers with their plumed helmets.[41] Another feature of

[32] Sotheby's, 16 April 1985, lot 147.
[33] Niebuhr 1776, vol. 2, p. 211.
[34] Drouville 1825, vol. 2, p. 118–19.
[35] Sotheby's 1 April 2009 lot 121.
[36] E.g. Tanavoli 2001, illustration on p. 319.
[37] Newid 2006, K.7, 11–13.
[38] Frembgen 1995, p. 200.
[39] Sotheby's 1 April 2009 lot 115.
[40] Allan and Gilmour 2000, p. 281; Zygulski 1992, pp. 96–97; for the most recent study of 'alams see Khavari 2004.
[41] Tanavoli 2001, p. 312.

the 'alams is that they are carried as symbols of a *mahalla*, or city or town quarter. Although not recorded until the 19th century, this may have been an early 18th century development, and would explain why so many similar 'alams have survived from that period. It is interesting to see this happening— 'alams coming from the military to the religious, but in the latter context being adopted by what is essentially a social grouping.

The Muharram processions in particular towns also include an unusual item, the *nakhl*, literally 'palm-tree'.[42] The largest and most famous *nakhl* is to be seen in the *maidan* (square) of Mir Chaqmaq in the city of Yazd (Pl. 4.7). Such *nakhls* are made of wickerwork and wood, and are shaped like a tear drop. During the 'Ashura ceremonies they are covered with a wide variety of materials—palms, feathers, paper ornaments, mirrors, carpets and textiles. Even though it bears no relationship in terms of shape, the *nakhl* is said to recall the bier or stretcher on which Husain's headless body was taken from the battlefield at Kerbala. Very little is known about the history of the *nakhl*, though an inscription in the Imamzadeh Isma'il in Isfahan records a firman of Shah Sultan Husain, dated 1115/1703, which, in perpetuity, exempts members of the local town quarter *(mahalla)* from the clothes and customs associated with the *nakhl* during the 'Ashura ceremonies.[43] *Nakhls* were widespread in Iran, at least in the Qajar period,

Pl. 4.7: *Nakhl* in the *maidan* (square) of Mir Chaqmaq in Yazd. Photo: J. W. Allan.

especially in towns along the edges of the Lut and Kavir deserts, and surviving examples weigh anything from 300–1500 kilos. Their origin is mysterious. However, given that the Shi'i mourning ceremonies themselves may have been influenced by the role of Siyavush in the *Shah-nameh*, a role which goes back to pre-Islamic times,[44] it is tempting to see the *nakhl* as a legacy of a much earlier, pre-Islamic past.

One further aspect of Muharram processions in Iran should be mentioned here: their role in the Islamic Revolution. Although we have distinguished the military use of 'alams from their religious use, the distinction is in reality a blurred one. For in Muharram processions, 'alams are symbolic of Husain's army at the battle of Kerbala. Standard-bearers and participants in the parades thus become the equivalent of Husain's troops, ready for self-sacrifice. This understanding enabled Khomaini to use processions as a means of politically mobilizing the population: revolutionary processions became a major force in the overthrow of the monarchy, and later enabled the government to rally popular support behind the Iraq-Iraq war. No wonder that these political processions were depicted on posters[45] and on banknotes[46] (Pl. 3.32).

[42] Chelkowski 2005, pp. 157–61.
[43] Godard 1937, pp. 136–37, who also, in Fig. 50, illustrates a *nakhl* in maidan in Taft.
[44] Yarshater 1979, pp. 90–93.
[45] Chelkowski and Dabashi 2000, p. 70 pl. 4.2.
[46] Chelkowski and Dabashi 2000, p. 200 pls. 12.8, 12.9, 12.10.

Let us now turn to the 'alams of Shi'i India. Here we find much less pictorial evidence than in Iran, making it impossible, so far, to trace the development of 'alam styles in India in the way that is possible in Iran. However, important information about 'alams is provided in various texts, and enough are depicted or have survived to provide some idea of the most widely used styles. Their military, totemic origin is suggested by a passage in the *Baburnameh*, where Babur (d. 1526) describes the ceremonies attached to the standards. He writes:

> The standards were acclaimed in Mughal [i.e. Mongol] fashion. The Khan dismounted and nine standards were set up in front of him. A Mughal tied a long strip of white cloth to the thigh-bone of a cow and took the other end in his hand. Three other long strips of white cloth were tied to the staves of three of the nine standards, just below the yak-tails, and their other ends were brought, for the Khan to stand on one, and for me and Sl. Muh. Khanika to stand each on one of the two others. The Mughal who had hold of the strip of cloth fastened to the cow's leg, then said something in Mughal while he looked at the standards and made signs towards them. The Khan

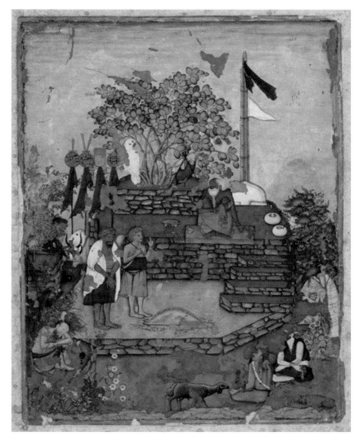

Pl. 4.8: A dervish receiving Ibrahim II Adil Shah under the 'alams, Bijapur, India, 1610. Bodleian Library inv.no. MS Douce Or.b.2(1) fol. 1a. Photo: Bodleian Library.

and those present sprinkled *qumiz* [fermented mare's milk] in the direction of the standards; hautbois and drums were sounded towards them; the army flung the war-cry out three times towards them, mounted, cried it again and rode at the gallop round them.[47]

On the other hand, an observation in the *Lata'if-i Ashrafi* suggests that 'alams had a religious role much earlier than Babur's time. For the author of the *Lata'if-i Ashrafi* says that Sufi sayyids, like Sayyid Muhammad Ashraf and Sayyid 'Ali Qalandar, "sat under the 'alam", and he recounts how *'ulema* and scholars visited the mosque in Jawnpur in Muharram to pay their respects to the 'alam. It has therefore been suggested that 'Ashura processions and 'alams were introduced into India by Sayyid Muhammad Ashraf Jahangir Simnani, who died in 1436–37.[48] Interestingly, an illustration from 1610 of a dervish receiving Ibrahim Adil Shah shows the dervish seated close to four 'alams, three of which bear names of the Panjetan,[49] and presumably exemplifies the idea of sitting "under the 'alam" (Pl. 4.8). Be that as it may, by the early 15th century 'alams evidently had a religious role in India.

[47] Randhawa 1983, p. 24.
[48] Rizvi 1986, vol. 2, p. 293.
[49] Zebrowski 1997, pl. 528.

The earliest examples of 'alams in Mughal painting are those in the famous, very large scale, *Hamza-nameh* manuscript, dating from c. 1562, which is now dispersed. Here we find the single dragon head on a long U-shaped neck, like those in the work of Siyah Qalem.[50] We see another such device on the top of the staff carried by a dervish in a contemporary painting,[51] indicating that by the mid 16th century it was used for both military and religious purposes. In the *Hamza-nameh* we also find an 'alam in the form of an eagle's head, as well as 'alams with designs more akin to Iranian examples—with a flat, pear-shaped centre above two outward-facing points, the pear shape surmounted by a boss, and the boss surmounted by a trident.[52] Another form has an ovoid centre, with a small sphere above, between outward-facing dragons.[53] A number of manuscripts from Akbar's reign help to fill out the picture. In the depiction of the acclamation of the nine standards in the manuscript of the *Babur-nameh* in the National Museum, Delhi,[54] we find that all the standards are of the same form, with a pear-shaped body surmounted by a trident. However, another picture of the same incident from a dispersed manuscript of the same text in the V&A[55] shows nine different 'alams made up of different combinations of spherical central elements, tridents, and the outer arms of tridents. Both images date from c. 1595–1605. The *Akbar-nameh*, dating from the early 17th century, is another useful source of images. Here we find the single dragon-head, definitely as a standard this time, together with a simple trident, and in another miniature a globular face (perhaps the sun?) with a smaller globe above.[56] Another pair of paintings in the *Akbar-nameh* shows a conflict between different Hindu groups, and illustrates a spear with a trident at the upper end—presumably the trident of Siva.[57] It is tempting to conclude that this is the source of the trident 'alam just described, and that the trident 'alam which we saw earlier in Iranian 16th–17th century paintings may also have come from India.

One other important group of representations should be noted: those in the Baadshahi Ashur Khaneh in Hyderabad, completed in 1596 by Muhammad Quli Qutb Shah. This ashur khaneh has exquisite tilework, the finest surviving in the Deccan, added by Abdullah Qutb Shah in 1020/1611. Here we find both depictions of 'alams, and other 'alam forms, surely intended to form a symbolic background to the metal 'alams which have always been displayed in the building during Muharram. The 'alams depicted (Pl. 2.34) are pear-shaped with dragons facing outwards, with a top consisting of seven leaves. They appear to have a pierced centre, and are very like those of the first Iranian group (above pp. 124–25). We have already noted the importance of this type of 'alam in Qutbshahi culture as a politico-religious symbol, witness its use in the interior decoration of the Chahar minar, dating from 1592, a very important building in the new late 16th century Qutbshahi capital of Hyderabad.

Although it is not possible to trace the development of Indian 'alams more accurately, it is possible to suggest locations for certain types. Thus, Hyderabad today is a centre for a style closely related to the first Iranian style, i.e. an almond-shaped body with a central inscription, surmounted by five projecting leaves, suggesting that this was probably its historic tradition. On the other hand, today in Lucknow we find a form with twelve roundels containing the names of the twelve imams, and a much longer point, often surmounted with a hand, again presumably reflecting a historic tradition in this area of India. Again, today in Lahore, 'alams are manufactured in the form of the hand of 'Abbas, and this style is particularly common in Pakistan.[58]

[50] Leach 1998, no. 2.
[51] Sellyer 2002, fig. 16.
[52] Sellyer 2002, fig. 69.
[53] Sellyer 2002, figs. 57 and 59. This also occurs in the *Akbar-nameh*, see Sen 1984, pl. 20.
[54] Randhawa 1983, pl. IV.
[55] Rogers 1993, pl. 2.
[56] Leach 1995, vol. 1, no. 2.143 on p. 285.
[57] Sen 1984, pl. 42.
[58] Frembgen 1995, Abb. 8, 10–12; Frembgen 2003, front cover.

Pl. 4.9: 'Alam with openwork inscription, brass, dated 1178/1764–5. Royal Ashur Khaneh, Hyderabad. Photo: Estate of Mark Zebrowski.

Pl. 4.10: Brass 'alams, the central one dated 1178/1764–5. Royal Ashur Khaneh, Hyderabad. Photo: S. Naqvi.

Certain other styles can probably be located in Hyderabad with some confidence. We may compare for example the design in the Baadshahi Ashur Khaneh with that of an 'alam in a design the Deccanis call tughras, that is 'alams with pierced inscriptions.[59] Another form, exemplified by a piece dated 1178/1764–65 (Pl. 4.9),[60] is presumably derived from Iranian examples like the Ardabil 'alam. The 'alam in the form of a hand is common today in Hyderabad (Pl. 4.10),[61] so perhaps it was popular there in Qutbshahi times.

From the discussion above, it will be clear that there are plenty of similarities between Mughal 'alams and those from Iran. This should come as no surprise. The widespread immigration to India from Iran, which brought to the Deccan the problem of relations between local Dakhanis and immigrant Persian Afaqis, would have also brought customs and objects of Iranian origin, and there was inevitably movement in the other direction too. We have also seen the way in which 'alams were sent around the Islamic world as gifts, witness the correspondence in the 1660s between the Nawab of Golconda and the Shaikh al-Haram in Mecca (above p. 72). However, it is worth pointing out that, as with textiles, there are problems with deciding where surviving pieces and particular styles were

[59] Zebrowski 1997, no. 530.
[60] Zebrowski 1997, pl. 490.
[61] Safrani 1992, pls. 1–2; Zebrowski 1997, pls. 529, 532, 542. In the latter it is combined with Zulfikar.

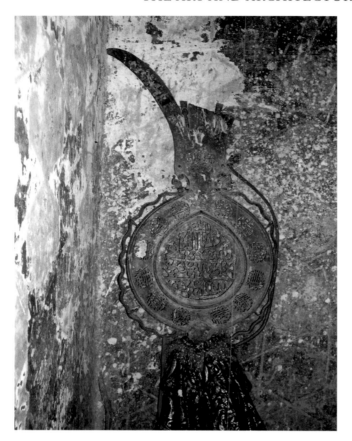

Pl. 4.11: Steel 'alam, India or Iran, c. 17th century. In the mausoleum of Ahmed I, Bidar, India. Photo: J. W. Allan .

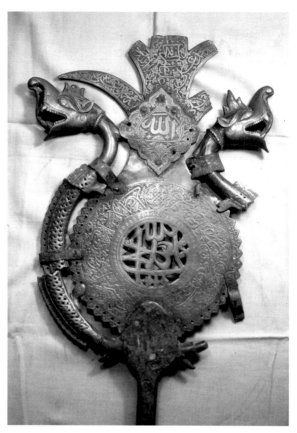

Pl. 4.12: Brass 'alam, India, 16th century. From the Shrine of Saikh Safi, Ardabil. National Museum, Tehran. Photo: J. W. Allan.

actually manufactured.[62] For example, 'alams which we ascribe to Iran are to be found in Indian shrines, while 'alams which we ascribe to the Deccan are to be found in Iranian shrines. Thus, in the tomb of the Bahmanid Ahmed I in Bidar, stand three rusty steel 'alams, one of which is appears to be Iranian 16–17th century (Pl. 4.11), and the Husaini 'alam at Bijapur has what looks like an Iranian 16th century steel centre, set in a Deccani mount. However, a magnificent brass 'alam from the Ardabil shrine, now in the National Museum in Tehran, has every appearance of being from India (Pl. 4.12). It bears the *nasr min allah* Qur'anic quotation, plus the *nad-e 'Ali*, so it is strongly Shi'i, but it also has two dragon heads which are typically Deccani.[63] That raises an interesting issue about one of a group of steel 'alams which, like the brass 'alam just mentioned, is in Tehran but originally came from the Ardabil shrine. For it has a dragon (if dragon it is) with a snake's body, running up the side, distinguished by its sinuous form. This is very unlikely to be an Iranian style, and we find it too in exactly the same form in one of the 'alams in Bidar. Hence, our attributions need to be treated with

[62] This idea was explored by Hamid Atighetchi in a paper entitled *'Indian and Persian Metalwork in the 16th Century'* at a conference on metalwork held at the Chester Beatty Library, Dublin, in 2004, but unfortunately his paper remains unpublished. Included in it was a late 16th century brass 'alam in a private collection made by Mahmud 'residing in Lahore'.

[63] Cf. Zebrowski 1997, pl. 543. For another somewhat similar 'alam see Gierlichs and Hagedorn 2004, fig. 1.

caution. More research may well show that the impact of India on Iran in this area is much greater than hitherto suspected.

Let us briefly return to the Baadshahi Ashur Khaneh in Hyderabad. Here we should notice the form of the great centrifugal inscription above the 'alams.[64] For this is almost certainly a copy of a textile type of 'alam which has continued through to the present day. For example, in the tomb of Abul Faiz in Gulbarga hang a modern pair of these textile 'alams, one decorated with the names of the Panjetan and the phrase "victory from God and swift conquest", its pair with the *nad-e 'Ali*, or prayer to 'Ali. Such 'alams are also depicted in occasional miniatures, for example a miniature showing Shah Jahan visiting Ajmer dating from c. 1656.[65] This makes it clear that this sort of item was a royal punka, or fan, but as another miniature shows it was also at a later date used by Hindus.[66] There are evidently cultural complexities here, to which we shall return.

The important role of 'alams is clear from Nizamu'-Din Ahmad's *Hadiqatu's Salatin,* in which he describes the Muharram ceremonies of Sultan Abdullah Qutb Shah (1626–72).[67]

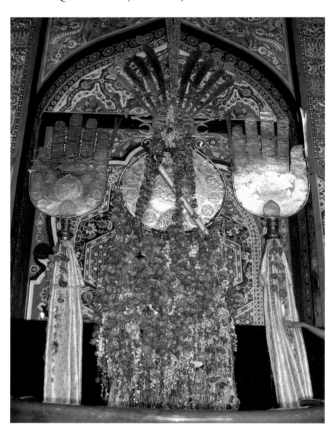

> Two lofty edifices ('ashur-khanas), one in the royal palace and the other in the bazaar had been constructed. Green and black carpets of broadcloth cover their vast courtyards. Their ceilings are hidden by swathes of blue velvet. Invocations and the names of the twelve imams are inlaid in beautifully painted and glazed tiles in both edifices ('ashur-khanas). Both are adorned with fourteen 'alams in the names of the fourteen impeccable ones. Their exquisite designs in gold and silver have been executed by expert artists and craftsmen. A length of brocade fourteen yards long, on which are woven the verses of the Qur'an, invocations and poetical verses, is clipped with each 'alam. The ornamentation and decoration of the 'alams are superb …

Today's 'alams are often thin sheet brass or silver, or even one suspects aluminium. But some Qutbshahi 'alams were certainly made of gold and studded with jewels. The lengths of brocade (*zarbafti*, or cloth of gold) are called dhatees, and are rectangular pieces of cloth tied over the bodi (or socket) of the 'alam, and hanging down to cover the naiza (the shaft). For most of the year the 'alams, like the minbar used at the weekly majlis, are dressed in black material, but during Muharram they are dressed in lavish dhatees (Pl. 4.13).

Pl. 4.13: Dressed 'alams in the Baadshahi Ashur Khaneh, Hyderabad. Photo: K. G. Ruffle.

[64] Zebrowski 1997, pl. 529.
[65] Beach and Koch 1997, pl. 41.
[66] Sen 1984, pl. 43.
[67] Rizvi 1986, vol. 2, pp. 335–38.

Nizamu'-Din Ahmad continues:

> In the afternoon the great sultan clad in garments embroidered with the names of the Prophet's descendants, slowly marches on a horse, or in a litter covered with black velvet and satin, specially prepared for 'Ashura ... Near the door of the *alawa*[68], the Sultan dismounts and enters, bare-footed, into the hall of the 'alams. There the Sultan, with his own hands, places garlands of flowers on the 'alams.

Not only are the 'alams dressed with dhatees, they are also dressed in flowers, in the same way as Hindu gods.

As the month of Muharram continues, further processions focus on the 'alams.

> On the eve of 6th Muharram, the *alams* of the bazaar *alawa*, are taken to the vast plain surrounding the Dad Mahal [House of Justice]. Lamps are lit on the roads from the bazaar and around the plain itself. In the bazaar, *tabut*, decorated with richly embroidered and gilded *gunbads* (canopies) are brought out with the 'alams ... On the morning of seventh Muharram ... the 'alam processions from the suburbs pass first before the Sultan ... The superintendents of the royal wardrobes are ordered to cover the 'alams from each *alawa* with lengths of silk. Purses full of coins are awarded to the attendants of the 'alams ... On night of 19th Muharram, the Sultan visits the palace *alawa* and places flower garlands around the 'alams.

Pl. 4.14: Mihrab of the Kotla, Ahmednagar, India. Photo: J. W. Allan.

The Muharram ceremonies practised in Hyderabad in the 1840's are described by Khwaja Ghulam Husain Khan.[69]

> Immediately after the appearance of the Muharram crescent the Husaini 'alam, Na' l Mubarak and 'alam Bibi are set up. The garland for the alams are donated by the king to earn long life. After two night-watches, a procession, headed by an elephant bearing the 'alam and accompanied by military contingents, moves bare-footed toward the Husaini 'alam, with thousands of civilians ... They (the people) tie the garlands round the Husaini 'alam ... On the tenth (of Muharram), all 'alams, taziyas and buraqs are carried in procession on the highway through (the) Husaini 'alam (ashur khaneh) to the Musi river. They follow the flag-decked elephants, bands and drums. Every Friday night the Husaini 'alam is separated from its rod and placed in a boat so that people can pay their respect.

The dressing of 'alams with dhatees and flowers leads us into a very interesting area of Indian 'alams, the way they reflect much wider Indian culture. First of all, we find them being adopted by Sufis. This use is exemplified by the miniature which have already mentioned showing Ibrahim Adil

[68] I.e. *allava*, a round hollow used as a fire-place in the courtyards of some Qutbshahi ashur khanehs, and hence the title of the building in which it is found.

[69] Rizvi 1986, vol. 2, pp. 341–46.

Shah of Bijapur being received by a Sufi dervish, with four 'alams behind him, three of the standard Deccani type, and the fourth in the form of a hand. In other words, he is seated "under the 'alam". Secondly, the Deccan witnesses an increasing interest in relics, which are often enclosed in 'alams. This is a topic we have discussed above (pp. 71–74) in some detail.

In addition we should notice the burning of incense. The Kotla in Ahmednagar, the Nizamshah Burhan's Shi'i college, has a mihrab filled with objects: lamps, ostrich eggs and pieces of cloth, incense and incense-burning vessels, an extraordinary mixture of mosque and

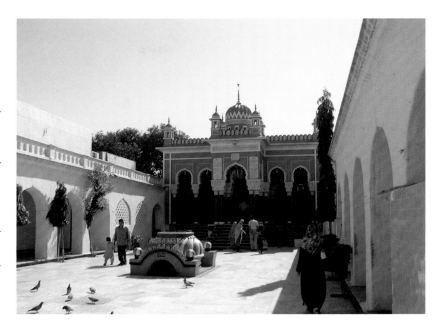

Pl. 4.15: Bibi ka Allava Ashur Khaneh, Hyderabad. Photo: J. W. Allan.

shrine (Pl. 4.14). And incense is used in Hyderabadi ashur khanehs too. At the Bibi ke Allava in Hyderabad it is burned inside and outside the building in an oodan, a metal incense-burner. The devotees may also bring their own incense to burn, when paying their respects to the 'alams. The ash of the ashur khaneh's oodan is considered to be sacred and is given to the devotees who apply to their foreheads in the same way as the Hindus apply vibhuti (sacred ash) in Hindu temples.

And then there is the allava, or fire-place, which gives its name to the ashur khaneh just mentioned (Pl. 4.15). The allava was the round hollow in which a fire was lit in the courtyards of the Qutbshahi ashur khanehs, around which both Muslims and Hindus gathered on Muharram nights to recite poems and sing folk songs about Kerbala. And still today, during the month of Muharram, the 'alams are processed round these allavas, and indeed the ashur khanehs are often named after them, as in the case of the Bibi ke Allava. In addition to the dhatees and flowers normally offered to the 'alams by Shiis, Hindus offer coconut and cooked rice.

How do we interpret all this? Naqvi lays emphasis on the needs of the Qutbshahi sultans to accommodate the heterogeneous elements in their multi-cultural society, and to promote tolerance. A key role in this policy of toleration was provided by the ashur khanehs and the 'alams they contained, as well as by the installation of 'alams in certain dargahs (sufi shrines). The Qutbshahs, according to Naqvi, redefined the significance of the 'alams and the ashur khanehs to attract the attention of the non-Muslim communities, and the 'alam was introduced as a symbol of piety, righteousness, and sympathy for the oppressed.

Naqvi also points out that at that period Deccani Hinduism was under the spell of the Bhakti cult. This laid more emphasis on the emotional aspect of worship, in which the devotee was expected to surrender himself and his worldly desires to God. Popular religion, in the same way, required rituals and religious ceremonies at shrines. Ashur khanehs and 'alams offered the Shi'i variation on this theme—they were a direct outcome of emotional attachment to Husain, and, as we have seen, the 'alams often contained relics, just as South Indian shrines commonly contained the relics of Buddhist, Jain or Hindu saints. The 'alam's hatelee, the central area representing the palm of a hand, and

bearing a tughra (a calligraphic design) inscribed with the names of the Shiʿi imams, provided fresh imagery to the eyes of the Hindu devotee, who had a long-standing tradition of worshipping the feet and palms of Hindu divinities. In Naqvi's opinion, "Qutb Shahi culture was based on the principle of sharing each others joys and sorrows irrespective of religious identity." One is tempted to be cynical—how many of us, after all, can hold to such morally upright intentions? And how, anyway, did the use of power affect such principles? Nevertheless, surprising things happen in India. There is for example a village close to Hyderabad whose inhabitants are 100% Hindu. Nevertheless, it has its own processions during the month of Muharram, when the story of Kerbala is told.[70] As Naqvi emphasises, the situation in India was not the same as that in Iran.

This comes out too in the architecture. Let us now return to the other buildings associated in India with the Muharram processions. Tekiyehs and Husainiyehs of course exist in Iran, but the Great Imambara in Lucknow was built not just for use during Muharram, when processions would proceed from it, and return to it, but also to house and display ʿalams throughout the year, so that the faithful could visit and venerate the objects at any time. And it was because of the ʿalams, and the barakat (or bless-

ing) which was associated with them, that its patron was buried in the centre of the great hall. This Indian idea of erecting a building for the ʿalams takes us well beyond Iranian horizons. Likewise, the Lucknow kerbalas were not built just as the places to which Muharram processions would go. They contained no body, but they were shrines in their own right, where ʿalams and tabuts were kept and venerated all the year round.

But they are also reflective of wider Indian culture in two other ways. First, they are related to what is technically known as "multi-aedicularity".[71] Aedicules are miniature buildings from which a full-scale building may be composed, or with which it may be decorated. Hence "multi-aedicularity" is the use of numerous miniature buildings in one of these ways. Multi-aedicularity is a very common feature of Hindu architecture, where it is used to decorate Hindu temples. And although tabuts are not used in the same way, nevertheless the idea of a miniature building, or model, almost certainly comes from that. And so tabuts themselves provide another way in which people of Hindu background can be drawn towards Shiʿism and feel part of it—they are symbols which are both recognisable and relevant (Pl. 4.16).

Pl. 4.16: Tabuts and ʿalams in the Husainabad Kerbala, Lucknow. The zereh is just visible behind the pier on the left. Photo: J.W. Allan.

[70] For this whole subject see Naqvi and Rao 2004.
[71] Lambourn forthcoming.

Secondly, tabuts are closely associated with a very elaborate Muharram tradition of carrying and burying taziyas in the grounds of these buildings. Some tabuts, made of metal, ivory or wood, are permanently sited in particular kerbalas, as reminders of the tomb of Husain—even though architecturally the two may have little in common. Some such tabuts are carried in Muharram processions. But taziyas are made by local people out of very flimsy material—split bamboo, paper, metal foil, tinsel and so on (Pl. 4.17),[72] and the Muharram processions end with the burial of these taziyas. This takes place in a special area associated with the local kerbala, a burial which reminds devotees of the burial of Husain after his death at the site of the battle of Kerbala.

This activity has been taking place at least since the early 17th century. Francisco Pelsaert of Antwerp, a factor with the VOC who lived in Agra from 1620–27, describes the first ten days of Muharram as follows:

Pl. 4.17: Taziyas in course of manufacture by local women near the Kazimain Kerbala, Lucknow. Photo: J. W. Allan.

> ... In the chief streets of the city the men make two coffins, adorn them as richly as they can and carry them round in the evening with many lights large crowds attending, with great cries of mourning and noise. The chief celebration is on the last night ... the outcry lasts till the first quarter of the day; the coffins are brought to the river, and if two parties meet carrying their biers (it is worst on that day), and one will not give place to the other, then, if they are evenly matched, they may kill each other as if they were enemies at open war, for they run with naked swords like madmen ... this continues till at least they have thrown them [the coffins] into the river.[73]

The rivalries exhibited by these types of tabut procession led to their being banned by the Mughal emperor, Awrangzib, in 1669.[74]

Tabuts and taziyas played an important role in the mourning ceremonies in Awadh under the Nawabs. Records surviving from Asaf ud-Dawla's court in the late 18th century show that at different stages of the ceremonies the Nawab would recite the *fatiha*, the opening sura of the Qur'an, over them, would circumambulate them, or place money in front of them, and on the 10th of Muharram the taziya procession would cross the river Gomti and the taziyas would be buried in the newly built

[72] E.g. von Folsach, Lundbaek and Mortensen 1996 no. 37, from Vellore, India, 1900.
[73] Rizvi 1986, vol. 2, pp. 297–98.
[74] Rizvi 1986, vol. 2, p. 299.

kerbala on the other side.[75] After 1808 the taziyas were buried in the Talkatora Kerbala.[76] Fascinatingly, at Bombay, the tabuts or taziyas, which would elsewhere be buried, are taken out into the sea as far as they can be carried, and abandoned to the waves.[77]

Interestingly, in Hinduism we find the practice of immersing Durga in the Ganges. This is related to Durga's ambivalent personality, and especially her dangerous aspects, and the desire to deal with her potential danger by the removal of her presence and the purification which immersion brings. In 2006, at the British Museum, a statue of Durga was made in the Great Court, with the objective of its immersion and dissolution in the Thames by Putney Bridge on October 2. The idea of burial is of course quite foreign to Hinduism, which practices cremation, so the two traditions are not identical. Nevertheless, there is an intriguing link between Hindu processional practices and the idea of immersing (in other words, dissolving a statue in water), and the Muharram procession leading to the burial of the taziya and its slow dissolution in the ground, or in the unusual case of Bombay, immersing it in the sea.

[75] Rizvi 1986, vol. 2, pp. 309–13.
[76] Rizvi 1986, vol. 2, p. 316.
[77] Hollister 1953, p. 173, quoting Birdwood.

CHAPTER 5

Conclusion

In the light of the preceding chapters we now need to look at the question: can one ever recognise art or architecture as Shi'i, and, if so, what then is the definition of Shi'i art ? Let us return to the shrines of the Imams in Iraq and Iran, which were the subject of Chapter 1. From the textual information which we compiled about those shrines, especially those at Kerbala, Najaf, Samarra and Kazimiya in Iraq, it became clear that during the first six centuries of Islam they developed a specific form. Originating probably as a simple domed chamber over the grave of the Imam concerned, there gathered around that focal point an ivan, porticos, halls, and minarets, all within a walled enclosure which defined and protected the sacred area. Walled enclosures are first recorded in the 9th century; riwaqs, or porticos, in the 10th century; minarets were associated with shrines by c. 1000; the *bahw*, or hall, was certainly in use by the mid 11th century; ivans probably appeared in the 12th century. Thus, by c. 1200 the great Imami shrines were architecturally identifiable. That, however, was not the end of the story. For over the next 700 years, the shrines continued to develop. They now included golden domes, first introduced by Shah Tahmasp in Mashhad in the 16th century, and popularised by Nadir Shah and the Qajars, and gold was increasingly used on minarets and ivans. They also featured porches, often on platforms, on one or more sides of the central building, features which were first used in the 19th century and have become defining features of the shrines. In addition, clock-towers were added, sited above gates through the enclosing wall, also a 19th century innovation.

It is true that no single architectural item within these complexes is unique to Shi'i Islam, but it is more important to realise that no other institution in the Islamic world combined these different architectural features in this way. It should also be noted, however, that Mashhad did not fully follow this tradition, in that it never adopted platforms and porches. The reasons for this can only be surmised. It may have been due to its geographical location, far from the other Iraqi shrines, though if the idea of porches came ultimately from Central Asia this would not be an adequate explanation. It may have been due to the overwhelming visual dominance of the Mosque of Gawhar Shad within the Mashhad shrine complex, or to the existence of other structures, which had already accumulated around the central tomb-chamber by the end of the Safavid period, hindering further central development of the site. Or it may have been due to the comparative lack of interest displayed by either Nadir Shah or the Qajars in architectural patronage of the shrine at Mashhad.

Nor did the Iraqi shrines lead to a tradition of building which encompassed all *imamzadehs*. Again there are exceptions, especially the shrine of Fatima, the sister of the 8th Imam, at Qum, which has many features in common with those in Iraq, and the late 20th century shrine of the Ayatollah Khomaini, in which such ideas have been developed in a contemporary idiom. But only a few others, like those at Rayy and Ardahal, seem to have adopted any particular elements: the great mass of *imamzadehs* in Iran continued the tradition of tomb-towers or domed chambers common to both religious and secular mausolea. In the Indian sub-continent, a rather different tradition emerged. The great Imami shrines did not influence shrine architecture; rather they were copied,

as faithfully as circumstances allowed, to provide centres of pilgrimage for local people unable to visit Iraq.

In Chapter 2 we discussed the patronage of shrines. It might be claimed that Sunni patronage of a Shi'i shrine reduces that complex's claim to be Shi'i. However, it was clear from our discussion that Sunni patronage came in a number of guises, and usually had other motives. For some, like the Ghaznavids in Mashhad, patronage resulted from their Sunni faith combined with devotion to 'Ali and his descendants, not from any sectarian motives. Other patrons had different reasons, for example the late 'Abbasid caliphs or Nadir Shah, who had a desire to unite Islam, or bring Shi'i Islam into the Sunni fold. These latter patrons of course recognised at the outset the Shi'i nature of the complex, and it was for that very reason that they wished to be seen as its patron, whatever their long-term religious or theological ambitions.

Hence, we can say with certainty that by the Mongol invasions the great shrines already had a form specific to them, and that the continuing development of that form has produced the unique contribution of the Shi'i world to the architecture of Islam at large. Surprisingly, though, it has had remarkably little architectural impact.

Oleg Grabar, introducing the 2009 London conference on Shi'i art and architecture, distinguished two categories of Shi'i identification. One he called "innate", that is objects which in their form or subject matter are always recognizable as Shi'i. Into this category fit the great Shi'i shrines. The other he called "a form of labelling", in which objects or monuments are formally proclaimed to be Shi'i (often by the use of inscriptions) whether they were meant to be such or not. He commented:

> … while such labelling makes a specific thing Shi'ite, it does not mean that such objects or monuments are always recognisable as Shi'ite without the adjunction of writing or of other signs and without the observer's awareness of their meaning.

Let us now turn to this second category in the Shi'i architecture of Iraq, Iran and the sub-continent.

In Chapter 1 we encountered the use of architectural inscriptions to highlight Shi'i claims, through Ibn al-Athir's description of sectarian conflict in Baghdad in the 11th century. In Chapter 2 we were able to flesh out the role of inscriptions in both Iran and the sub-continent, and to show how, from earliest times, inscriptions were used on coins to draw attention to the beliefs of Shi'i rulers, e.g. Shi'i coins in 8th–10th century Tabaristan. Inscriptions also survive on architectural monuments in Iran to give veracity to the stories told by Ibn al-Athir (e.g. the mihrab in the mosque at Na'in which quotes Sura 33:33). During the next two or three centuries, there would appear to be an expansion in the variety of inscriptions used, although for the present the course of this expansion cannot be traced. Certainly, by the time of Oljeitu, we find a hadith being used to support a royal Shi'i position on the mihrab of the Friday Mosque in Isfahan (1310).

However, one aspect of this development needs further comment: the Shi'i re-use of texts which already have significance for Sunnis, most obviously Qur'anic quotations. There is of course only one Qur'an, so Shi'is had to justify their theological position by quoting, but re-interpreting, particular verses e.g. Sura 33:33. This leads to the difficulty of interpreting Sura 61:13 on 14th century Sarbadarid coins. Is it a Sunni quote, or a Mahdist one? But such verses also bed Shi'ism in Islam, leaving the responsibility of interpretation to the viewer. This willingness to adopt and accept ambiguity seems to grow with time, leading to the use of the *Asma al-Husna,* the 99 names of God, in the Shi'i period restoration of Pir-e Bakran under Oljeitu, despite their obvious relevance to Sunnism. And it is an ambiguity which appears again in symbols, as we shall note below.

However, it has also become clear that in terms of inscriptions Shi'ism begins to assert itself most dynamically with the rise of the Safavids and the establishment of a Shi'i state in Iran. Of course, Arabic inscriptions, in particular Qur'anic Arabic inscriptions, are part of the universal art of Islam:

they occur on religious buildings throughout the Islamic world. In fact they are often the defining features of Islamic architecture. As an example we may recall the Dome of the Rock. The Dome of the Rock is an octagonal stone building and has a central dome: it therefore continues a Byzantine, commemorative building tradition. It was originally decorated both inside and outside with mosaics, again a Byzantine tradition, though it is true that these are not figural. But the defining decorative item is the inscription which runs around the inner octagonal arcade: this proclaims in Arabic, through the use of Qur'anic texts, that this is definitely not a Christian building, but a Muslim one.

We find a parallel approach in Shi'i Islam, especially in Iran. The Masjid-e Shah in Isfahan follows the 4-ivan plan, a plan which appeared in Iranian mosque architecture under the Saljuqs in the 12th century, and has continued to be the most popular form for such buildings in Iran ever since. Not only was the plan as a whole invented during Sunni times, but that plan includes a dome chamber, four ivans, a courtyard, minarets, and a variety of other architectural features, which are all individually at home in Sunni buildings before the rise of the Safavids. The brick and tile-work combination used in the Masjid-e Shah is also part of an on-going building and decorative tradition in Iran, going back at least to the 11th century. So what is Shi'i about the building? The answer is the inscriptions. They are Islamic in that they include quotations from the Qur'an in Arabic, but they also include specific Shi'i references—hadiths of the Prophet which emphasise the role of 'Ali ibn Abi Talib and so on. Moreover, these quotations are in high profile positions, e.g. on the drum of the dome, on the portal, and on the mihrab, and are often extraordinarily detailed and lengthy. Shi'ism thus insists on asserting itself through the written word, as Islam has always done. At this stage in the development of Shi'ism, no other, specifically Shi'i, buildings were deemed necessary. For Shi'is, the mosque remained the focus of worship, and the madrasa the focus of learning. These Islamic institutions, and the forms associated with them, therefore remained unchanged. But the message of the buildings changed, for the inscriptions emphasise the Shi'i understanding of the role of 'Ali and the Imams. Once we understand this, we realise that the Masjid-e Shah, regardless of its architectural form and origin, by proclaiming such a powerful, visual, inscriptional Shi'i message, i.e. by being labelled so loudly Shi'i, is a Shi'i building, and stands not for Islam in general but, within Islam, specifically for Shi'ism.

Turning to the Indian sub-continent, Qutbshahi dynastic cenotaphs, engraved with long prayers to the 12 Imams, or with the *nad-e 'Ali*, proclaim the Shi'i beliefs of the rulers concerned. However, the Deccani scenario is not so clear cut as that of Safavid Iran. For, in the Deccan, Shi'i inscriptions, with the exception of those used on cenotaphs, are usually very short, and there is the background of *taqiya*—an unwillingness of Shi'is to be identified as anything other than Muslims for fear of persecution. Nevertheless, however short an inscription, if it is sufficient to identify the nature of the building, then that building, whatever its form, and whatever the origin of that form, becomes, by labelling, an example of Shi'i architecture. At this point it is interesting to observe that in the Deccan, as in pre-Safavid Iran, it is the mihrab of a building which so often provides the clue to its sectarian identity, hence, for example, the Shi'i inscriptions on the mihrab in the winter prayer hall of Oljeitu in the Masjid-e Jame' at Isfahan, which we have just mentioned, and those on the mihrab of the Masjid-e Jame' at Varamin (1322–26), in Iran, and those above or on the mihrab of such mosques as the Damri Mosque in Ahmednagar (1568), or the Nau Gumbaz in Bijapur (1620's), in India.

And such a Shi'i identity is true too of buildings which contain motifs or symbols which are specific to the Shi'i tradition and community. So, for example, Deccani mosques or other buildings decorated with 'alams, such as the mosques in Golconda fort, the Char Minar in Hyderabad, or the Damri mosque in Ahmednagar, are thereby labelled as Shi'i, and the buildings therefore become examples of Shi'i architecture.

Returning to Iran, it is evident that numerous other buildings from the Safavid period and later used inscriptions to assert their Shi'i identity. It was not until the Qajar period, however, that specific

buildings were developed for specifically Shi'i purposes. Of these the most notable were the *tekiyehs* used for the *ta'ziyeh* dramas, the most famous of which was the Tekiyeh Dawlat built by Nasir al-Din Shah. In addition, *saqqa-khanehs* provided water for the public and in so doing reminded people of the story of Kerbala, while *husainiyehs* were built as part of the Muharram ceremonies. Unfortunately we know very little about the forms, architectural merit and architectural development of these different buildings, so it is difficult to assess their importance in our story. 'Alams were adopted as important elements in the Muharram processions in Iran, but at certain periods at least, their significance as symbols of town quarters *(muhallas)* may have been as important as their religious symbolism. Certainly, there never arose in Iran anything equivalent to the ashur khanehs of Hyderabad or the imambaras of Lucknow, where 'alams, as well as being processed in the month of Muharram, were displayed and venerated, with the relics they sometimes contained, throughout the year. A hall, varying in size and form according to local requirements and local architectural traditions, was the main requirement, though it was usually part of a complex which included a mosque, tombs and other buildings, and the scale of the Great Imambara complex in Lucknow is breath-taking. Also into the sub-continent, as just mentioned, came kerbalas, shrines which copied (more or less) the form of the shrine of Husain at Kerbala, and provided a focus for local pilgrimage for those unable to visit the shrines of Iraq or Mashhad. Although ashur khanehs had already been part of the Shi'i architecture of the Deccan in the 16th century, it was the 18th–19th century which saw the architecture of Shi'ism develop new purpose and new forms both in Iran and the subcontinent.

Interestingly, the sub-continent proved a much more inventive ground for Shi'i architecture than Iran. Why this should be is unclear, though various reasons might be suggested. One would be the multi-faith nature of Indian society, where Hindu, Jain and Islamic buildings all competed for attention. The Shi'i need to have a visual identity within this multi-cultural scene could well have pressurised its adherents to give architectural expression to their institutions. Another might have been the need to offer some sort of architectural setting which would welcome and embrace members of other faiths taking part in Shi'i processions, a common feature of synchretist Indian life. A further element might be the greater interest in relics shown by Indian Shi'is compared to those of Iran, and the need to provide an architectural setting where they could be both protected and venerated.

On the Iranian side, one might ask why religious theatre only became institutionalised in the Qajar period ? It is tempting to see influence from the west, where drama was a much more highly developed art form, and suitable architecture had also been developed for its enjoyment. And in the case of the Tekiyeh Dawlat, direct influence of the Royal Albert Hall is a key factor. However, that very fact militates against there being any other obvious relationship between *ta'ziyeh* and western drama, for western style theatres or opera houses failed to have any influence at all on Iranian *tekiyehs,* which remained simply spaces for the dramatic spectacle, with or without staging, surrounded by some sort of seating or accommodation arrangements.

Turning now to art as opposed to architecture, is there indeed Shi'i art, and if so how do we recognise it? Which parts of it are innate, and which are Shi'i by labelling? It has been suggested that the 13th–14th century lustre tile industry was a Shi'i-run industry serving the needs of Shi'i imamzadehs, though that theory remains unproven. We have suggested that another industry in Iran, steelworking, which was responsible for an extraordinary production of padlocks, may have depended on Shi'i shrines and the intercession of those buried in them for its ubiquity and continuing prosperity. Shi'ism in these instances can be seen as a catalyst which led to the development of specific industries. And we have drawn attention to the huge number of high quality objects that were stored in shrine treasuries and displayed to pilgrims in the shrines themselves, whether in precious metal, textile or marquetry. However, many of these, carpets for example, would have had very little, apart from perhaps a *waqf* (endowment) inscription, identifying them as objects produced for a specifically Shi'i

context. Hence, they were only deemed to be Shi'i by their labels, and by the contexts in which they spent most of their useful lives.

In other media, too, many objects were and are only identifiably Shi'i through the inscriptions they carry. An undecorated copper basin says nothing about its purpose or identity. However, such an object decorated with the names of the Fourteen Immaculates, or the *nad-e 'Ali*, or the phrase *nasr min allah wa fath qarib* (correctly interpreted), immediately proclaims its Shi'i identity. Many objects, Iranian or Indian, including amulets, seals, magic bowls, kashkuls, bazubands, pen-cases, combs, mirror-cases, water vessels, implements, weapons, tomb covers, talismanic jackets and other articles of clothing, do exactly that.

Still other objects or designs, however, are innately, and immediately identifiable as, Shi'i. A *ziya-rat-nameh* bearing a prayer asking for God's peace on Husain is clearly a devotional Shi'i object from the shrine of the Imam Husain at Kerbala. A few objects may even have been decorated with Muhar-ram scenes, like the *minai* bowls made in Kashan c. 1200. Again we may ask, to what extent are such objects, whether inscribed or pictorial, Shi'i? In Britain, when from time to time a coronation takes place, drinking mugs are produced for sale bearing the royal coat-of-arms or a picture of the mon-arch. These would traditionally have been Royal Worcester, Spode, Crown Derby, or Wedgewood, and they might have been sold to tourists from overseas, whose country of origin had no connection with the British monarchy. Regardless of the identity of their manufacturer or their purchaser, these mugs are called "Coronation Mugs". They are identified by the event they celebrate. In the same way, vessels or other objects bearing Shi'i inscriptions may be identified by what they celebrate: belief in the sanctity of the 12 Imams, trust in the intercession of 'Ali or the martyrdom of Husain, or expecta-tion of the final victory of the Mahdi.

Most important are the 'alams used in the Muharram processions in Iraq, Iran and India, and in India displayed in specifically Shi'i buildings, imambaras or ashur khanehs, throughout the year, their uniquely Shi'i identity often further reinforced by inscriptions. Another Shi'i object is the lion, which symbolises 'Ali, *asad allah*, "the lion of God". But lions are not unique to Shi'i art: they are common in Islamic art at large. Hence, there was a need to place the lion at the feet of 'Ali so that the connection is in no doubt, or to use a calligraphic design in which the lion's form consists of the *nad-e 'Ali,* to point out to the viewer the correct, Shi'i, interpretation.

It is important at this point to see that the lion brings the topic of ambiguity once again into the discussion. We have already noted how it occurs in inscriptions, for example in the use of Qur'anic texts, and we find it, not just with lions, but with other symbols too. In Shi'i terms, the hand used as an 'alam design is the hand of 'Abbas, or the hand of 'Ali, or a symbol of the Panjetan, and its funda-mentally Shi'i message is strengthened by its use as an 'alam. But a hand is widely used as a decorative motif in Sunni Islam, where it is almost always called the hand of Fatima, providing another example of the ambiguity. Moreover, Zulfikar, the sword of 'Ali, has a place in both Sunni and Shi'i art. In the former it is the weapon of the champion warrior of the faith, and hence the symbol of *ghaza*, and a widely used symbol on Ottoman banners. In the latter it is associated with 'Ali, again as a champion warrior, but with specific allusion to his status as the first Imam among twelve, and hence to Twelver Shi'ism.

However, most obviously and innately Shi'i are the Iranian paintings which we have discussed. These, at different periods, have highlighted the importance of 'Ali, Husain, and other members of the family of the Prophet, and the events of the battle of Kerbala. In the 16th century the increasing importance of 'Ali is seen through the illustration of manuscripts; in the 18th-19th century we find the growth of pardeh paintings, visual backdrops to recitation of the Kerbala story; in the 19th century the growth of portraits of members of the Prophet's family, especially of 'Ali, Hasan and Husain; and in the 19th–20th centuries the decorating of *husainiyehs* and *tekiyehs* with wall paintings or tilework

showing the Kerbala story and its heroes and heroines. Although occasional portraits are known from India, nothing equivalent to these Iranian developments was to be seen there. And the pictorial tradition continues in Iran to this day. The Islamic Revolution produced bank-notes and stamps to commemorate Shi'i personalities, e.g. the Ayatollahs Muddarres and Khomaini, and to highlight the role played by processions in the Revolution, while posters pushed Shi'i art beyond the general theme of Kerbala, with its heroes and heroines among the Prophet's family, to portray individual Iranians, killed in the Revolution or the Iran-Iraq war, as Shi'i martyrs in the tradition of Husain.

We can thus conclude with certainties. There are a vast array of buildings and objects which are identifiably Shi'i only through the inscriptions which proclaim that fact, in other words, following Grabar, through their labelling. But there are also buildings which are unique to Shi'ism, objects which are unique to Shi'ism, and pictures which are unique to Shi'ism. Above all, Shi'i art is alive and on-going, pushed forward by the Islamic Revolution in Iran, and pushing through new frontiers as the religious ideology of the Revolution and Iran's ongoing Islamic government.

Glossary

'abbasiyeh, building dedicated to 'Abbas, the water-carrier and the carrier of Husain's 'alam at the battle of Kerbala (Iran)

abjad, a system by which each letter of the Arabic alphabet is given a different and particular numeric value

adhan, the call to prayer

ahl al-bayt, (lit. "people of the house") the family of the Prophet

'alam, a metal standard carried in Muharram processions

alawa, see allava

'Alawi, pl. *'Alawiyyin*, descendant of the Prophet

alif, the letter "a", the first letter of the Arabic alphabet

'alim, pl. *'ulama* (Persian pl. *'ulema*), religious scholar

allava, round hollow used as a fire-place in the courtyards of some Qutbshahi ashur khanehs, and hence the title of the building in which it is found (India)

asad allah (Arabic) or *shir-e khuda* (Persian), "the lion of God", an epithet of 'Ali ibn Abi Talib

'Ashura, or Day of 'Ashura, the tenth day of the month of Muharram, when the death of Husain at the battle of Kerbala is commemorated

ashur khaneh, building used for the display and veneration of 'alams, and as a focus for the Muharram processions (India)

Asma al-Husna, the ninety-nine beautiful names of God

bahw, an enclosed, covered hall

barakat, blessing

bazuband, armlet, often of steel

buq'a, shrine (Iran)

Buraq, the name of the creature on which the Prophet rode on his "night-journey"; a model or picture of that creature as used in Muharram processions and in ashur khaneh painting in India.

chador, head-scarf

char 'Ali, or char Muhammad, the name of *'Ali* or *Muhammad* repeated four times, forming an interlocking, revolving figure.

chini-khaneh, room in a shrine in which Chinese porcelain was displayed

daniq, a weight used in Arab and Persian metrology, a sixth of a *mithqal* (q.v.)

dar al-huffaz, building for reciters of the Qur'an

dar al-siyyada, building for descendants of the Prophet

dargah, sufi shrine (India)

dhatee, rectangular piece of cloth, tied round the neck of an 'alam, hanging down to cover the shaft (India)

Dhu'l-Faqar, the name of the sword of 'Ali, often transcribed as Zulfaqar, or in India as Zulfikar

dikka, platform

diwan-khaneh, office of the royal court

faqih, pl. *fuqaha*, legal scholar

firman, legal document or order

Fourteen Immaculate Ones, the 12 Imams, together with the Prophet and the Prophet's daughter, Fatima

futuwwa, urban fraternal communities of artisans and craftsmen

ghaza, warfare to extend the frontiers of Islam

ghulur-khana, soup kitchen

hadith, the Traditions of the Prophet: his sayings or actions as recorded by those who knew him, and transmitted down the course of history by sound authorities

hajib, lit. "chamberlain", but also a chief minister under the 'Abbasid caliphate

hajj, the annual pilgrimage to the two holy cities of Mecca and Medina

hatalee, central part of an 'alam (India)

hegiri, the Islamic dating system based on lunar years and beginning in 622 AD

husainiyeh, building dedicated to the Imam Husain, used for *rawzas*, as the focus of Muharram processions, and for the storage of 'alams (Iran)

imambara, building used for the display and veneration of 'alams, and as a focus for the Muharram processions (India)

imamzadeh, descendant of the Prophet, or the mausoleum of a descendant of the Prophet

islami, the vine-and-tendril motif used in manuscript illumination

iwan (Arabic) or *ivan* (Persian), a large vaulted hall, open at one end, of variable depth

jihad, holy war

Ka'ba, the cuboid building in the courtyard of the mosque in Mecca

kashi-gari, tile-making

kashkul, dervish water and drinking receptacle

Kerbala, the site of the battle in which Husain was martyred in 680 (Iraq); the name of a building which recalls the shrine of Husain at Kerbala and is used as a substitute centre of Shi'i pilgrimage (India)

kerbala, building recalling the shrine of Husain at Kerbala (India)

khanqa, or *khanegah*, dervish institution

khatam-kari, marquetry

khatib, reciter

khil'at, robe of honour

khita'i, painting in the Chinese style

khutba, the Friday sermon

khiyaban, avenue or promenade

kiswa, "veil" or textile covering of the Ka'ba in Mecca

kufi, or kufic, a type of angular script named after the town of Kufa in Iraq

kunj, a niche facing onto a courtyard with a doorway in the rear; the doorway leads into a room behind, and there is often a second storey above

kursi, Qu'ran stand

lustre, a type of glazed pottery decorated with a metallic sheen

madhhab, school of religious law, of which there are four in Sunni Islam

madrasa, religious school

mahalla, quarter or part of a town

Mahdi, the 12th Imam who is in occultation i.e. has disappeared and will return to earth on the Day of Judgement

mahmal, textile litter, carrying a Qur'an, which was the focus of the annual pilgrimage caravan to Mecca

maidan, square

majlis, pl. *majalis*, mourning ceremony

maqbara, tomb

mashhad, a shrine in general, or the central shrine building

masjid, mosque

mawla, trustee or helper

mihrab, the niche in a mosque indicating the direction of prayer

minai, over-glaze painted stone-paste ceramics, produced in Kashan in the later 12th and early 13th century

minbar, the pulpit in a mosque

mithqal, the weight of the dinar, from the late 7th century 4.25 grams

mohreh-ye namaz, or *mohreh*, prayer tablet made of Kerbala clay

mufassir, Qur'anic exegesist

Muharram, the first (lunar) month of the Islamic year

mujtahid, a learned man who can exercise rational judgement in matters of religious law

mustawfi, finance minister

nad-e 'Ali, prayer to 'Ali

nadiri, coinage of Nadir Shah (1736–47) in Iran

naiza, staff of an 'alam (India)

nakhl, lit. palm-tree, but also a tear-shaped wooden structure, carried in Muharram processions in particular towns in Iran

naqar-khaneh, building where trumpets and drums were stored

naqib, leader, or syndic, of the Shi'i community

naskh, cursive Arabic script

nasta'liq, a Persian cursive script, commonly used for calligraphy from the 15th century onwards

nayib al-hukama, deputy governor

nazar, votive object

nisba, part of an Arab or Persian name, expressing the relation of the individual to a group, person, place, concept or thing

pahlavan, wrestler

Panjetan, (lit. "the five") used of the Prophet, 'Ali, Fatima, Hasan and Husain

pardeh, or *shamayel*, painting used to help in public story-telling

qadam gah, a building housing the footprint of the Prophet, or of an Imam

qadam rasul, or *qadam sharif*, a building housing the footprint of the Prophet (India)

qalam, reed pen

qibla, direction of Muslim prayer (towards Mecca)

qubba, dome

qumiz, fermented mare's milk

rabat, dervish lodging

rawda, the sacred precinct around a shrine

rawza, funeral oration

rawzeh-khani, the public recitation and chanting of elegies recounting the Kerbala story

riwaq, portico

safina, ship, mentioned in the Qur'an, alluding to Noah's ark

sahib al-zaman, "Lord of Time", a title which relates to the Mahdi

sahn, courtyard

saqqa-khaneh, public water fountain

sardar-e lashkar, head of the army

sayyid, descendant of the Prophet

sebil-khaneh, room containing a water fountain

shahada, statement of faith, or creed. The Sunni *shahada* is *la allah illa allah muhammad rasul allah*, "There is no god but God, Muhammad is the Prophet of God". The Shi'is add, *wa 'Ali wali allah*, "and 'Ali is the friend of God".

BIBLIOGRAPHY

— 2001. 'Popular religious art in the Qajar period'. In ed. N. Pourjavady. *The Splendour of Iran*. Vol. 3. *The Islamic Period*, pp. 324–341. London.

— 2005. 'From the Sun-Scorched Desert of Iran to the Beaches of Trinidad: Taziyeh's Journey from Asia to the Caribbean'. *The Drama Review*, Winter 2005, Vol. 49, No. 4, pp. 156–170.

— 2006. 'Monumental Grief: The Bara Imambara'. In ed. R. Llewellyn-Jones, *Lucknow. City of Illusion*, pp. 101–137. Munich.

Chelkowski, P. and H. Dabashi. 2000. *Staging a Revolution: the Art of Persuasion in the Islamic Republic of Iran*. London.

Christie's. 2009. *Art of the Islamic and Indian Worlds*. London. 31 March.

Cole, J.R.I. 1988. *Roots of North Indian Shi'ism in Iran and Iraq. Religion and State in Awadh. 1722–1859*. University of California Press. Berkeley, Los Angeles & London.

— 2002. 'Iranian Culture and South Asia, 1500–1900'. In ed. N.R. Keddie and R. Matthee, *Iran and the Surrounding World. Interactions in Culture and Cultural Politics*, pp. 15–35. Seattle and London.

Combe, E., J. Sauvaget and G. Wiet. 1939. *Répertoire chronologique d'épigraphie arabe*. Vol. 10. Cairo.

Cousens, H. 1890. *Notes on the buildings and other antiquarian remains at Bijapur. with translations of the inscriptions by E. Rehatsek*. Bombay.

— 1916. *Bijapur and its architectural remains*. Bombay.

Creswell, K.A.C. 1969. *Early Muslim Architecture*. 1 part 1. Oxford.

— 1989. *A Short Account of Early Muslim Architecture*. Revised and supplemented by J.W. Allan. Aldershot.

Crone, P. 2004. *Medieval Islamic Political Thought*. Edinburgh.

Davies, P. 1989. *The Penguin Guide to the Monuments of India. 2. Islamic. Rajput. European*. London.

Desai, Z.A. 1999. *Arabic. Persian and Urdu Inscriptions of West India. A topographical list*. New Delhi.

de Slane, M.G. (trans.). 1968. *Ibn Khallikan's Biographical Dictionary*. 4 vols. Paris.

DeWeese, D. 1994 *Islamization and Native Religion in the Golden Horde: Baba Tükles and Conversion to Islam in Historical and Epic Tradition*. Pennsylvania.

Dickinson, M.B., and S.C. Welch. 1981. *The Houghton Shahnameh*. 2 vols. Cambridge, Mass.

Dreaming of Paradise. 1993. Museum of Ethnology. Rotterdam.

Drouville, G. 1825. *Voyage en Perse, fait en 1812 et 1813*. 2 vols. Paris.

Dumarçay, J. 1971. *Damas. Bagdad. Capitales et terres des califes*. Beirut.

L'Etrange et les Merveilleux en terres de l'Islam. 2001. Musée du Louvre. Paris.

Ettinghausen, R. 1962. *Arab Painting*. Geneva.

Falk, T. (ed.) 1985. *Treasures of Islam*. London.

Far, M. 1999. *Shi'ah Artistic Elements in the Timurid and the Early Safavid Periods: Book Illustrations and Inscriptions*. London.

Farhat, M. 2002. *Islamic piety and dynastic legitimacy: the case of the shrine of 'Ali B. Musa al-Rida in Mashhad (10th–17th century)*. Ph.D. thesis. Harvard University.

Fontana, M.V. 1994. *Iconografia dell' Ahl al-bayt. Immagini di arte persiana dall XII al XX secolo*. Napoli.

Francklin, W. 1790. *Observations made on a tour from Bengal to Persia*. London.

Fransis, B. and N. al-Naqshbandi. 1949. 'al-Athar al-khashb fi dar al-athar al-'arabiyya'. *Sumer* 5, pp. 55–64.

Fraser, J.B. 1826. *Travels and adventures in the Persian provinces on the southern banks of the Caspian Sea*. London.

— 1838. *A Winter's Journey*. 2 vols. London.

Frembgen, J.W. 1995. 'Shiitische Standartenaufsätze'. *Tribus* 44. October, pp. 194–207.

— 2003. *Nahrung für die Seele. Welten des Islam*. Munich.

— 2005. 'Traditional Art and Architecture in Hunza'. In ed. S. Bianca. *Karakorum. Hidden Treasures in the Northern Areas of Pakistan*, pp. 133–148. Turin.

Gans-Ruedin, E. 1978. *The Splendor of Persian Carpets*. Fribourg.

— 1984. *Indian Carpets*. London.

Ghirshman, R., V. Minorsky and R. Sanghvi. 1971. *Persia: the Immortal Kingdom*. London.

Ghouchani, A. 1985. *Angular Kufic: On Old Mosque of Isfahan*. Iran.

Gibb, H.A.R. (trans.). 1962. *The Travels of Ibn Battuta*. Vol. 2. Cambridge.

Gierlichs, J. and A. Hagedorn (ed.). 2004. *Islamic Art in Germany*. Mainz am Rhein.

Godard, A. 1937. 'Isfahan'. *Athar-e Iran* 2, pp. 7–178.

— 1965. *The art of Iran*. London.

Godard, Y. A. 1937. 'L'imamzadè Zaid d'isfahan. un édifice décoré de peintures religieuses musulmanes'. *Athar-e Iran* 2, part 2, pp. 341–348.

Godman, F. du C. 1901. *The Godman collection of Oriental and Spanish pottery and glass. 1865–1900*. London.

Golombek, L. 1977. 'Mazar-i Sharif—A Case of Mistaken Identity?' In ed. M. Rosen-Ayalon. *Studies in Memory of Gaston Wiet*, pp. 335–343. Jerusalem.

Golombek, L. and D. Wilber. 1988. *The Timurid Architecture of Iran and Turan*. 2 vols. Princeton.

Goron, S. and J. P. Goenka. 2001. *The Coins of the Indian Sultanate*. New Delhi.

Grabar, O. 1966. 'The Earliest Islamic Commemorative Structures. Notes and Documents'. *Ars Islamica* 6, pp. 1–46.

Gray, B. 1961. *Persian Painting*. Skira.

— (ed.). 1979. *The Arts of the Book in Central Asia*. UNESCO.

Griffiths, J. 1805. *Travels in Europe. Asia Minor and Arabia*. London.

A Guide to the Arab Museum at Khan Marjan in Baghdad. 1938. Baghdad.

Halm, H. 1991. *Shiism*, Edinburgh University Press.

Hammer-Purgstall, J. F. von. 1842–3. *Geschichte der Ilchane, das ist der Mongolen in Persien*, 2 vols.

Hanaway, W. L. 1985. 'The Symbolism of Persian revolutionary Posters'. In ed. by B. M. Rosen. *Iran since the Revolution*, pp. 31–5. Boulder.

Haram (social and cultural). A Guide Book to the Sacred Premises of the Holy Shrine of the Imam Reza (A.S.). n.d. Mashhad.

Hartmann, A. 1993. 'al-Nasir li-Din Allah'. *Encyclopaedia of Islam*. 2nd edition. 7, pp. 996–1003. Leiden and New York.

Hasan, S. A. 1964. 'Münejjim Bashi's account of Sultan Malikshah's reign'. *Islamic Studies* 3, pp. 426–69.

Herzfeld, E. 1948. *Ausgrabungen von Samarra* VI: *Geschichte der Stadt Samarra*. Hamburg.

Hillenbrand, C. 1993. 'al-Mustansir'. *Encyclopaedia of Islam*. 2nd edition. 7, pp. 727–9. Leiden and New York.

— 2000. *The Crusades*. London.

Hillenbrand, R. 1974. *The Tomb Towers of Iran to 1550*. University of Oxford D.Phil. thesis.

— 1986. 'Safavid Architecture'. In ed. by P. Jackson and L. Lockhart. *The Cambridge History of Iran*. Vol. 6. *The Timurid and Safavid Periods*, Chapter 15(b), pp. 759–842.

— 2002. 'The tomb of Shah Isma'il I at Ardabil'. In ed. by S. R. Canby. *Safavid Art and Architecture*, pp. 3–8. British Museum. London.

— 2003. 'The Sarcophagus of Shah Isma'il at Ardabil'. In ed. by A. J. Newman. *Society and Culture in the Early Modern Middle East: Studies on Iran in the Safavid Period*, pp. 165–190. Leiden and Boston.

Hollister, J. N. 1953. *The Shi'a of India*. London.

Holmes, W. R. 1845. *Sketches of the Shores of the Caspian*. London.

Honarfar, L. A. 1965. *Ganjina-yi athar-i tarikhi-yi Isfahan*. Isfahan.

Honigmann, E. 1978. 'Karbala'. *Encyclopaedia of Islam*. 2nd edition. 4, pp. 637–9. Leiden.

— 1978/1. 'al-Najaf'. *Encyclopaedia of Islam*. 2nd edition. 7, pp. 859–61. Leiden.

Ibn Hauqal. 1964. *Configuration de la Terre (Kitab Surat al-'Ard)* trans. J. H. Kramers and G. Wiet. Beirut and Paris.

Ipsiroglu, M. S. 1976. *Siyah Qalem*. Graz.

— 1980. *Masterpieces from the Topkapi Museum*. London.

Islam, R. 1979–82. *A Calendar of Documents on Indio-Persian Relations (1500–1750)*. 2 vols. Tehran and Karachi.

Janabi, T. J. 1983. *Studies in medieval Iraqi architecture*. Baghdad.

Jawad, M. 1969. *Baghdad*. Baghdad.

Kaczmarczyk, A., R. E. M. Hedges and H. Brown. 1977. 'On the occurrence of mercury-coated dirhems'. *Numismatic Chronicle* 7th series, 17, pp. 163–170.

Kalter, J. 1987. *Linden-Museum. Stuttgart*. Stuttgart.

Kalus, L. 1981. *Catalogue des cachets. bulles et talismans islamiques*. Bibliothèque Nationale. Paris.

— 1986. *Catalogue of Islamic seals and talismans*. Ashmolean Museum. Oxford.

Kemp, P. M. (trans. and ed.). 1959. *Russian travellers to India and Persia [1624–1798]. Kotov. Yefremov. Danibegov.* Delhi.

Kendrick, A. F. 1931. 'The Persian Exhibition III. Textiles, a general survey'. *Burlington Magazine.* Vol. 58, pp. 15–21.

Kennedy, H. 1993. 'al-Mutawakkil 'ala 'llah'. *Encyclopaedia of Islam.* 2nd edition. 7, pp. 777–8. Leiden and New York.

Keshani, H. 2006. 'Architecture and the Twelver Shi'i Tradition: the Great Imambara Complex of Lucknow'. *Muqarnas* 23, pp. 219–250.

Khavari, M. A. 2004. 'Die schiitischen Standarten und ihre historischen Vorläufer'. *Münchner Beiträge zur Völkerkunde.* 9, pp. 177–223.

Kiani, M. Y. 1986. *A General Study on Urbanization and Urban planning in Iran.* Tehran.

Komaroff, L. 1992. *The Golden Disc of Heaven. Metalwork of Timurid Iran.* Costa Mesa, California and New York.

Kratchkovskaia, V. 1931. 'Notices sur les inscriptions de la mosquée djoum'a à Véramine. *Revue des Etudes Islamiques* 5, pp. 25–58.

Kreiser, K. 1997. 'Public monuments in Turkey and Egypt. 1840–1916'. *Muqarnas* 14, pp. 103–117.

Lambourn, E. A. Forthcoming. 'A self-conscious architecture—micro-architecture and the imagination of modes of decoration in Islamic South Asia'. *Muqarnas.*

Leach, L. Y. 1995. *Mughal and Other Indian Paintings from the Chester Beatty Library.* 2 vols. London.

— 1998. *Paintings from India.* In ed. J. Raby. *The Nasser D. Khalili Collection of Islamic Art.* 8. Oxford.

Leisten, T. 1998. *Architektur für Tote.* Berlin.

Lentz, T. W. and G. D. Lowry. 1989. *Timur and the Princely Vision.* Los Angeles County Museum of Art. Los Angeles. CA.

Le Strange, G. 1900. *Baghdad during the Abbasid Caliphate.* Oxford.

Lewis, B., "Alids'. 1960. *Encyclopaedia of Islam.* 2nd edition. 1, pp. 400–403.

Llewellyn-Jones, R. 1985. *A Fatal Friendship. The Nawabs, the British and the City of Lucknow.* New Delhi.

Lowry, G. D. and M. C. Beach. 1988. *An Annotated and Illustrated Check-list of the Vever collection.* Smithsonian Institution. Washington, DC.

Lukens-Swietochowski, M. 1979. 'The School of Herat from 1450–1506'. In ed. by B. Gray. *The Arts of the Book in Central Asia,* pp. 179–214. Paris.

McChesney, R. D. 1981. 'Waqf and public policy: the waqfs of Shah 'Abbas, 1011–1023/1602–1614' *Asian and African Studies* 15, pp. 165–190.

— 1991. *Waqf in Central Asia. Four hundred years in the history of a Muslim shrine, 1480–1889.* Princeton.

Maddison, F. and E. Savage-Smith. 1997. *Science. Tools and Magic.* 2 parts. In ed. by J. Raby. *The Nasser D. Khaili Collection of Islamic Art.* 12. London.

Madelung, W. 1971. 'Imama', *Encyclopaedia of Islam.* 2nd edition. 3, pp. 1163–1169.

— 1997. 'Shi'a'. *Encyclopaedia of Islam.* 2nd edition. 9, pp. 420–424. Leiden.

Mahir, S. 1969. *Mashhad al-imam 'Ali fi al-Najaf wa-ma bihi min al-hadaya wa-al-tuhaf.* Cairo.

Majeed, T. 2006. *The Phenomenon of the Square Kufic Script: the Cases of Ilkhanid Isfahan and Bahri Mamluk Cairo.* D.Phil. thesis. Faculty of Oriental Studies, University of Oxford.

Makdisi, G. 1957. 'Autograph diary of an eleventh-century historian of Baghdad—V'. *Bulletin of the School of Oriental and African Studies* 19, pp. 426–43.

Makiya, M. 2006. *Baghdad.* London.

Maricq, A. and G. Wiet. 1978. *Le minaret de Djam. Mémoires des la délégation archéologique française en Afghanistan.* Vol. 18. Paris.

Mechkati, N. n.d. *Monuments et sites historiques de l'iran.* Tehran.

Melikian-Chirvani, A. S. 1982. *Islamic Metalwork from the Iranian World 8th–18th Centuries. Victoria and Albert Museum Catalogue.* London.

Membré, M. 1993. *Mission to the Lord Sophy of Persia (1538–42).* trans. with introduction and notes by A. H. Morton. London University.

Merklinger, E. S. 2005. *Sultanate Architecture of Pre-Mughal India.* New Delhi.

Micara, L. 1979. 'Mobile architecture in the Moharam festival in Iran'. In ed. D. Jones and G. Michell. *Mobile architecture in Asia: ceremonial chariots. floats and carriages. AARP* 16, pp. 40–46.

Michell, G. and M. Zebrowski. 1999. *Architecture and Art of the Deccan Sultanates. New Camrbidge History of India* I:7. Cambridge.

Miles, G. 1965. 'Al-Mahdi al-Haqq. Amir al-mu'minin'. *Revue Numismatique* 6ᵉᵐᵉ série. 7, pp. 329–341.

Minorsky, V. (trans.). 1959. *Calligraphers and Painters. A Treatise by Qadi Ahmad. son of Mir-Munshi (circa A.H. 1015/A.D. 1606)*. Freer Gallery of Art. Washington.

Mirzaee Mehr, A-A. 2006. *The Paintings of the Iranian Holy Shrines.* Tehran. (in Persian).

Miskawaihi. The Experience of the Nations. 1921. trans. by D.S. Margoliouth. Vol. 2. Oxford.

Mitchiner, M. 1977. *The World of Islam.* London.

Morris, J., R. Wood and D. Wright. 1969. *Persia.* London.

Mortimer Rice, F. and B. Rowland. 1971. *Art in Afghanistan.* London.

Morton, A.H. 1974. 'The Ardabil Shrine in the reign of Shah Tahmasp I'. *Iran* 12, pp. 31–64.

— 1975. 'The Ardabil Shrine in the reign of Shah Tahmasp I'. *Iran* 13, pp. 39–58.

Nakash, Y. 1993. 'An attempt to trace the origin of the rituals of 'Asura'. *Die Welt des Islam* 33. Part 2, pp. 161–181.

— 1995. 'The visitation of the shrines of the Imams and the Shi'i Mujtahids in the early twentieth century'. *Studia Islamica* 81, pp. 153–164.

al-Naqshbandi, N. 1950. 'Sanadiq maraqid al-a'imma fi Iraq'. *Sumer* 6, pp. 192–202.

Naqvi, S. 1987. *Qutb Shahi 'Ashur Khanas of Hyderabad City.* 2ⁿᵈ edition. Hyderabad.

— 2003. *The Iranian Afaquies Contribution to the Qutb Shahi and Adil Shahi Kingdoms.* Hyderabad.

— 2006. *Muslim Religious Institutions and their Role under the Qutb Shahs.* Hyderabad.

— 2006/1. *The 'Ashur Khanas of Hyderabad City.* 3ʳᵈ edition. Hyderabad.

Naqvi, S. and V.K. Rao (ed.). 2004. *The Muharram ceremonies among the non-muslims of Andhra Pradesh.* Hyderabad.

Nasr, SH. 1978. 'Ithna 'ashariyya'. *Encyclopaedia of Islam.* 2ⁿᵈ edition, 4, pp. 277–9.

Nayeem, M.A. 2005. 'Safawid Iran and Adil Shahi Bijapur—Their Relations'. In ed. by V. Kishan Rao and A. Satyanarayana. *A Thousand Laurels—Dr. Sadiq Naqvi. A Festschrift.* Vol. 1, pp. 79–107. Hyderabad.

Nazim, M. 1936. *Bijapur Inscriptions. Memoirs of the Archaeological Survey of India* no. 49. Delhi.

Necipoglu, N. 2007. 'Qur'anic inscriptions on Sinan's imperial mosques: a comparison with their Safavid and Mughal counterparts'. In ed. F. Suleman, *Word Of God. Art of Man: The Qur'an and its Creative Expressions*, pp. 69–104. Oxford.

Newid, M.A. 1998. 'Stone cauldrons from Isfahan—an example of ritual fine art in the Safavid era'. *Acta Orientalia* 59, pp. 83–105. Copenhagen.

— 2006. *Der schiitische Islam in Bildern. Rituale und Heilige.* Munich.

Niebuhr, C. 1776. *Voyages en Arabie.* 2 vols. Amsterdam/Utrecht.

Nöldeke, A. 1909. *Das Heiligtum des Husain in Kerbala.* In ed. by G. Jacob. *Türkische Bibliothek.* 2. Berlin.

Northedge, A. 1995. 'Samarra'. *Encyclopaedia of Islam.* 2ⁿᵈ edition. 8, pp. 1039–1041. Leiden.

— 2006. 'The Qubbat al-Sulaybiyya and its interpretation'. In ed. by P.L. Baker and B. Brend. *Sifting Sands. Reading Signs. Studies in honour of Professor Géza Fehérvári*, pp. 71–82. London.

O'Kane, B. 1987. *Timurid Architecture in Khurasan.* Mazda Publishers.

Olearius, A. 1669. *The Voyages and Travels of the Ambassadors.* Trans. by J. Davies. London.

Omar, F. 1971. 'Harun al-Rashid'. *Encyclopaedia of Islam.* 2ⁿᵈ edition. 3, pp. 232–4. Leiden and London.

Öz, T. 1953. *Hırka-i Saadet Dairesi ve Emanat-ı Mukaddese.* Istanbul.

Özdemir, K. 1993. *Ottoman clocks and watches.* Istanbul.

Page, J.A. 2001. An historical memoir on the Qutb: Delhi. In ed. M. Juneja. *Architecture in Medieval India. Forms. Contexts. Histories*, pp. 143–170. New Delhi.

Papadopoulo, A. 1980. *Islam and Muslim Art.* London.

Parviz, N. 2000. *The Complete Pictorial Guide to Tehran. Historical Monuments.* Tehran.

Peck, L. 2006. *Delhi. A thousand years of building.* New Delhi.

Persian and Mughal Art. 1976. Colnaghi & Co. London.

154

Persian Art. 1931. *Persian Art. An Illustrated Souvenir of the Exhibition of Persian Art at Burlington House London.* 2nd edition. London.

Peterson, S. R. 1979. The Ta'ziyeh and Related Arts. In ed. by P. Chelkowski. *Ta'zyeh. Ritual and Drama in Iran*, pp. 64–87. New York.

— 1979/1. 'Painted tiles at the Takieh Mu'avin' ul-Mulk (Kirmanshah)'. *Akten des VII. Internationalen Kongresses für Iranische Kunst und Archäologie. München 7.–10. Setember 1976*, pp. 618–628. Berlin.

— 1981. *Shi'ism and Late Iranian Arts.* Ph.D. thesis. NYU.

Polo, Marco. 1993. *The travels of Marco Polo : the complete Yule-Cordier edition : including the unabridged third edition (1903) of Henry Yule's annotated translation, as revised by Henri Cordier, together with Cordier's later volume of notes and addenda (1920).* New York.

Poole, R. S. 1887. *The Coins of the Shahs of Persia*, London.

Pope, A. U. (ed.). 1938. *A Survey of Persian Art.* 6 vols. Oxford.

Pope, J. A. 1956. *Chinese porcelains from the Ardebil Shrine.* Washington.

Porter, V. 2007. 'The Power of the Word in Islamic Culture'. In ed. D. Francis. *Faith and Transformation. Votive Offerings and Amulets from the Alexander Girard Collection*, pp. 108–9. Museum of International Folk Art. Santa Fe.

Porter V. and H. N. Barakat. 2004. *Mightier than the Sword. Arabic script: beauty and meaning.* Kuala Lumpur.

Pourjavady, N. 2001. *The Splendour of Iran.* 3 vols. London.

Prochazkka, A. B. 1990. *Khwarizm.* Zurich.

— 1993. *Bukhara.* Prague.

Pugachenkova, G. A. 1981. *A Museum in the Open.* Tashkent.

Rabino, H.-L. 1915–16. *Les Provinces Caspiennes de la Perse. Le Guîlân.* Vol. 32 of *Revue du Monde Musulman.* Paris.

Rabino di Borgomale, H. L. 1945. *Coins, Medals and Seals of the Shahs of Iran. 1500–1941.* Hertford, England.

Raghib, Y. 1970. 'Les premiers monuments funéraires de l'islam'. *Annales Islamologiques* 9, pp. 21–36.

Rahnama-yi muza-yi astan-i quds-i Rezavi. N.d. Mashhad.

Randhawa, M. S. 1983. *Paintings of the Babur Nama.* National Museum. New Delhi.

Reid, D. M. 1993. 'The Postage Stamp: a Window on Saddem Hussein's Iraq'. *Middle East Journal* 44, i, pp. 77–89.

Richards, D. S. (trans. and ed.). 2002. *The annals of the Saljuq Turks: selections from al-Kamil fi'l-Ta'rikh of 'izz al-Din Ibn al-Athir.* London.

Rizvi, K. 2003. 'Religious icon and national symbol: the tomb of Ayatollah Khomaini in Iran'. *Muqarnas* 20, pp. 209–224.

Rizvi, S. A. A. 1986. *A Socio-intellectual History of the Isna 'Ashari Shi'is in India.* 2 vols. Canberra.

Robinson, B. W. 1958. *A descriptive catalogue of the Persian paintings in the Bodleian Library.* Oxford.

Rogers, J. M. 1972. 'The genesis of Safavid religious painting'. In ed. by M. Y. Kiani and A. Tajvidi. *The Memorial Volume of the Vth International Congress of Iranian Art & Archaeology. Tehran-Isfahan-Shiraz. 11th–18th April 1968.* Vol. 2, pp. 167–188. Tehran.

— 1993. *Mughal Miniatures.* British Museum. London.

— 1995. *Empire of the Sultans. Ottoman Art from the collection of Nasser D. Khalili.* Musée d'art et d'histoire, Geneva. Londonj.

Royal Academy of Arts. 1931. *Catalogue of the International Exhibition of Persian Art at the Royal Academy of Arts. London. 7th January to 28th February 1931.* London.

Saadat, B. 1976. The Holy Shrine of Imam Reza. Mashhad. Shiraz.

Safrani, S. H. 1992. 'Golconda Alums. Shimmering Standards'. In ed. S. H. Safrani. *Marg: Golconda and Hyderabad.* Bombay.

al-Samarra'i, Y. I. 1971. *Tarikh madinat Samarra.* 2. Baghdad.

Sarwar, G. 1939. *History of Shah Isma'il Safawi.* Aligarh.

Sarre, F. and E. Herzfeld. 1911–20. *Archäologische Reise im Euphrat- und Tigris-Gebiet.* 4 vols. Berlin.

Satyanarayana, S. V. 2000. 'Diamonds in the Deccan—An Overview'. In ed. by H. K. Gupta et al. *Deccan Heritage*, pp. 135–156. Hyderabad.

Savage-Smith, E. 2003. 'Safavid Magic Bowls'. In ed. by J. Thompson and S.R. Canby. *Hunt for Paradise*. chapter 9, pp. 240–7. Milan.

Savory, R.M. (trans.). 1978–1986. *The history of Shah 'Abbas the Great: Tarik-e 'alamara-ye 'Abbasi by Eskandar Beg Monshi*. 3 vols. Boulder.

Sebn, G. 1984. *Paintings from the Akbar Nama*. Calcutta etc.

Schmucker, W. 1993. 'Mubahal'. *Encyclopaedia of Islam*. New edition. 7, pp. 276–7. Leiden and New York.

Seherr-Thoss, S.P. 1968. *Design and Colour in Islamic Architecture*. Washington.

Sen, G. 1984. *Paintings from the Akbar Nama*. Calcutta et al.

Seyller, J. 2002. *The Adventures of Hamza. Painting and storytelling in Mughal India*. Smithsonian Institution. Washington.

Sherwani, H.K. 1974. *History of the Qutb Shahi dynasty*. Delhi.

Shirazi, F. 2005. 'The Daughters of Karbala: Images of Women in Popular Shi'i Culture in Iran'. In ed. K.S. Aghaie, *The Women of Karbala. Ritual Performance and Symbolic Discourses in Modern Shi'i Islam*, pp. 93–118. Austin, Texas.

Simpson, M.S. 1998. *Persian Poetry, Painting and Patronage. Illustrations in a Sixteenth-Century Masterpiece*. Washington.

Smith, J.M. 1970. *The history of the Sarbadarid dynasty 1336–1381 A.D. and its sources*. The Hague/Paris.

Soudavar, A. 1998. 'A Chinese Dish from the Lost Endowment of the Princess Soltânum'. In ed. K. Eslami. *Papers in Honor of Iraj Afshar*, pp. 125–147. Princeton (NJ).

Sourdel-Thomine, J. 1953. 'Deux minarets d'époque seljoukide en Afghanistan'. *Syria* 30, pp. 108–136.

Stchoukine, I. 1973. 'Qasim ibn 'Ali et ses peintures dans les *Ahsan al-Kibar*'. *Ars Asiatique* 28, pp. 45–54.

Stern, S.M. 1967. 'The coins of Amul'. *Numismatic Chronicle* 7th series. 7, pp. 205–278.

Streck, M. 2004. 'Mashhad'. *Encyclopaedia Islamica*. 2nd edition. 12. Supplement, p. 605.

Strika, V. 1974. 'Il Santuario di al-Kazimaini a Baghdad'. *Oriente Moderno* 54, pp. 6–22.

Sultanzade, H. 1997. *Tabriz. A Solid Cornerstone of Iranian Architecture*. Tehran.

Sutudeh, M. 1977. *Az Astar ta Istarbad*, vol.2. *Shamil-e athar va banaha-ye tarikhi-ye Gilan bi pish*. Tehran.

Sykes, P.M. 1910. *The Glory of the Shia World*. London.

Tabataba'i, H.M. 1976. *Turbat-i Pakan*. 2 vols. Qum.

Talbot Rice, D. 1976. *The Illustrations to the 'World History' of Rashid al-Din*. Edinburgh.

Tanavoli, P. 2001. 'Religious and ritual paraphernalia'. In ed. N. Pourjavady. *The Splendour of Iran*. vol.3. *The Islamic Period*, pp. 312–323. London.

Tanavoli, P., and V. Porter. 2007/1. 'Parts of the Body in Shi'a Islam'. In ed. D. Francis. *Faith and Transformation. Votive Offerings and Amulets from the Alexander Girard Collection*, pp. 110–113. Museum of International Folk Art. Santa Fe.

— 2007/2. 'The Magic of Letters and Numbers in Mystical Islam'. In ed. D. Francis. *Faith and Transformation. Votive Offerings and Amulets from the Alexander Girard Collection*, pp. 114–5. Museum of International Folk Art. Santa Fe.

Tanavoli, P., and J.T. Wertime. 1976. *Locks from Iran, Pre-Islamic to Twentieth Century*. Smithsonian Institution, Washington D.C.

Tandan, B. 2001. *The architecture of Lucknow and its dependencies, 1722–1856: a descriptive inventory and an analysis of Nawabi types*. New Delhi.

Tattersall, C. 1931. 'Carpets and textiles at the Persian Exhibition'. *Apollo* vol. 13, pp. 82–89.

Thackston, W.M. 2001. *Album prefaces and other documents on the history of calligraphers and painters*. Leiden.

Thompson, J., and S.R. Canby (ed.). 2003. Hunt for Paradise. Court Arts of Safavid Iran. 1501–1576. Milan.

Titley, N.M. 1983. *Persian Miniature Painting*. British Library. London.

Veinstein, G. 1997. 'Süleyman'. *Encyclopaedia of Islam*. 2nd edition. 9, pp. 832–42. Leiden.

Vernoit, S. 1997. Occidentalism. In ed. by J. Raby. *The Nasser D. Khaili Collection of Islamic Art*. 23. London.

von Folsach, K. 2001. *Art from the World of Islam in The David Collection*. Copenhagen.

von Folsach, T. Lundbaek, and P. Mortensen (ed.). 1996. *Sultan, Shah and Great Mughal. The history and culture of the Islamic world*. The National Museum. Copenhagen.

von Hammer-Purgstall, J. 1842–3. *Geschichte der Ilchane, das ist der Mongolen in Persien*. 2 vols. Darmstadt.

Watson, O. 1977. *Persian lustre tiles of the thirteenth and fourteenth centuries*. Ph.D. thesis. SOAS.

— 1985. *Persian Lustre Ware*. London.

— 1994. Documentary Mina'i and Abu Zaid's Bowls. In ed. by R. Hillenbrand. *The Art of the Saljuqs in Iran and Anatolia*, pp. 170–6. Costa Mesa.

Welch, A. 1997. 'The shrine of the holy footprint in Delhi'. *Muqarnas* 14, pp. 166–178.

Welch, S. C. 1972. *A King's Book of Kings. The Shah-nameh of Shah Tahmasp*. London.

— 1985. *India. Art and Culture 1300–1900*. Metropolitan Museum of Art. New York.

— 1987. *The Islamic World. The Metropolitan Museum of Art*. New York.

Wensinck, A. J. 1960. ''Ashura''. In *Encyclopaedia of Islam*, 2nd edition, vol. 1 p. 705.

Wilber, D. N. 1955. *The Architecture of Islamic Iran. The Il Khanid Period*. Princeton.

Wills, C. J. 1886. *Persia as it is*. London.

Wilson, S. G. 1896. *Persian Life and Customs*. London.

Wolff, H. E. 1966. *The Traditional Crafts of Persia*. Cambridge. Mass.

Wright, E. 2009. *Islam. Faith. Art. Culture. Manuscripts in the Chester Beatty Library*. Dublin.

Yaqut 1929. Ed. D. S. Margoliouth. *The Irshad al-Arib ila Ma'rifat al-Adib, or Yaqut's Dictionary of Learned Men*. Vol. VI.5. London.

Yarshater, E. 1979. 'Ta'ziyeh and pre-islamic mourning rites in Iran'. In ed. by P. Chelkowski. *Ta'ziyeh: Ritual and drama in Iran*, pp. 88–94. New York.

Yurdaydın, H. G. 1976. *Beyan-ı menazil-i sefer-i Irakeyn-i Sultan Süleyman Han. Nasuhü's-Silahi (Matrakçı); tıpkı basımı yayına haz*. Ankara.

Zebrowski, M. 1997. *Gold, Silver and Bronze from Mughal India*. London.

Zygulski, Z. 1992. *Ottoman Art in the Service of the Empire*. New York/London.

Appendix: Shi'i Dynasties of Iran and India

Safavids (Iran) 1501–1732

Isma'il I 1501–1524
Tahmasp I 1524–1576
Isma'il II 1576–1578
Muhammad Khudabanda
 1578–1588

'Abbas I 1588–1629
Safi I 1629–1642
'Abbas II 1642–1666
Sulayman I 1666–1694
Husain 1694–1722

Tahmasp II 1722–1732

Qajars (Iran) 1779–1924

Agha Muhammad 1779–1797
Fath 'Ali Shah 1797–1834
Muhammad 1834–1848

Nasir al-Din 1848–1896
Muzaffar al-Din 1896–1907
Muhammad 'Ali 1907–1909

Ahmad 1909–1924

Nizamshahis (Ahmednagar) 1490–1636

Ahmad 1490–1510
Burhan 1508–1553
Husain 1553–1565
Murtaza 1565–1588
Husain II 1588–1589

Isma'il 1589–1591
Burhan II 1591–1595
Ibrahim 1595
Ahmad II 1595
Bahadur 1595–1600

Murtaza II 1600–1610
Burhan III 1610–1631
Husain III 1631–1633
Murtaza IV 1633–1636

Adilshahis (Bijapur) 1490–1686

Yusuf 1490–1510
Isma'il 1510–1534
Mallu 1534–1535

Ibrahim I 1535–1558
Ali I 1558–1580
Ibrahim II 1580–1627

Muhammad I 1627–1656
Ali II 1656–1672
Sikandar 1672–1686

Qutbshahis (Golconda and Hyderabad) 1489–1687

Quli 1489—1543
Jamshid 1543–1550
Subhan 1550

Ibrahim 1550–1580
Muhammad Quli 1580–1611
Muhammad 1611–1626

Abdullah 1626–1672
Abul Hasan 1672–1687

Nawabs of Oudh (Lucknow) 1722–1856

Saadat Khan 1722–1739
Safdar Jang 1739–1753
Shajauddaula 1754–1775
Asafuddaula 1775–1797

Saadat Ali Khan 1798–1814
Ghaziuddin Haidar 1814–1828
Nasiruddin Haidar 1827–1837
Muhammad Ali Shah 1837–1842

Amjad Ali Shah 1842–1847
Wajid Ali Shah 1847–1856

List of Illustrations

Maps

Figures

Plates

Chapter 1

Chapter 4

Index[1]

A

Aaron see Harun
Abaqa Khan 82, 83
'Abbas, uncle of the Prophet 71
'Abbas, Abu'l-Fazl 59, 60, 72, 73, 96, 100, 111, 113, 114, 119, 121, 122, 130
'Abbas I Safavi 27, 32, 51, 52, 54, 56, 60, 86–88, 93, 94, 101, 102
'Abbas II Safavi 33, 88
'Abbasiyeh 59, 79
'Abd al-'Azim b. Hasan 33
'Abdallah ibn Yahya ibn Khaqan 42
Abd al-Qadir Nizam Shah 61
'Abd al-Qadir al-Gilani 43
'Abd al-Vahhab Isfahani 126
Abdulhamid II, Sultan 32
Abdullah Qutb Shah 72–75, 118, 130, 133
Abdulmecid, Sultan 32
'Abd al-Husain al-Tehrani, Sheikh 30
Abraha, Yemeni king 84
Abu Bakr 1–3, 44, 108
Abu Bakr 'Abd al-Rahman ibn Ahmad ibn 'Abdallah al-Marwazi al-Qaffal 104
Abu'l-Fath Mirza 91
Abu Hamid al-Gharnati 16
Abu Hanifa, tomb of 43
Abu'l-Haija 'Abdallah Hamdani 12, 16
Abu Hasan 'Ali ibn 'Abdallah ibn Wasif al-Nashi'i 86
Abu Ja'far b. al-Mansur 36
Abu Muhammad ibn al-Nasawi 13
Abu'l-Qasim Kashani 83
Abu'l-Qasim Muhammad ibn al-Hasan, see Mahdi
Abu Sa'd al-Sarkhasi 14
Abu Sa'id, Il-Khanid sultan 46
Abu Tammam 13, 14
Abu Yusuf Ya'qub al-Mansur (Almohad) 92
Abu Zaid 80, 83
Adam, grave of 28, 36
Adhan see call to prayer
Adnan ibn al-Radi 13

'Adud al-Dawla, Buyid 12, 28, 35, 36, 38, 40, 47
'Adud al-Din Faramarz 15
Agha Muhammad Khan Qajar 30
Agha Muhsin Khurasani, Haji 73
Ahmad b. Hanbal 13, 14, 15
Ahmad Nizam Shah Bahri 61, 70
Ahmednagar 45, 74
 Damri Mosque 63, 68, 71, 141, pl. 2.18, 2.19
 Kotla 135
 tomb of Ahmad Bahri 70
Ahsan al-Kibar, "The Best of the Greatest" 108
'Ain al-Baqr 16
Ajmer 133
Akbar 130
Akbar-nameh 130
'Alam 68, 70–75, 77, 85, 99, 103, 114, 118, 119, 121–36, 141–43, pl. 2.24–26, 2.34, 3.15, 4.1–6, 4.8–13, 4.16
 na'l-e mubarak 72
 'alam-e sar-tawq mubarak (sartooq) 72–73, pl. 2.31
 Husaini 'alam 72, 131, 134
 'alam-i Abu'l-Fazli'l 'Abbas 72
 hazrat Qasim's 'alam 72, 73; Bibi Ka 'alam 72
 very 'alam 73–74;
Alawa 134
'Alawiyyin see Sayyids
Alem Majlesi 118
Aleppo 121
Ali I Adil Shah 61, 70, 74
Ali II Adil Shah 61, 67
'Ali Akbar 111, 113
'Ali Asghar 97, 111, 113
'Ali al-Hadi, 10th imam 3, 67; see also Samarra, Twelve Imams
'Ali Reza, 8th Imam 2, 41, 42, 48, 71, 105; see also Mashhad, Qadamgah, Twelve Imams
'Ali b. Abi Talib, 1st Imam 1–3, 5–7, 10, 13–17, 19, 28, 29, 35, 38, 40, 43–46, 48–50, 52, 54–57, 61, 63, 64, 67, 82, 90, 100, 107, 108, 110, 114, 120, 124, 125, 127, 139, 141, 143, pl. 3.12, 3.20, 3.21; see also Twelve Imams
